WORK SMALL, LEARN BIG!

SKETCHING WITH PEN & WATERCOLOR.

17 international artists show you the fast way to build your painting skills

STARTING SMALL IN PEN AND WATERCOLOR IS THE FASTEST WAY TO BUILD ALL YOUR PAINTING SKILLS!

See how small on-site sketches can be built into major paintings

Pen and watercolor is the unsung hero of art instruction, yet it is the easiest, fastest way to build painting skills.

Speak to most master artists and they will tell you that preparatory studies are the best way to design a painting, to concretize ideas and pave the way for larger paintings. Pen and watercolor is one of the tools master artists routinely use for such studies.

In this book 17 accomplished international artists reveal their personal methods for working with pen and watercolor.

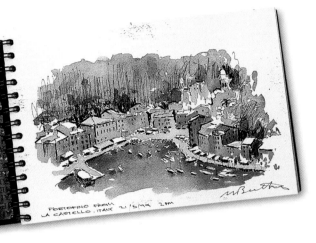

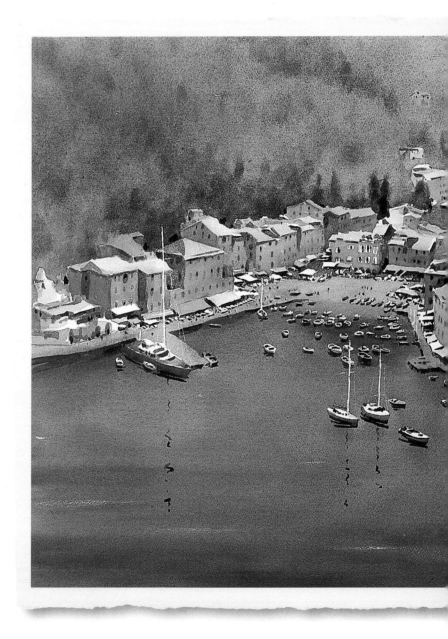

![international artist]

International Artist Publishing, Inc
2775 Old Highway 40
P.O. Box 1450
Verdi, Nevada 89439
Website: www.artinthemaking.com

Edited by Jennifer King
Designed by Vincent Miller
Typeset by Ilse Holloway and Cara Herald
Editorial Assistance by Dianne Miller

ISBN 1-929834-27-6

Printed in Hong Kong
First printed in hardcover 2003
07 06 05 04 03 6 5 4 3 2 1

Distributed to the trade and art markets in North America by:
North Light Books,
an imprint of F&W Publications, Inc
4700 East Galbraith Road
Cincinnati, OH 45236
(800) 289-0963

- They show how to use the classic pen and watercolor study as the first stage of a major painting.
- They demonstrate how working with pen and watercolor can generate ideas and how it can develop personal style.
- There are chapters on improving design and on problem solving.
- Several artists show how to journalize your travels with pen and watercolor.
- Another section shows how to tackle complex architectural subjects.
- There's even a chapter on how to create pen and watercolor "products" for quick sale to galleries.

Every artist has something unique and informative to offer. They spell out the materials and methods used, including their choice of sketchbooks and papers, and even how they make the most of sketching on site.

All this information is presented in a way that entices rather than intimidates. This book will boost the reader's confidence from day one. But most of all, because it is based on a classic approach, it will turn many beginners into real artists much quicker than if they worked with any other method.

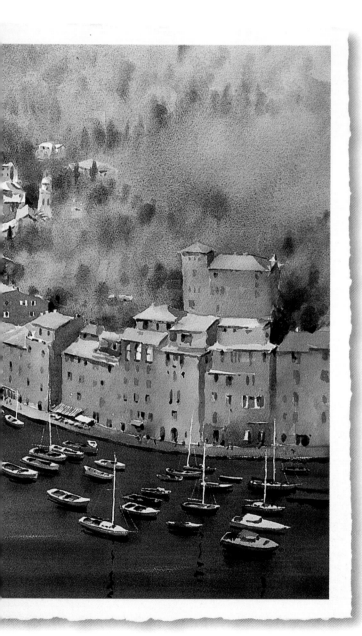

All 17 chapters have a unique format so you can see how each international artist focuses on their personal approach to working with pen and watercolor.

The elements in each chapter

17 DIFFERENT WAYS TO USE PEN AND WATERCOLOR
All 17 artists describe their personal way of working with pen and watercolor, and the main ideas you can use in your own art.

THE MATERIALS NEEDED
Each artist specifies their favorite tools — pens, inks, paints, brushes, photographs, sketchbooks.

STEP-BY-STEP DEMONSTRATIONS
The book is full of step-by-step sequences showing all the stages of development of a pen and watercolor painting. Full descriptive captions, plus a list of colors and materials used, turn each demonstration into an exercise you can follow.

FINISHED PAINTINGS SHOW YOU WHAT CAN BE ACHIEVED
See how pen and watercolor drawings capture the essence of the scene. You have the option of framing the finished pen and watercolor drawing or using the information gathered to turn your ideas into a magnificent finished painting. Either way, you'll learn more about selecting and editing the important elements from the information and demonstrations in this book than you'll learn in a year on your own.

Vincent Miller was responsible for the original concept and design of this book, which was compiled by a team of International Artist staff, including Editor/Executive Publisher, Terri Dodd, US Editor, Jennifer King, International Editor, Jeane Duffey and UK Editor, Susan Flaig.

CONTENTS

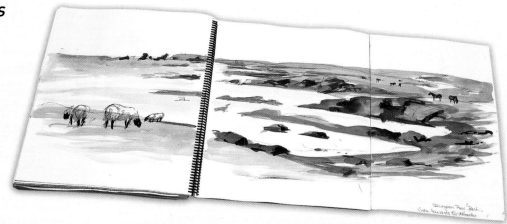

PUTTING SKETCHBOOKS TO WORK

If you plan to really make use of your pen-and-wash sketches back in the studio, follow Anthony J Batten's guide to putting the most into your sketchbooks so you can get the most out of them.

I often feel intimidated when I see other artists' sketchbooks. Their permanent bindings and careful neat entries look more like a diary created for posterity and a biographer than for real use in the workshop. That's not how I approach on-site sketching at all.

My sketchbook is very much a personal information bank compiled to trigger my memory when I am in the studio. As such, I include far more than just line drawings enhanced with color washes. I take written notes, draw close-ups, match up other references and so much more. While my methods may not be as "pretty" as some artists', they pay off in the long run when I'm ready to work by providing all the information I need conveniently enclosed in a single package.

Visualizing my ideas

When it comes to using pen and wash to sketch on location, my works are rarely 100 percent accurate renderings of the site. They are very much my reaction to that particular location. In the sketches as well as the final works, I will freely move trees, lamp standards and even take liberties with structures as long as the essential mood is retained. I don't necessarily include every detail of the subjects either.

For example, I might move two important buildings so that they appear closer together than they actually are. This allows me to create a well-framed composition that encapsulates a collective memory of the area. In fact, I once turned an equestrian statue 180 degrees so that the horse and rider would lead the eye into the composition. It was reproduced on a widely distributed greeting card, and no one noticed the change until I brought it up!

Such changes must appear to be totally natural to be convincing, and the preparatory sketch is the ideal place to experiment with various options. Several concepts can be drawn on a single page, which can look a bit messy or confusing, but that's what sketchbooks are all about — the visualization of the thought process behind the finished painting.

"DOOR TO SOUTHWEST PORCH OF ST JAMES' CATHEDRAL", 14 x 22" (36 x 56cm)
Note how I try to keep my photographic and slide references together with my sketches so I have everything in one place.

WHAT THE ARTIST USES

I have developed a highly compact set of sketching supplies that fit into a comfortable backpack. My kit allows me to be inconspicuous when I'm sketching out in public. It contains:

- *A loaded camera (slide film or digital)*
- *HB pencils and sharpener*
- *Pilot V-Ball pens in black (they work on dry and wet paper)*
- *A mini-box of watercolors*
- *Two or three brushes of varying widths*
- *Paper towels*
- *Water bottle*

- *Painter's low-adhesive tape (very handy for creating a clean edge in a watercolor wash such as a window or lamp post)*
- *Sketchbook (an artist's quality, spiral-bound book of white, heavy, smooth paper, about 11 x 14" sheet size; my current favorite is the 50-page Robert Bateman Cover Series, which incidentally uses recycled paper and benefits the World Wild Life Fund; I find the spiral binding is stronger than most, allowing me to easily add and subtract pages as needed)*

Making fast work of the thing

Another reason my sketchbook pages aren't always as neat as some is that I need to work fast. As a painter of architectural studies and urban scenes, it is vital to get down the essentials of a view quickly. In the urban-scape, a wonderful view can vanish with the arrival of a newly parked truck!

I utilize a camera a lot to record my views. (I often allow or even encourage local people to be a part of my photographs as they add a much-needed human reference for the scale of nearby structures. Likewise, cars and other vehicles add life and local flavor to the finished work.) For years, I have preferred to use slide film, ➡️

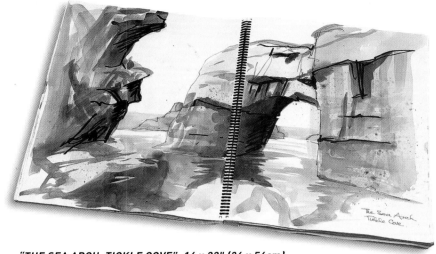

"THE SEA ARCH, TICKLE COVE", 14 x 22" (36 x 56cm)
My paintings and sketches are not limited to architecture. I enjoy painting all manner of landscapes.

"THE DOMESTIC RANGE OF UNIVERSITY COLLEGE, UNIVERSITY OF TORONTO",
14 x 33" (36 x 84cm)
Instead of trying to squeeze a panoramic view onto two pages of a sketchbook, I simply add a third page. This gives me plenty of room to capture the fullness of my subject.

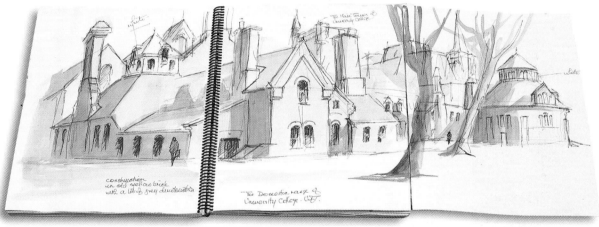

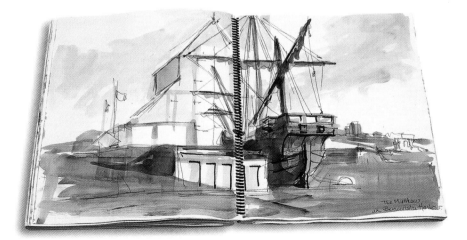

"THE MATTHEW IN BONAVISTA HARBOUR", 14 x 22" (36 x 56cm)
Many artists keep their pen-and-wash sketches small, but I like to work at a good size and frequently use both pages. I find it allows me to record a stronger impression of the subject.

I INCLUDE FAR MORE THAN JUST LINE DRAWINGS ENHANCED WITH COLOR WASHES. I TAKE WRITTEN NOTES, DRAW CLOSE-UPS, MATCH UP OTHER REFERENCES AND SO MUCH MORE.

7

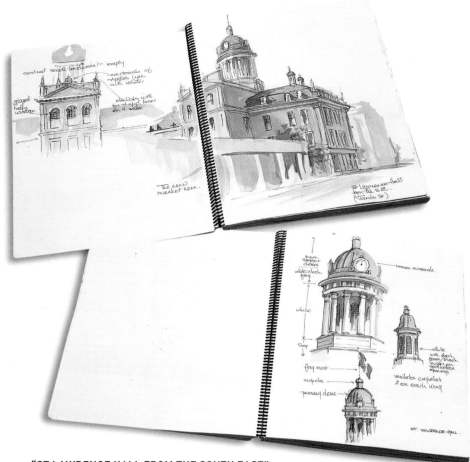

"ST LAWRENCE HALL FROM THE SOUTH EAST",
14 x 22" (36 x 56cm) AND 14 x 11" (36 x 28cm)
I often do a pen-and-wash sketch of the overall
subject and then paint some close-up details,
perhaps on the same spread or a nearby page.

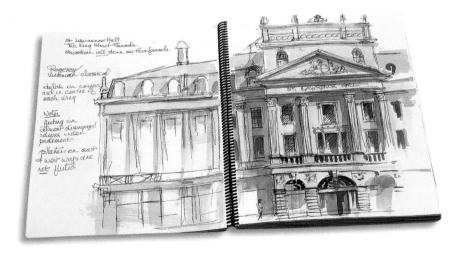

"ST LAWRENCE HALL, KING STREET FAÇADE", 14 x 22" (36 x 56cm)
Notice how my pen-and-wash sketches are done very loosely.
I am mostly trying to record my impression of the subject, which
includes writing notes and drawing out some details. Of course,
this information is supplemented with photographs when I go to
paint the finished work.

as the ability to project the image in my studio gives me yet another chance to edit my view and to carefully review details that I may have missed on site. The ability to change the size of the projected image by using the enlarging feature in the projector has frequently turned an "okay" view into a great small-scale work or an extensive panoramic piece. This advantage over regular prints is now being equaled by digital cameras and their accompanying technology.

Whether I've shot slides or digital photographs — or perhaps even found some other visual reference such as a newspaper cutting — these, too, get attached or pasted into my sketchbook, preferably on or near the corresponding sketches. In this way, I have all of my references together in one handy location.

Adding on to the book

I've also developed a few other habits that, again, may look a bit crude but provide me with vital information when doing my studio work. Right on top of my pen-and-wash sketches, I usually take down brief notes regarding colors, textures, details and the like. Thanks to my background in art history, some of my cryptic notes are probably unintelligible to others. For example, a classic sash-window will, in my sketchbook, simply show "3/3 over 3/3/3" to denote an arrangement of panes 3 wide by 5 deep with a sash-divider 2 panes from the top. All artists, however, can develop their own type of short-hand based on their personal experience and take whatever notes they deem necessary.

I sometimes carry with me sheets of tracing paper cut to the size of the sketchbook. Taped over existing sketches, these transparent "overlays" allow me to quickly explore alterations to the composition without destroying the

sketch. I leave the best of my ideas taped into the sketchbook.

And finally, as I enjoy creating horizontal, panoramic sketches, I often extend the format of my sketchbook by taping on a third piece of watercolor paper cut to the same size as the book's pages. It doesn't matter if the papers don't match exactly. The important thing is to record my composition and the necessary details.

Putting sketchbooks in their place

To me, sketchbooks are the workhorses of the painting process. They are where the hard work, thinking and creativity take place, where concepts and essential information get recorded for future use. Thus, sketchbooks don't need to be pristine or neat, just functional and chock-full of great ideas waiting to come to life. □

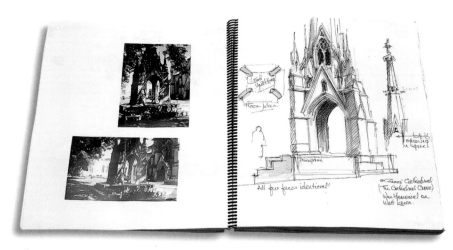

"WAR MEMORIAL ON WEST LAWN OF ST JAMES' CATHEDRAL", 14 x 11" (36 x 28cm)
Sometimes a floor plan can be a beneficial aid in remembering a subject.

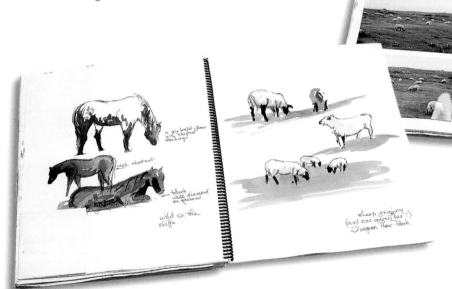

"PONIES AND SHEEP, DUNGEON PROVINCIAL PARK", 14 x 22" (36 x 56cm) AND 14 x 33" (36 x 84cm)
When I find a subject I really like, I try to record as much information as I can through sketching, photography and any other source I might find.

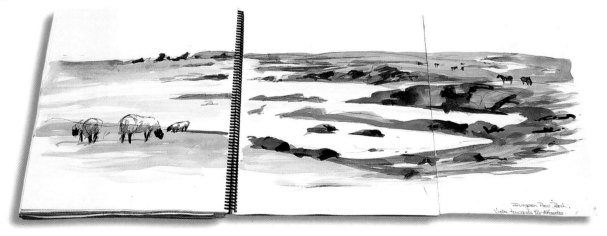

ART IN THE MAKING *"THE DOGE'S PALACE, VENICE"*

Pen-and-wash sketching is actually just one step in my overall creative process. The information I record in my watercolor sketchbooks and loose pencil sketches get transformed into finished paintings back in my studio.

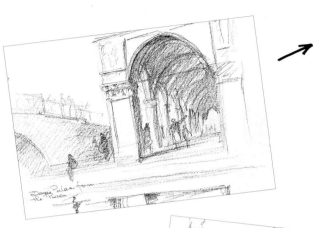

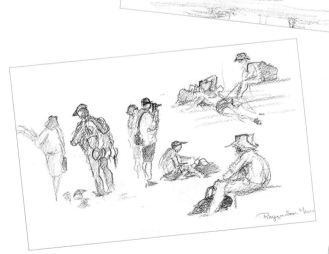

CAPTURING THE DETAILS

After a minimal amount of pen drawing, I went to work on creating my sketch. Working with just a small set of watercolors and a few brushes, I painted my favorite viewpoint, paying close attention to recording the correct colors, light, details and textures. I used strips of low-adhesive painter's tape to produce the crisp edges of the buildings.

NAILING THE COMPOSITION

I began the process by doing several quick thumbnail pencil sketches of possible compositions around the Doge's Palace.

GATHERING MORE INFO

As I often like to include figures in my architectural paintings for scale, I also sketched several bystanders in the area. Note that they have that "tourist" look about them — good walking shoes, cameras and the like.

TAPED OVER EXISTING SKETCHES, TRANSPARENT "OVERLAYS" ALLOW ME TO QUICKLY EXPLORE ALTERATIONS TO THE COMPOSITION WITHOUT DESTROYING THE SKETCH.

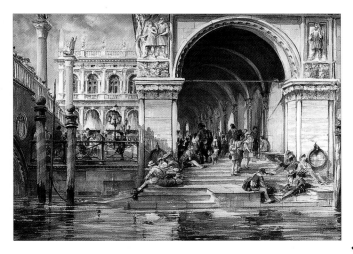

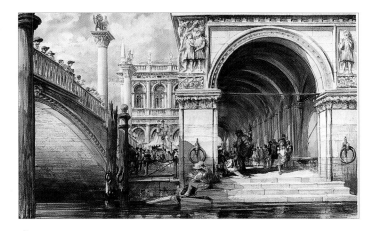

WORKING FROM REFERENCES
Back in the studio, I developed two new paintings based on my pencil drawings, pen-and-wash sketches and photos taken on site.

EXTENDING THE EFFORT
The figures I had sketched on location also appeared in this painting of Venice.

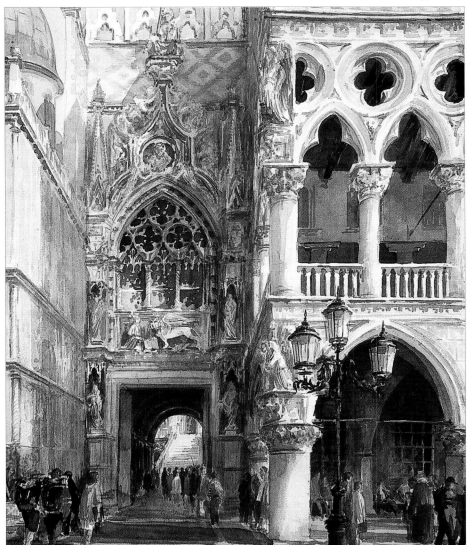

ADDING LOCAL FLAVOR

Including humanizing touches such as figures and cars is a wonderful way to suggest scale and add local flavor to any landscape. But if you think you might want to do this in the studio, make sure you give yourself appropriate references by sketching those details on site. For example, if you think you'd like to include a waiter in your European café scene, be sure you jot down sketches of a few European waiters. Trying to use Canadian or American waiters won't work because they dress differently and will detract from the authenticity of your image if you try to put them in later. And here's one last tip — update these references from time to time to keep pace with changing styles.

BUILD YOUR PICTURE MAKING SKILLS

Malcolm Beattie shows why working small is so important in mastering all the skills you'll need for tackling larger works.

I made this sketch while leaning on the parapets of La Costello, overlooking the small coastal village of Portofino hundreds of feet below. The sketch took about 15 minutes. I enjoyed the short break as a welcome respite from the rather arduous climb up the hill. Several weeks later, back in my Melbourne studio, I used this sketch as the inspiration for the full sheet watercolor shown here.

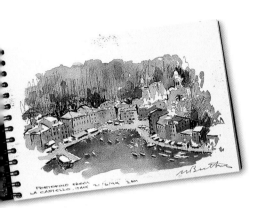

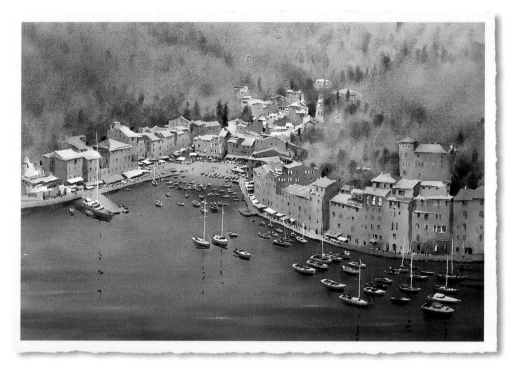

WHAT THE ARTIST USES

Board Paper Drawing Pad
Indian Ink
Watercolor paper sketchpads
Small towel

A small pocket palette
• 12 half-pans of watercolor
• 3 mixing trays
• water bottle
• water container

This all folds up in a small box that easily slips into a pocket

Collapsible watercolor brush (round, synthetic Size 10)

Assorted waterpoof drawing pens of various thicknesses

Shaped bamboo stick
Marker Pen
Shaped ice cream stick
Crowquill pen

MAKE RESOURCE SKETCHES ON SITE

I will often fill up pages with pen and watercolor sketches (sometimes more doodles), searching for ideas and inspiration for a forthcoming exhibition. Usually, after a couple of days, I have more ideas than I can possibly use — but what a great resource for further paintings!

You will notice that I don't always use color — after a while, and with a lot of practice, you can visualize it! Often the challenge is to re-create the spontaneity of the small pen and wash sketches as we translate them to large gallery works.

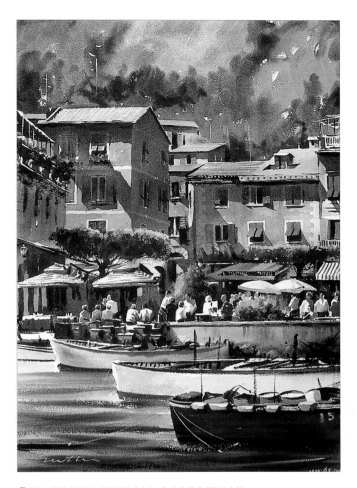

"TRATTORIA TRIPOLI, PORTOFINO"

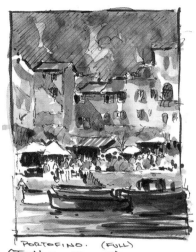

"THE GATEKEEPERS, VENICE"

TRY COMBINING DIFFERENT MEDIA AND TOOLS

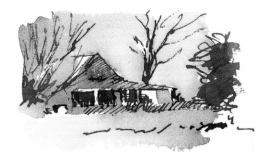

Drawn with a whittled ice cream stick using waterproof sepia ink.

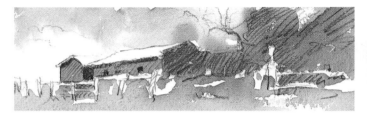

Drawn with a 4B pencil.

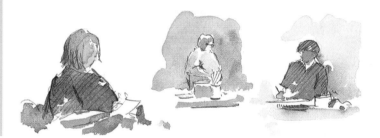

Drawn with a crowquill steel nib and sepia ink.

MAKE PEN AND WATERCOLOR GREETING CARDS

See how I divided up a full sheet of watercolor paper and produced 17 cards from the one sheet!

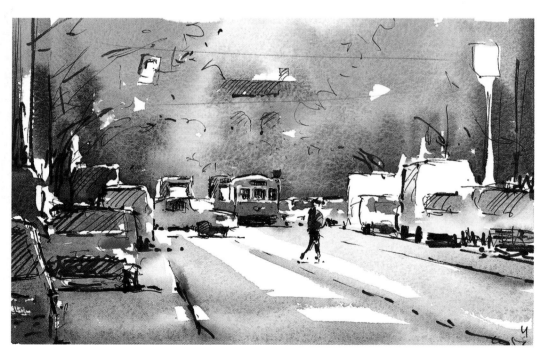

Dropping in colors and allowing them to merge as well as controlling "dry" edges where necessary. Drawn with a crowquill steel nib and Indian Ink.

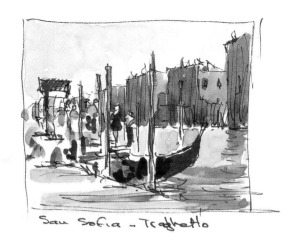

San Sofia - Traghetto

"SAN SOFIA TRAGHETTO, VENICE"

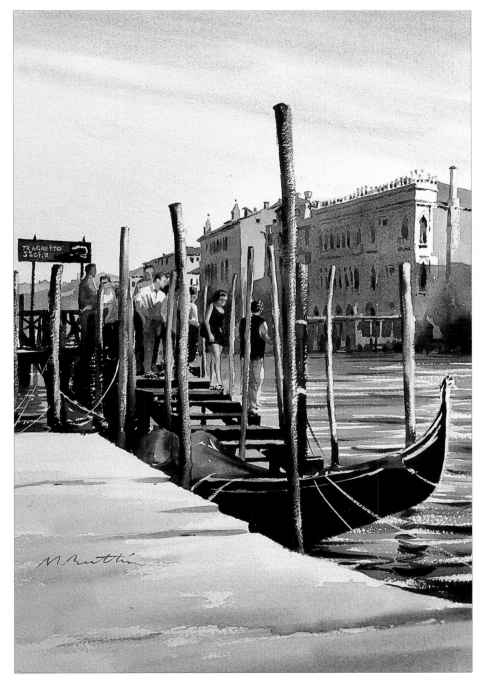

SMALL ON-SITE
SKETCHES CAN BE
BUILT INTO MAJOR
PAINTINGS.

Drawn with black, technical drawing pens (two line thicknesses).

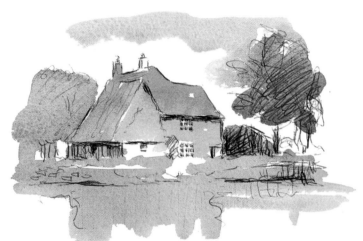

Drawn with black ballpoint pen.

ART IN THE MAKING **MAKE 5-MINUTE SKETCHES IN CAFÉS AND RESTAURANTS**

During a day of painting and sketching along one of our bayside beaches, our group took a well earned "coffee and cake" break in a nearby café, where I noticed an elderly lady sitting alone by a window having a cup of tea.

She was so serene and quietly dignified that I could not resist painting her. Without fuss, I sketched and painted her in about five minutes using my small pocket palette and sketchbook.

No-one in the café (other than my companions) was aware of what I was doing. I think I captured the essence of the moment, quickly, sensitively and without intruding upon her privacy.

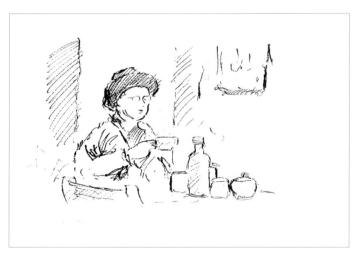

1 I quickly rough in the main shapes, firstly establishing the broad shapes as accurately as time allows

2 I now add emphasis to the sketch with a heavier line weight so that the sketch has substance and authority that will allow a bold application of pigment. →

TRY COMBINING DIFFERENT MEDIA AND TOOLS.

Drawn with chisel tipped calligraphy pen (sepia ink).

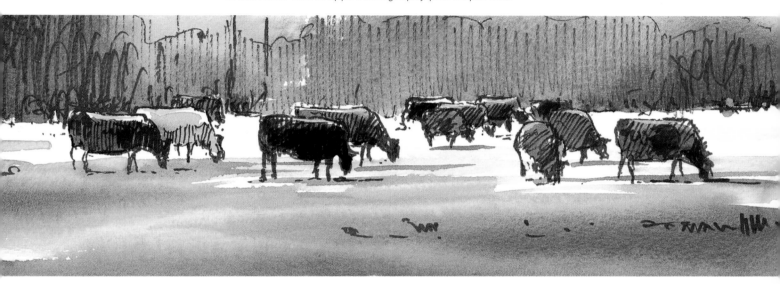

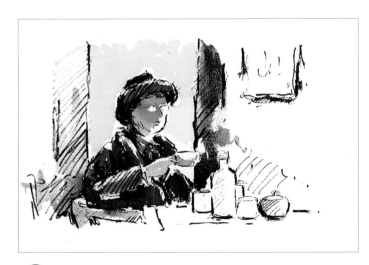

3 I place the colors directly, using dry paper to control the washes, otherwise allowing them to blend. I continue until I am satisfied that I have captured the image.

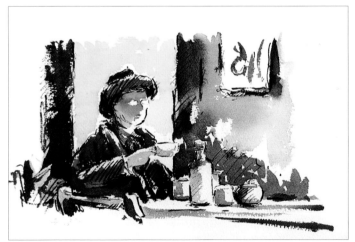

4 I use a wet brush fully loaded with pigment. If done correctly the drawing will be strong enough to hold the image together.

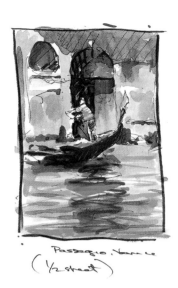

Passegio, Venice
(½ sheet)

"PASSEGIO, VENICE"

Drawn with chisel tipped
calligraphy pen (sepia ink),
painted wet-into-wet.

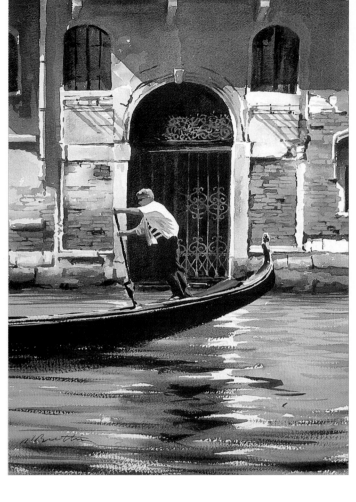

IN THIS SKETCH,
I DREW THE TOP
HALF, AND ONLY
PAINTED THE
BOTTOM HALF.

FABER CASTELL CALIF-PLUS 1513

18

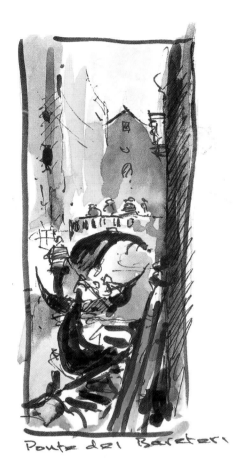

Ponte dei Bareteri

**STARTING SMALL IN
PEN AND WATERCOLOR
IS THE FASTEST WAY
TO BUILD ALL YOUR
PAINTING SKILLS.**

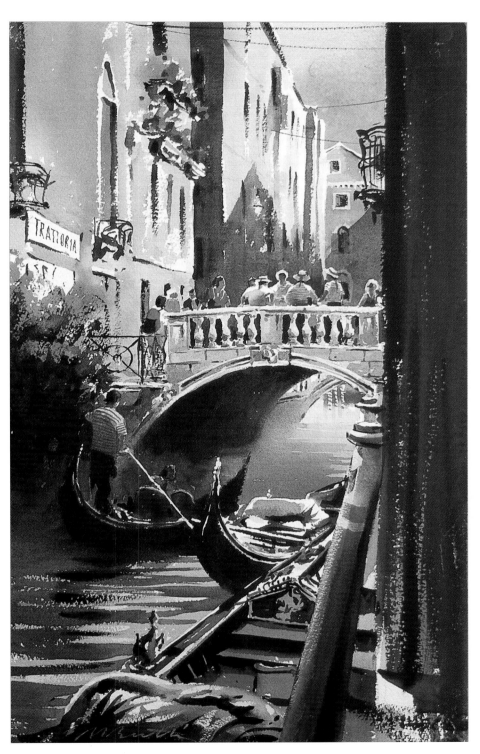

"PONTE DEI BARETERI, VENICE"

MAINTAINING YOUR CONNECTION TO YOUR SUBJECT

Toss aside the need you may have for making carefully drawn, highly detailed pen-and-wash sketches. Even a loose, quickly rendered sketch, says Dave Beckett, will re-kindle your passion for your subject when you return to the studio.

Gathering painting references on location isn't always easy. I have had rogue waves wash away my sketchbooks and watercolor sets. I have been chased by dogs and bulls, annoyed by tourists, lost in the bush, and fallen in creeks both in the dead of winter and the early spring. Some of my sketches have been done at –25° Celsius and the watercolor froze before it dried (as did my fingers)! Why do I persist in this activity? On-site sketches provide immediate reminders of the circumstances, sounds and smells of each location in a more intimate way than photos ever can.

Though I work mainly in pastel in the studio, I've found that pen-and-wash sketching in a book or on a watercolor paper block is an easier, more permanent way to work in the field. Packed in my camera bag or backpack, these few art supplies allow me to record an instant impression without carrying a large selection of other material. That heartfelt impression often makes the difference in creating a great finished painting as opposed to a handsome copy of a photo. The sketch may not always be the best rendering but it does give me a "feel" for the subject, which has proved invaluable when I get ready to paint in pastel.

Remembering the purpose

I must admit that my sketches are often quite primitive or loose — that is, after all, the nature of a true sketch. No particular effort is made to develop a perfect sketch, as it is only a guide for future work. However, that is just what I want in

terms of serving the two purposes I see in this activity.

First, sketching helps me to understand the subject better, to become familiar with the big shapes, structure and tonal values within the scene. A sketch is also a good place to record my impressions or interpretations of the colors, local or imagined. It's

WHAT THE ARTIST USES

The pen-and-wash tools I use are very simple, light and easily carried in my camera bag, backpack or pocket.

- *Micron #20 Archival Ink Pen*
- *1" Golden Sable Brush (washes)*
- *6 x 8" Strathmore #400 Series Regular Surface Paper*
- *12 x 16" Watercolor block for larger work*
- *Winsor & Newton portable watercolor boxed set*

Note on sketchbooks: *I find the 6 x 8" size ideal for my purposes. The 80-pound stock seems to work for me, though I have tried other weights. The ring binding is flexible, and the previous sketch pages can be folded back out of the way when working on a new one. I use the larger 12 x 16" block for larger pieces, though the smaller is my preference.*

important for me to capture my immediate, emotional response to the subject while on site so that I can later communicate it in my final painting. All this can be easily accomplished with a minimal amount of pen work and color washes.

Second, the sketches serve merely as guides for me back at the studio when I am ready to render the subject in greater detail. I typically work in my studio on a pastel painting for long periods of time. I can easily lose my inspiration or passion for a subject when I'm concentrating on the detail and developing something as large as four by six feet. Thus, the big advantage in doing these sketches is to give me a sense of being there, which is so important to me if I am going to stimulate the viewer to "walk into my paintings". Even the humblest of sketches can become an instant reminder of the sights, sound and smells of the scene, allowing me to re-connect with my subject.

Emphasizing tone and color

I am attracted to bright, sun-filled subjects for my sketches because that is what my work is all about — the contrast of light and deep shadow, as well as vibrant color. Today, more than ever before, we need color and contrast. It brightens us and help us put aside the troubles of the world.

Once I see a subject I like, I set about sketching it very quickly. I don't really compose the scene as I plan to paint it — I can take care of that later back in the studio.

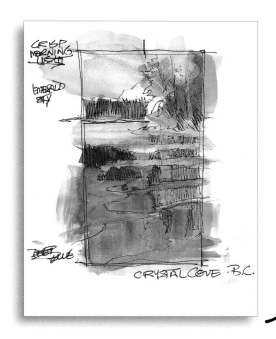

"CRYSTAL COVE, BC",
PEN-AND-WASH SKETCH, 8 x 6" (21 x 15cm)

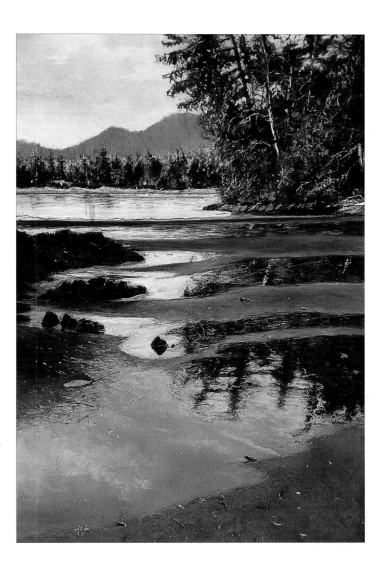

"LOW TIDE AT TOFINO", PASTEL, 29 x 17" (74 x 44cm)

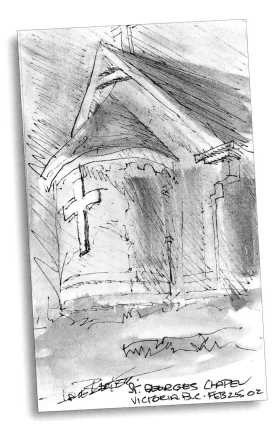

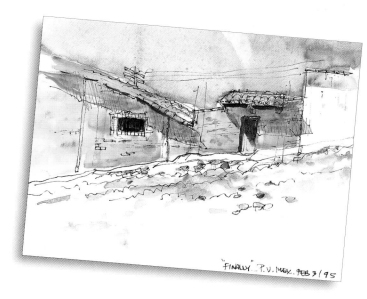

"ST GEORGE'S CHAPEL, VICTORIA, BC", 8½ x 5½" (21 x 14cm)

"FINALLY . . . PUERTO VALLARTA, MEXICO",
6 x 8" (15 x 21cm)

ART IN THE MAKING *"MORNING SUN"*

EMBRACING A SUBJECT
The morning sun casting shadows across this snowy field caught my attention so I decided to stop for a quick sketch.

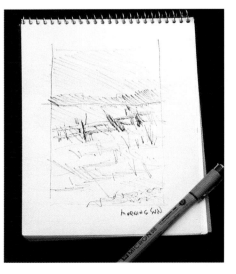

CAPTURING THE MAIN POINTS
Using a fine-point, waterproof black pen, I quickly sketched in the main lines of the subject, along with a few details. My goal, however, was to keep it loose.

GETTING STARTED
With a 1-inch soft brush, I laid down a few light washes of blues and grays in the sky and foreground.

Instead, I start right in with a very rough, minimal pencil sketch to develop the focal point or a sense of perspective. Then I usually start directly with the pen at my point of interest, developing the horizon and gradually moving forward to the foreground. Finally, I apply loose washes of color, typically using a 1-inch soft brush. With the washes, capturing spontaneous color and using tonal value to create depth or a dramatic sense of contrast are important to me. However, texture and detail are not prime concerns in these small sketches.

Brief notes in the margin about lighting, weather conditions and happenings around the area where I'm sketching usually complete my on-site work. Later, they help to restore the intimacy I felt while on location. The sketches and notes, coupled with the many photographs I take on location, come together to give me what I need for my realistic pastel paintings back in my studio.

Treasuring the moments
Despite the sometimes difficult circumstances in which I find myself doing pen-and-wash sketches, every page in my sketchbook is a treasure of my career! What a delight when I review my notes years later and reminisce about the trips and happenings recorded on these pages. □

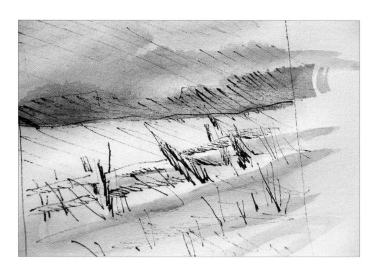

THE SKETCH MAY NOT ALWAYS BE THE BEST RENDERING BUT IT DOES GIVE ME A "FEEL" FOR THE SUBJECT, WHICH HAS PROVED INVALUABLE WHEN I GET READY TO PAINT IN PASTEL.

INCORPORATING VIBRANT COLOR
Here's where I began to really loosen up with the sketch, using colors not seen but felt on location.

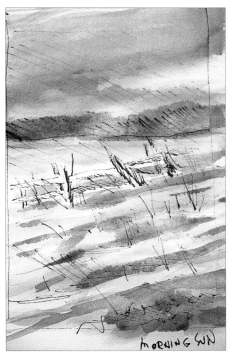

GOING BOLD
Bold strokes of richer color finished off the sketch.

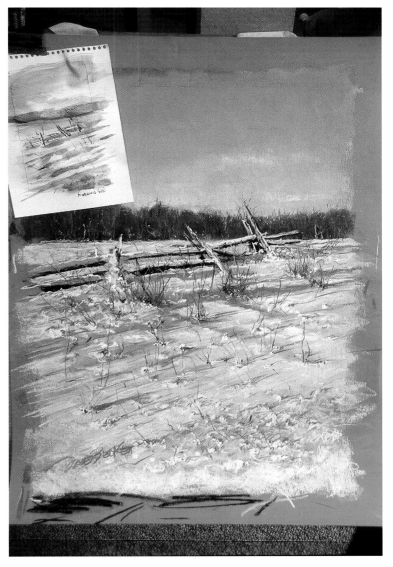

TRANSFORMING THE WORK
Back in the warmth of my studio, I turned the sketch into a pastel painting. Notice how my pastel has much richer contrasts and more vibrant colors because I was working off the sketch and not just the photograph.

ART IN THE MAKING "LAKE REFLECTIONS"

DISCOVERING A SITE
A glorious, calm, sunny view of the lake — what a great subject!

LEAVING BREATHING ROOM
Over a minimum of pencil lines to place the main elements,
I quickly drew in the tree shapes in waterproof pen, leaving the
rest of the paper open for interesting things to happen in paint.

WASHING IN COLOR
A wide, soft brush and plenty of water
allowed for nice graduated washes in
the sky and water.

EMPHASIZING MOOD
In putting in the both warm and cool
greens, I avoided painting the tight
details and focused instead on shapes,
tonal value and mood.

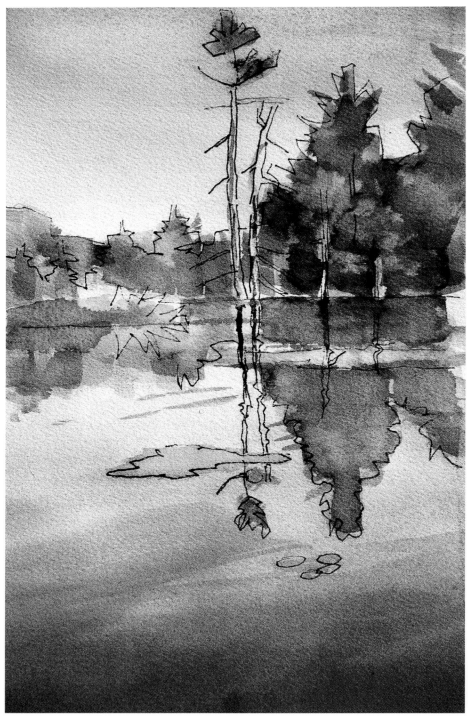

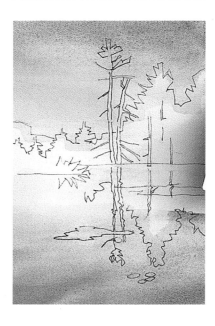

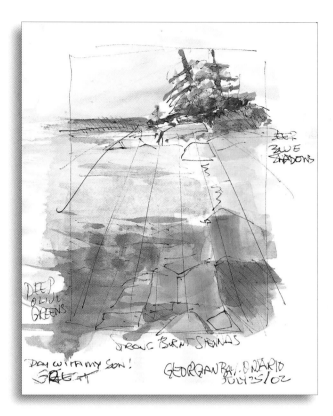

"GEORGIAN BAY, ONTARIO",
PEN-AND-WASH SKETCH, 8 x 6" (21 x 15cm)

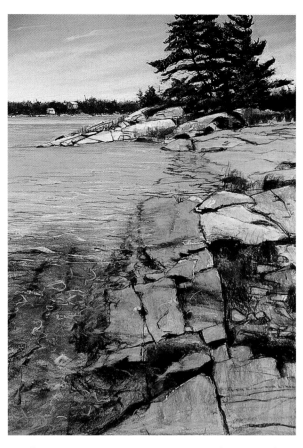

"GEORGIAN ROCK", PASTEL, 30 x 20" (76 x 51cm)

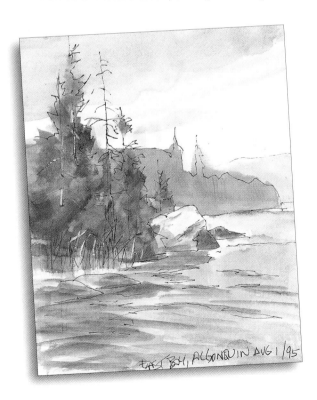

"EAST BAY, ALGONQUIN PARK", 8 x 6" (21 x 15cm)

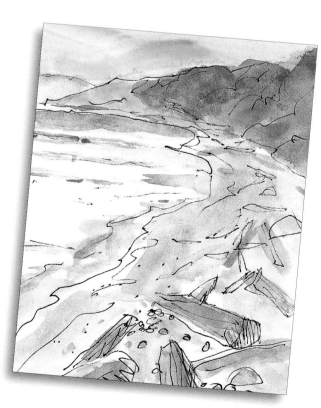

"BEACON HILL PARK", 8½ x 5½" (21 x 14cm)

"POLLO HUEY, SAN MIGUEL DE ALLENDE", 5½ x 8½" (14 x 21cm)

"LOG AND ROCKS, BEACON HILL SHORE", 5½ x 8½" (14 x 21cm)

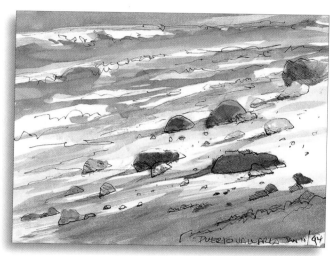

"PUERTO VALLARTA", 6 x 8" (15 x 21cm)

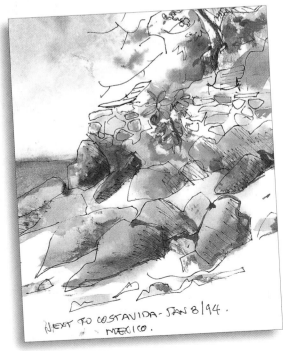

"NEXT TO COSTA VIDA, MEXICO", 8 x 6" (21 x 15cm)

"AT COSTA VIDA HOTEL", 6 x 8" (15 x 21cm)

I MUST ADMIT THAT MY SKETCHES ARE OFTEN QUITE PRIMITIVE OR LOOSE — THAT IS, AFTER ALL, THE NATURE OF A TRUE SKETCH. NO PARTICULAR EFFORT IS MADE TO DEVELOP A PERFECT SKETCH, AS IT IS ONLY A GUIDE FOR FUTURE WORK.

PACK RAT

I've been known to drag all sorts of items home with me — fencing and gates, driftwood and large tree branches, barnboard, bits of hinges, boxes of rocks of all sizes, and bits and pieces of debris from the ocean's shore. I find them both inspiring and useful when working in the studio.

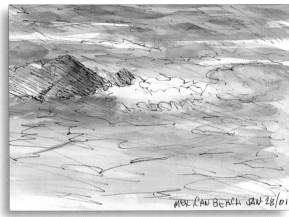

"MEXICAN BEACH", PEN-AND-WASH SKETCH, 6 x 8" (15 x 21cm)

"MEXICAN BEACH", PASTEL, 16 x 23" (41 x 59cm)

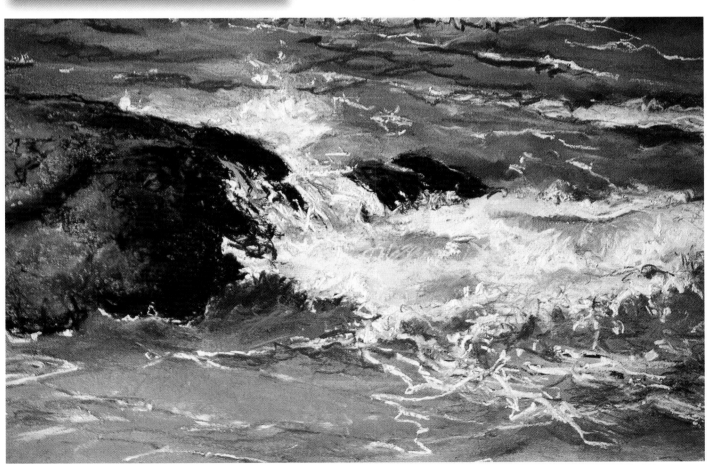

SOAKING UP THE SENSORY EXPERIENCE

Beyond recording the visual characteristics of a place, pen-and-wash sketching allows you to immerse yourself in a total sensory experience. Francis Boag explains how this enriches your studio paintings.

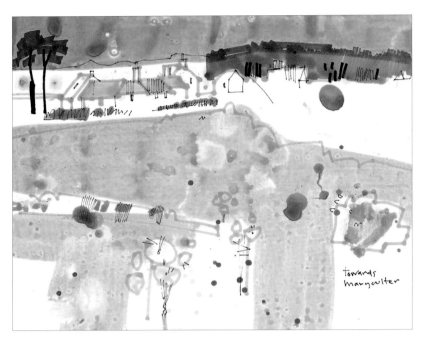

"TOWARDS MARYEULTER", INK AND ACRYLICS, 8 x 10" (21 x 26cm)

My work is created mainly in the studio, although on-site sketching is still part of the creative process. In my opinion, my studio paintings should have a discrete appeal that is not necessarily connected to the content of the painting, but at the same time, I want the place or elements portrayed to appear familiar and inviting. For me, sketches help me achieve a sense of an observed, as opposed to an imagined, landscape.

With the way I work now, I rarely use on-site drawing to gather specific details for my studio paintings. Yet, becoming very aware of my surroundings through pen-and-wash, even when travelling in a car or a train with the images

WHAT THE ARTIST USES

My travelling kit for working outdoors is a bit like a Russian doll, with a range of increasingly bigger sets of tools and materials. I have a "micro-kit", which is the absolute minimum I can get away with and can be carried easily in a pocket. But my standard kit is carried in a custom-made pouch. This is exactly like a gents' toiletry bag and contains everything I need to work outdoors. When not in use, this pouch lives in an old nylon school-bag with lots of pockets to hold a small set of acrylics, large brushes, prepared boards or small canvasses, inks, mediums and a variety of sketchpads. Some of my favorite materials include:

Pencils *I often sketch in pencil, using a propelling pencil with a 0.9B lead as this gives me a soft, dark, smooth flowing line that feels very comfortable. The propelling pencil keeps the line a constant thickness and avoids the tiresome task of constant sharpening.*

Pens *For line work, I use a number of different drawing and technical drawing pens. Spirit-based markers are useful for adding heavier lines and color notes to a sketch.*

Paints *I color many of my sketches with artists' quality watercolors, typically from a set of 12 half pans.*

However, I sometimes use dilute acrylics to add texture to the sketches.

Brushes *My choice of brush depends entirely on the character of the mark I wish to make. Years of trial and error have taught me which brush to use for the effect I am seeking. As a general rule, I use soft-hair round brushes of sable, ox or even nylon, but I do have some square-cut brushes if I am looking for a hard edge.*

Paper *As much as I prefer a smooth surface that allows the pen to move easily across the paper, I also use*

lots of water in my washes and like it to puddle, leaving tide marks. This requires a soft, absorbent paper such as sketch, cartridge or 140 lb not watercolor paper. To avoid as much "bubbling" as possible, I first stretch the paper on board. I then usually divide the paper into smaller squares for each sketch. If I have not planned ahead with this, I will instead use a heavier watercolor board cut into 20 x 25cm pieces so I can get started without more ado.

Sketchpads *I have dozens of pads of every conceivable size, shape, type of paper and style of binding, but all of a good quality. It's wonderful to be*

flashing by, can bring plenty of ideas and inspiration. More than allowing me to observe and record the topography of some area that I may later refer to in the studio, sketching allows me to soak in the total experience of the day and refuel the memory bank on which I rely so heavily to make my easel paintings.

I think sketching works to inform my art because it forces me to take time to experience each place. Sketching means staying in the same place, looking at the same thing for an extended period — even if it's just 10 minutes. With the hectic pace of life today, taking time for passive absorption is almost unknown. When was the last time you stood still and observed anything around you for more than a few seconds before shifting your gaze or moving on? Not merely visual images but also sounds, smells, the weather and how I'm feeling will all affect my memory when I try to recall a place in the studio, and this is what I gain through sketching.

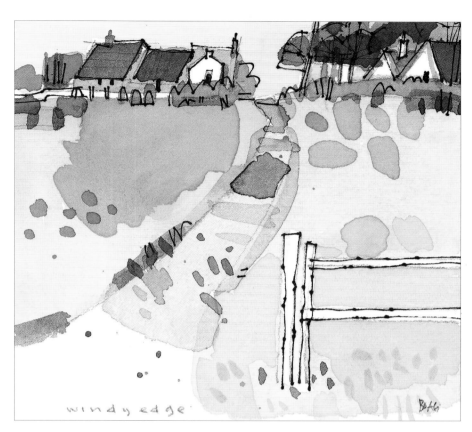

"WINDY EDGE", INK AND WATERCOLOR, 5 x 6" (13 x 15cm)

able to experiment with the different ways papers respond to pencil, ink and paint. A recent and useful addition to my paper armoury has been custom-made sets of blank note cards, postcards and greetings cards made from good quality watercolor paper, perfect for making a very personal card for a special occasion. Without wishing to seem immodest, I know that the thank-you notes and birthday cards I've sent to friends are much sought after and appreciated.

My bag of materials usually stays in the car and goes with me on holidays and so on. Sometimes it comes back unused but I feel much happier knowing that if the opportunity presents itself, I'll have all I need to make a painting or two. You can probably guess by now I was a boy scout and took our motto (Be Prepared) very much to heart.

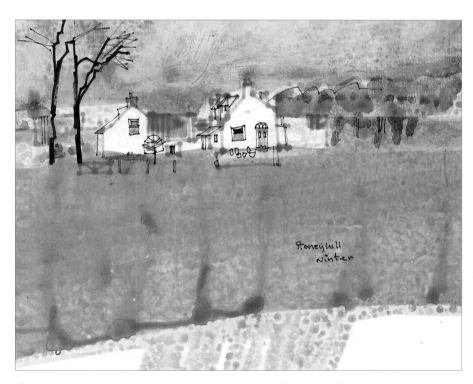

"STONEYHILL WINTER", INK AND ACRYLICS, 8 x 10" (21 x 26cm)

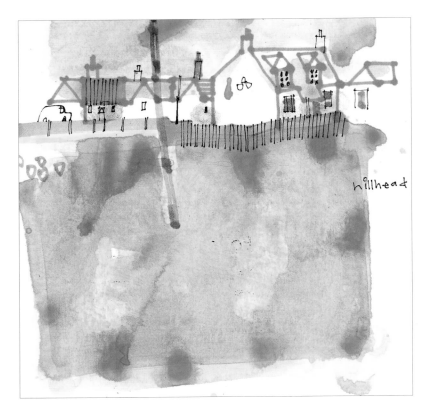

"HILLHEAD", INK AND ACRYLICS, 7 x 7" (18 x 18cm)

Doing the field work

In addition to doing straight pencil drawings, I have developed **three different approaches** to sketching in pen-and-wash on site. The first is ideal for beginning sketchers, while the second two may require slightly more advanced drawing and painting skills. Sometimes the results are quite realistic, while at other times they are abstracted.

1. Wash first, then ink. This first approach is very traditional in planning and execution. I do a whole set of small paintings in one sitting, and each little sketch follows the same basic process: I begin with a quick pencil drawing to indicate the composition. I then put in an overall watercolor wash of yellow ochre — a neutral color that will happily accept further washes of both warm and cool colors — painting around any white areas. Next, I block in large areas of warm color, followed by large areas of cool color. To complete the watercolor stage, I introduce smaller areas of heightened color, increasing tonal contrast as I go.

I find it best to give my sketches some breathing space before adding the final black pen line for detail and definition. I put the whole series aside and look at them in a day or two. If I am still happy, that's the time to add the final, definitive line. But once that line is there, I resist the temptation to make any further additions or alterations so that I don't overwork these small images. A simple wash-and-ink sketch should be like a soufflé — light, airy and hopefully delicious!

This is a very safe, straightforward way to make pen-and-wash drawings, as risk of complete failure is kept to a minimum. Perhaps it's because it allows a more relaxed, spontaneous approach to develop. Working on several pieces at the same time lets me be more cavalier and less "precious" in my approach as there is always another work just ready and waiting to be developed.

Thanks to this risk-taking method in which I explore many ideas and feelings while on location, I continue to move my work forward in new directions without falling back on tried and tested methods.

2. Ink first, then paint. This approach seems to be more idiosyncratic and personal, allowing for more individualized, imaginative results. On site, I begin with a quick pencil sketch to establish the composition. I then switch to pen, putting in detail and defining shapes. Once I am satisfied with each drawing, I put it aside until I return to the studio.

Back in the studio where I have a larger range of materials to work with, I give the drawings a coating of diluted pva adhesive/medium before considering the application of the color washes. The medium, which is a milky liquid but dries with a slight satin sheen, will protect and hold the ink line under subsequent paint applications. I then use a 2" flat bristle brush to apply thin washes of acrylic paint. The dilute acrylics allow me to create a variety of textural effects in the color washes, and I am able to concentrate on achieving maximum impact with minimal brush work. Although these works have the appearance of being very loosely painted, they are, in fact, the most controlled.

This method is very close to how I create my larger studio paintings. The experimental and almost "out-of-control" quality of these pieces mirrors my approach in the studio. The crucial difference is the stage at which the drawing becomes part of the painting. In the sketches, the drawing comes first because I am making a visual record of a new environment and the corresponding emotions. In the studio, the drawing is introduced much later and is in response to the memories and feelings that

the embryonic painting is beginning to evoke.

3. Mostly drawing. As this approach is based mainly on the strength of the line work, it requires a more confident, experienced approach at the outset. Drawing directly with a waterproof spirit marker and pen leaves little room for error.

I usually use a softer color spirit marker first, such as gray or ochre, which I then contrast against the finer, crisper black line made by the technical pen. Because the spirit marker and pigment pen are both waterproof, the lines won't bleed when I add the final watercolor washes. I generally keep the color more muted in these drawings to allow the line work to remain the predominant feature.

Drawing primarily with markers and pens aids my studio practice by allowing me to develop compositional and color possibilities and to begin to interpret the visual record made at the scene. It is often the first stage in visualizing the abstract qualities that will be an important aspect of the studio work.

Feeding my memory bank

Before I was able to devote every day to painting, I needed the starting point of one or more reference drawings or even a photograph before I felt confident enough to begin a painting. Now I work mostly from memory, but I still greatly enjoy pen-and-wash sketching, especially when traveling through some of my favorite places such as France, Ireland, California, Italy, Spain and my home, Scotland. I know that my studio work continues to be enriched by the experience of immersing myself in the sights and sensations of my subjects, and I'm sure your paintings will be too if you decide to adopt any or all of my sketching approaches. □

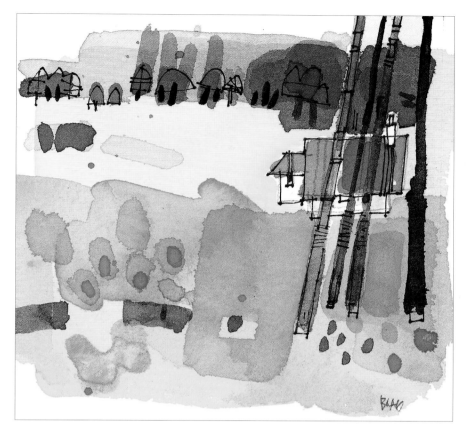

"EAST TOWN", INK AND WATERCOLOR, 5 x 6" (13 x 15cm)

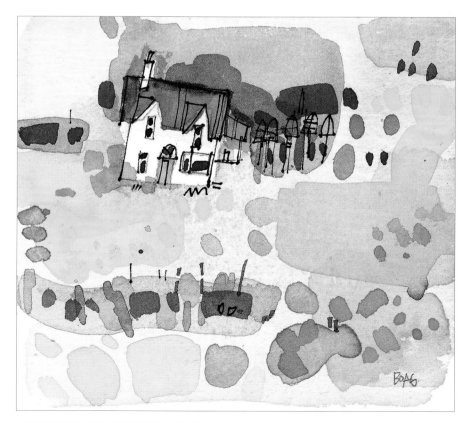

"COOKNEY", INK AND WATERCOLOR, 5 x 6" (13 x 15cm)

ART IN THE MAKING *WASH FIRST, THEN INK*

LIVELY LINES

Have you given much thought to the quality of your lines? What makes a line "come alive"? Several years as a professional cartoonist provided me with countless hours of line-drawing experience. My goal was to create a line that was uniquely mine. By trying dozens of pens and using acres of paper, I did learn an awful lot about how ink flows, how various line thicknesses create different effects, how the ink sits on some surfaces while becoming absorbed into others, whether a fast line is better than a slow one and on and on. It showed me that time spent with a pen or pencil in your hand can always be turned into a learning experience. You can even learn from writing your grocery list by experimenting with different pens and paper!

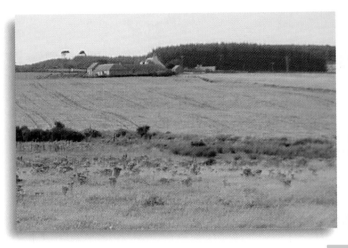

1. FINDING A GOOD SUBJECT
Everyone approaching Aberdeen from the south passes this scene on the outskirts of the city. The block of converted steadings sitting high on the horizon and silhouetted by a bank of trees is only a five-minute car ride from the centre of Scotland's third city. Very typical of the rural hinterland, it is a subject I enjoy working with.

4. CONTRASTING SHAPE WITH LINE
I introduced the pen line at this stage, working with a combination of soft-colored, thick marker lines and sharp, fine black pen lines for detail.

5. BALANCING WITH COLOR BLOCKS
I attempted to bring the work to a speedy conclusion but without any clear plan of how I might achieve this. I used the cool green and black to sharpen up the drawing of the buildings, and introduced some more precise collage elements where I wanted to move the eye along. The work at this stage, I hope, stands on its own as a drawing, but it also provides me with the genesis of a larger studio painting.

2. STARTING WITH WARM BRIGHTS

Working on a page of 250gsm A4 Bristol board taped to a second board, I began without any preliminary drawing. As soon as the initial acrylic wash of Cadmium Yellow began drying, I applied another wash of Cadmium Orange.

3. BUILDING TACTILE TEXTURE

Before continuing with wet media, I applied some collage effects, using a range of specially selected papers — graph paper, a Japanese wood grain and a hand-painted cartridge. I usually prefer to tear the paper rather than cut it as I like the softer edges.

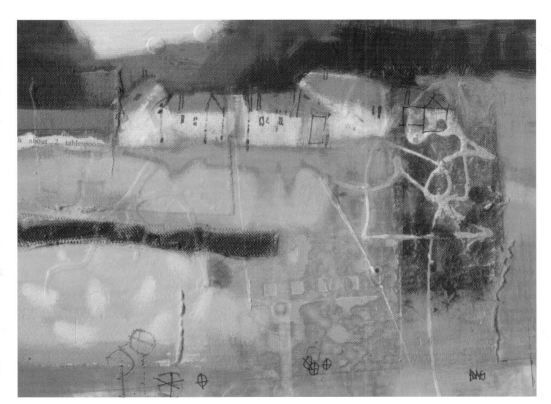

6. EXTENDING THE ACTIVITY

*Having explored my composition and colors, as well as some collage effects, in my small preliminary, I was ready to produce this studio painting called "**Culter View**" (mixed media, 20 x 24" or 51 x 61cm).*

ART IN THE MAKING *MOSTLY DRAWING*

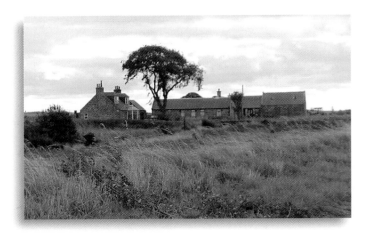

1. CHOOSING A DIRECTION
I decided to take a "mostly drawing" approach with this classic Scottish farm so I could begin to interpret the subject in a somewhat abstract fashion.

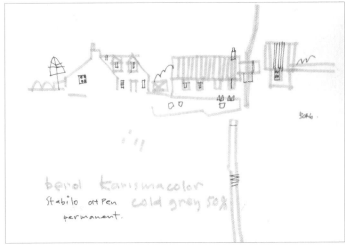

2. PUTTING IN LINE
Working on a piece of watercolor board measuring 5 x 7", which I had previously prepared with an acrylic primer, I began drawing the main forms using a spirit marker. I chose to work with cold gray 50% as I was looking for a soft, understated effect. I then added some detail with a fine black pen.

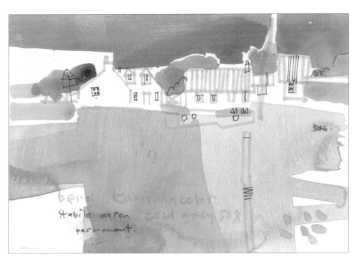

5. SUGGESTING SPACE
Next, I introduced a contrasting cool green to suggest trees and foliage, and then mixed it with a little Lemon Yellow for strips of grass. These horizontal slashes of green are very important as they introduce a sense of perspective or distance for the first time.

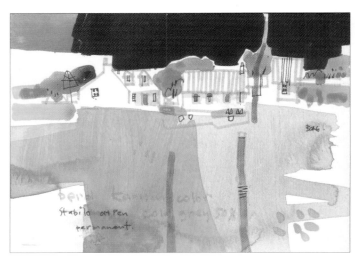

6. ADDING A BLAST OF CONTRAST
I added black as a positive color. The idea of black as a positive, as opposed to a lack of color, came to me from Matisse, one of my favorite painters. I used it to try to jolt you into looking at the work. It was a little bit risky because if I hadn't got it right the first time, I would have been left with little choice but to abandon the painting.

7. FINISHING OFF

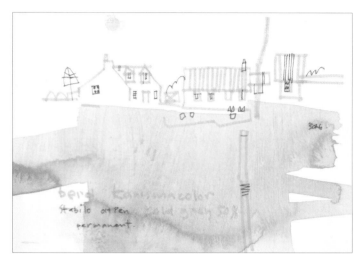

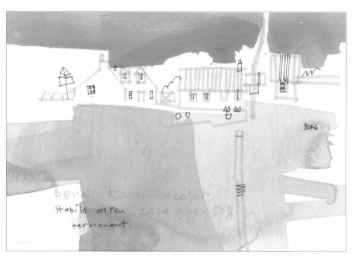

3. STARTING WITH EMOTION

Using a flat 2" housepainter's brush loaded up with very liquid paint, I quickly laid in a foreground color of dilute Crimson acrylic. I chose Crimson for its dramatic and emotive qualities. I allowed the very wet surface to dry naturally so the paint would "puddle", thereby creating some interesting textural effects.

4. EXTENDING THE COLOR

I filled the upper part of the sketch and part of the foreground with a wash of Cadmium Red.

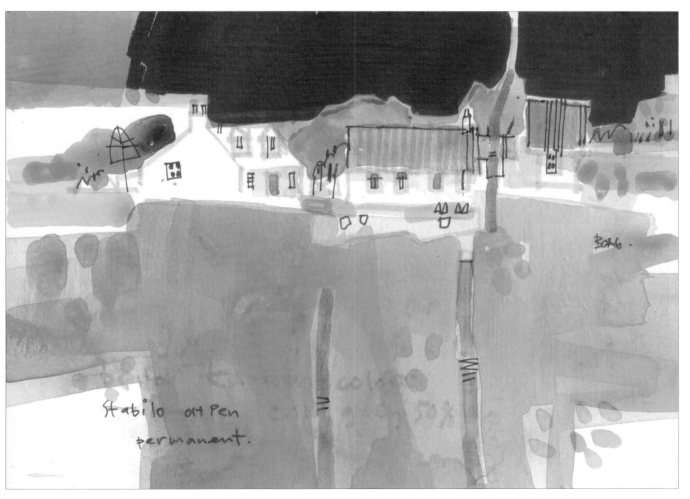

MAKING IT YOUR OWN

Borrowing specialized techniques developed by this artist, Keith Bowen, will give your sketches a more personal style and flair.

For more than 30 years, my on-site sketching philosophy has remained the same: get out there, draw lines, cover paper and fill sketchbooks. Something's bound to happen. It doesn't matter if I make mistakes in my sketchbook, as I am just thinking in visual terms, mulling over thoughts and ideas, of which there will be inevitable dead ends and plans that don't work.

But it has to be my way of doing things, my way of thinking, a diary of engagements that obliquely reflects the stuff of life, of my life in particular. To that end, I have developed a number of unusual techniques that help me capture my subjects in an instant and allow me to be more expressive in how I present them.

Making marks

I am particularly fond of drawing figures, especially people on the move — farmers working with their horses and sheep, for example — which means speed is important. But even when I am working with a stationary subject, such as a barn or a posed model, I like my first go at capturing the image to be quick and gestural. This requires a lively, varied line made with a flexible tool.

So when I head out to work, I take along a number of drawing instruments to choose from. First, I have a host of steel nibs in various widths and styles, which I've collected over the years. I also have several quill pens I've made from poultry feathers. Each one is

different, providing a wonderful diversity and unpredictability to the lines they create. Variations in the line quality are enhanced when I modulate the amount of pressure I put on the quill pen. And finally, my kit includes a few small brushes. I find I can make a multitude of marks with a Chinese calligraphic brush simply by adjusting how much of the tip I use.

Not only do I enjoy putting a lot of variety into the flowing lines of my initial sketch, I like to include different types of marks as I develop the image. I often use hatched, parallel lines to shade and define the forms of my objects. These can range from short to long, from dense to sparse and from straight to scribbled. Through

WHAT THE ARTIST USES

QUILL PENS

It was just before Christmas, and I had come down off the Welsh hills into the farmyard of a shepherd I know, thinking that I could do with a cup of tea. Out of one of the barns feathers flew and were caught up on the wind. I made my way over and poked my head into the dark interior, which was a blizzard of white feathers, as a figure plucked away at hanging poultry.

"Oh, hello," said Robyn the shepherd, just recognizable in his new plumage.

Then I saw the pile of large quilled feathers, and I thought I'd like to try them for ink drawing. I remembered that Rembrandt had used quills, so if it was good enough for Mr Van Rijn . . .

"Help yourself," said Robyn with a puzzled expression, as I gathered up a bagful.

Back in the studio I began fashioning them into quill pens, taking off the lower feathers, sharpening the ends into a nib-like point, and giving the vital quarter-inch cut down its length to hold the ink.

I still have my store of quills, and enjoy their marvelous flexibility of line. I like to load the ink, draw the quill across the paper, apply a little more pressure to thicken up the line, and ease it off again to bring it back to a fine, needle-sharp mark. When I work quickly, all this happens in an instant. Even better, though, are the accidents as when the end of the quill catches and splatters across the page. The amalgam of marks,

considered and accidental, make up and give excitement to an ink drawing.

STEEL NIBS

I have boxes of nibs from years ago that I still use. If I am ever rooting through a junk shop and find a store of old nibs, I immediately buy them. Sometimes they work, other times not, but once I have a nib that is flowing, I am reluctant to abandon it. I still have three boxes of nibs that I have yet to open and try.

CHINESE CALLIGRAPHIC BRUSHES

Sable or squirrel hair give these brushes a wonderful flow, from the fully loaded broad brush approach to the fine line achieved by only lightly using the very tip. This is a quality of mark that is immediately recognizable and uniquely its own.

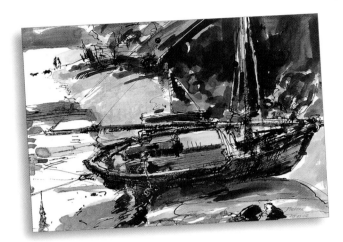

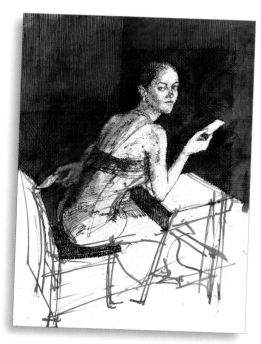

"BOAT ASHORE, PLOCKTON",
INDIA INK APPLIED WITH PEN AND BRUSH,
12 x 16½" (30 x 42cm)

"CARD PLAYER, STUDY 2", INK AND GOUACHE,
16½ x 12" (42 x 30cm)

DIFFUSER SPRAYER

Dip one end in a bottle of ink and blow in the other. Out comes a fine mist of colored ink, which becomes more intense the longer you concentrate the spray on one particular area.

INKS

I have used many varieties of ink over the years, but currently use Daler Rowney FW Acrylic Artists Ink. They are water resistant, with transparent and opaque colors within the range, all with tremendous intensity. I don't know what FW means, maybe Fantastically Wonderful! I also mix up the colors to give other tints that provide a contrast to vibrant "out of the bottle" colors.

PAINTS

I use Winsor and Newton Designers Gouache to mix up washes and for more opaque paint where I need to cancel out and correct previous ink marks. The gouache gives a matte quality, which sits well with the applied inks on the paper. I also draw back over the dry gouache washes with ink as this achieves a slightly softer line.

SKETCHBOOKS

I have a friend who tells the story of his mother calling him for supper when he was a boy and saying:
 "Jerry, tonight it's your favorite."
 "What's that, Ma?"
 "Food!"
 I'm like that with paper. Frankly, it doesn't matter what it is, cheap or expensive, rough or smooth, I'll draw on it. When I was a boy, I loved the card that came with shirt boxes. One side was so smooth, even glossy, that the ink flowed easily. So today a smooth paper of about A3 in size and of 220gsm weight feels okay.

However, I also like rough handmade, heavyweight watercolor paper to work on as it can stand a great deal of battering and gives the marks a more robust feel. I can work on and on, using the inks in combination with the gouache in an almost limitless process of overdrawing and correcting. The paper can take the strain and gives the drawing more depth and intensity.

The nice thing about a sketchbook is that it is a book. You want it to stay together as a book as you work through it and refer to it sometimes years later. I still have all my student sketchbooks. They are spiral bound, old, grubby and beaten up, but are incredibly special to me as a diary of a particular era. These days, I just want a sketchbook to stay together in one piece without the pages flying out and to be able to stand up to robust treatment, from being flung in the back of a car to being stuffed into a rucksack. It is my primary source as it goes out into the field or is scribbled on in the corner of the studio.

I can remember as an 18-year-old hopeful student attending an interview at college for my degree course. It was going to be a tough one to crack, and competition was fierce with entrants from all over the country.

I sat in the ante-room with other students waiting to be called. They all seemed far more assured and confident than I did, with smart-looking folders of work. Of course, I had my battered folder but had also taken along a cardboard box full of sketchbooks, as these were the things I had spent most time on. They were a little bit grubby and dog-eared from drawing around the local colliery, and I thought that nobody would be interested in them. I nearly left them at home.

When it was my turn, I went in to be confronted by four senior tutors who were bored at the end of a long day. It did not go well, and I felt that they were about to wrap it up. They asked whether I had anything else to show, so I tentatively brought out my cardboard box. They each took some sketchbooks and began flicking through. They passed them round, started asking questions that I could answer and became much more animated and interested. We got talking: when did you do that drawing, how long did that take, what did you use to get that effect? And so on.

"Would you like to join us next year?" they asked.

"I think I can manage that," I replied, thinking "Yes!"

So for the next three years I drew and drew, filling sketchbook after sketchbook. One of my tutors was tyrannical about checking how many drawings I had completed over a weekend. I would be in his office with the sketchbooks on a Monday morning, as he cajoled me to do more and more. The pressure was good, and stood me in good stead for later.

I LIKE MY FIRST GO AT CAPTURING THE IMAGE TO BE QUICK AND GESTURAL. THIS REQUIRES A LIVELY, VARIED LINE MADE WITH A FLEXIBLE TOOL.

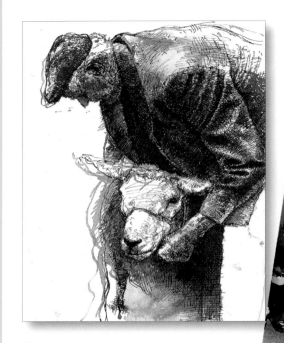

**"SHEPHERD HOLDING SHEEP",
INK APPLIED WITH PEN, QUILL AND BRUSH,
14 x 11" (36 x 28cm)**

experimentation, I've found many other types of marks that are ideal for suggesting textures and select details. It just takes practice and a bit of imagination.

One other unusual tool I use for applying ink to my sketches is a mouth-blown diffuser. It's a bit like a primitive airbrush for applying ink in a splattered spray pattern. As the ink tends to come out in a large swath of color, as opposed to lines as with all of my other instruments, it provides a nice note of contrast in my drawings. The diffused color blocks can vary from a single fine misting to multiple, heavy coats of ink dots.

Considering other qualities
While variety of line is a fundamental component of my sketches, I think tonal value is an equally important part of making them personal. Not only do I use tonal value to bring out the three-dimensional qualities of my subject, I also employ the classic technique of using tonal value contrast to draw your attention to the most important parts of the image. By these methods, I hope to increase the intensity and heighten the viewer's awareness of the subject.

Because tonal value or quality is of primary importance, I tend to be more conservative with my colors. Many of my sketches are harmoniously monochromatic, based on variations of a single color, often earth colors.

ART IN THE MAKING *"MOTHER, SUNNY DAY IN THE GARDEN"*

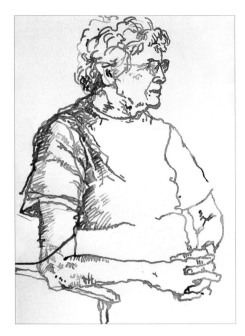

VARYING THE LINES
Using a diluted combination of red and brown ink, I quickly sketched in the main contours and a few details of the figure. I used a quill pen to apply the ink because I like to create variations in the line width by varying the pressure on the pen.

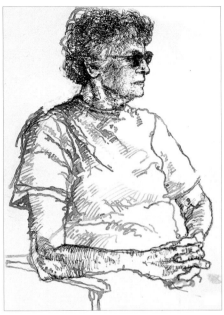

DEFINING THE FORMS
Switching to a steel nib pen and sepia ink, I hatched lines to define the forms and suggest shadows, especially in the face and head.

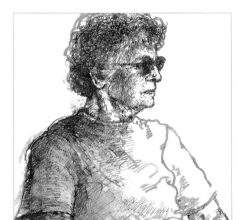

TIDYING UP
I then applied more of both inks using both instruments to define the form and shadows of the body and arm. Since sketching is a rapid process, I had made a few mistakes in **"Mother, Sunny Day in Garden" (ink and gouache applied with pen and brush, 16½ x 12" or 42 x 30cm)**. *I cleaned these up with pure white gouache, and then applied a diluted wash of white gouache to create another interesting texture in a few areas on the figure.*

Sometimes the different hues come from different ink colors, while at other times I simply dilute the same pigment to gain a lighter value.

Keeping things in perspective

Because I work so rapidly and deliberately use some hard-to-control tools, mistakes sometimes occur. A line may go astray, some ink may run or I might get a bit too dark with the hatching. No matter! I simply apply a bit of gouache — sometimes thinned with water and sometimes used opaquely — to make a few modifications to my sketches. After all, they are not meant to be gallery quality, merely personal records of my life and the world as I see it. □

IT DOESN'T MATTER IF I MAKE MISTAKES IN MY SKETCHBOOK, AS I AM JUST THINKING IN VISUAL TERMS, MULLING OVER THOUGHTS AND IDEAS, OF WHICH THERE WILL BE INEVITABLE DEAD ENDS AND PLANS THAT DON'T WORK.

ART IN THE MAKING
MAN LEADING SHIRE HORSE

SKETCHING WITH A BRUSH
Working on watercolor paper in a sketchbook, I used a brush and a medium-brown ink to quickly sketch in my subject on the page.

BLOWING ON COLOR
Using a mouth-blown spray atomizer, I applied a darker, cooler brown (a combination of orange, violet and gray inks) to quickly establish the darkest areas.

ART IN THE MAKING MAN AND SHETLAND SHEEP

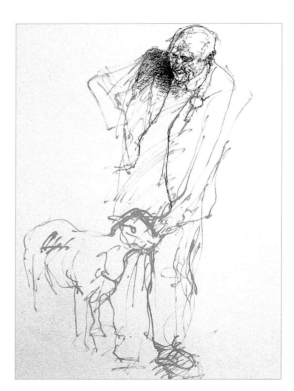 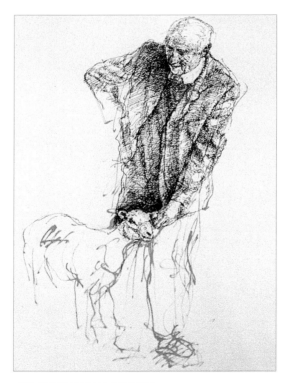

CAPTURING THE MOMENT
With a quill pen and ochre ink, I rapidly sketched in the figure and sheep to capture the wonderful gesture.

WORKING TOP TO BOTTOM
Starting at the man's head and working my way down, I next used India ink and a steel-nibbed pen to put in the value changes that define the forms.

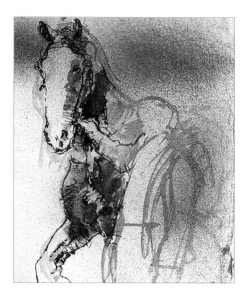

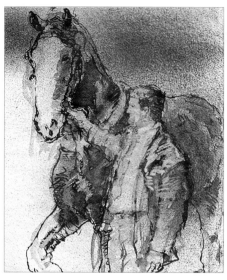

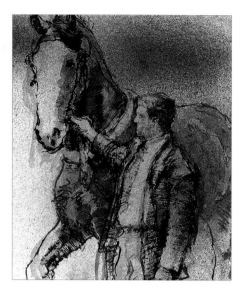

DEVELOPING THE IMAGE
Next, I picked up my Chinese calligraphic brushes and began to put in some form and shadow in the horse with dark brown ink.

LIGHTENING DARK-DARKS
After I had done the same with the figure, I felt I had gone a bit too dark. I lightened this part of the drawing with a diluted wash of white gouache.

FINISHING WITH DETAIL
To complete *"Man Leading Shire Horse"* (ink applied with Chinese brush and spray diffuser, 14 x 11" or 36 x 28cm), I went in with a fine Chinese brush and black India ink to add some finishing details.

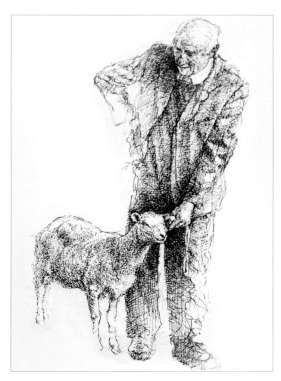

INDICATING TEXTURE
Notice how the various types of hatching I used suggested the different textures in my subject, such as the man's suit and the sheep's wool.

HIDING MY MISTAKES
Touches of white gouache corrected a few errors in *"Man and Shetland Sheep"* (ink and gouache applied with pen and brush, 16½ x 12" or 42 x 30cm).

ART IN THE MAKING *"BARN AND SCRAP METAL"*

1 ***STARTING WITH LITTLE***
As you can see from the black shadows in this photo of my subject, I was going to need some creativity to make my sketch intriguing.

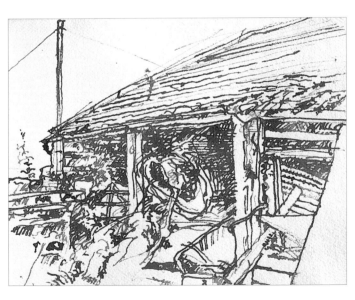

2 ***ENHANCING INTEREST***
To begin, I used sepia ink and a quill pen to sketch in the main contours of the barn. I then began to break up the large foreground shapes with interesting details I could see in the surrounding area.

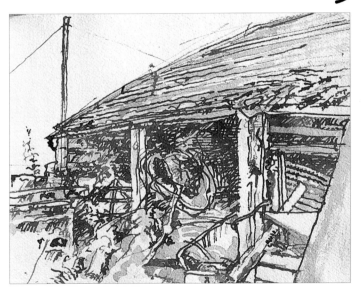

3 ***SUGGESTING FORM***
A lighter, diluted brown ink applied with a larger quill pen helped to bring out the three-dimensionality of the subject.

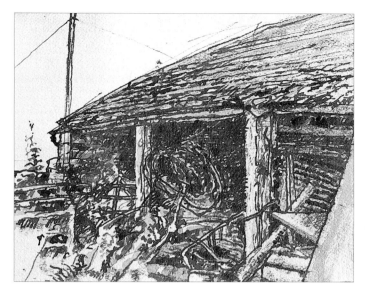

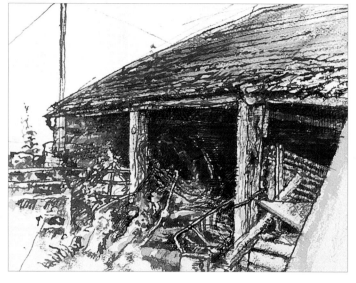

4 **REFINING THE IMAGE**
Next, I returned to the sepia ink and quill pen to refine the details of the image.

5 **INCREASING CONTRAST**
Upon further evaluation, I decided the sketch would benefit from some greater value contrast. I darkened several areas, using a brush to apply more sepia ink.

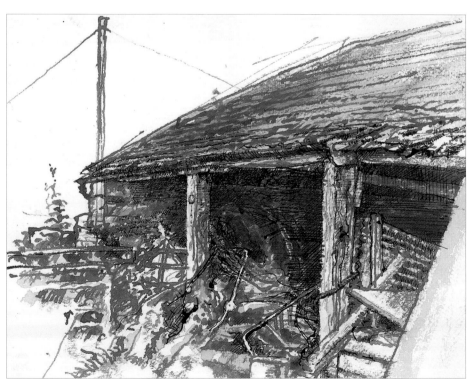

BECAUSE I WORK SO RAPIDLY AND DELIBERATELY USE SOME HARD-TO-CONTROL TOOLS, MISTAKES SOMETIMES OCCUR. A LINE MAY GO ASTRAY, SOME INK MAY RUN OR I MIGHT GET A BIT TOO DARK WITH THE HATCHING. NO MATTER!

6 **FINALIZING WITH FINE LINE**
I decided to add just a few last details to *"Barn and Scrap Metal"* (ink applied with pen, quill and brush, 11 x 14" or 28 x 36cm) with black India ink and a steel nib.

RISING TO THE NEXT LEVEL

By now you're probably hooked on pen-and-wash sketching, so make it part of your permanent painting repertoire. Borrow Catherine Brennand's ideas for expanding on this engaging approach to creating finished works.

I thoroughly enjoy drawing on location, especially when I'm surrounded by the rich textures and fascinating details of old architecture. But I also like to incorporate "other materials" in my paintings and to work on a larger scale, so doing pen-and-watercolor sketches in the field is not always practical for me. Fortunately, I've found a way to combine my on-site drawings with additional studio techniques. The result is a totally unique type of finished painting that retains all of the energy and freshness of a two-hour sketch, only enriched with the luxury of time.

Toeing the line

Once my subject is thoroughly drawn out in pencil on a generously sized sheet of stretched watercolor paper, I start in on the line work in ink. I prefer to use a "mapping" dip pen, which has a separate pointed nib in a triangular shaped holder. I also prefer black,

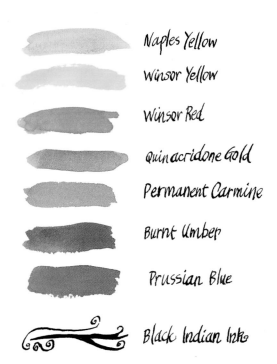

Colour Pallette

Naples Yellow

Winsor Yellow

Winsor Red

Quinacridone Gold

Permanent Carmine

Burnt Umber

Prussian Blue

Black Indian Ink

Winsor and Newton Cotman Paper 200lb
Dip Pen Lino Roller Brown Paper Tape
White Acid Free Tissue Paper PVA Medium
Brushes: W&N Cotman 10mm One Stroke
W&N Cotman Round Nos. 9, 3, 00

MASTERING THE PEN

Learning to use a dip-style pen requires a little practice. With some experimentation, you'll find you can get a wide variety of lines, all from the same pen nib, just by applying different amounts of pressure and changing the angle of the pen. Once you've got that down, have fun learning to create your own styles of shading with hatching, scribbling, dots and more.

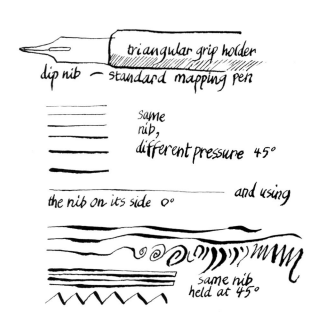

triangular grip holder

dip nib – standard mapping pen

same nib, different pressure 45°

the nib on its side 0° and using

same nib held at 45°

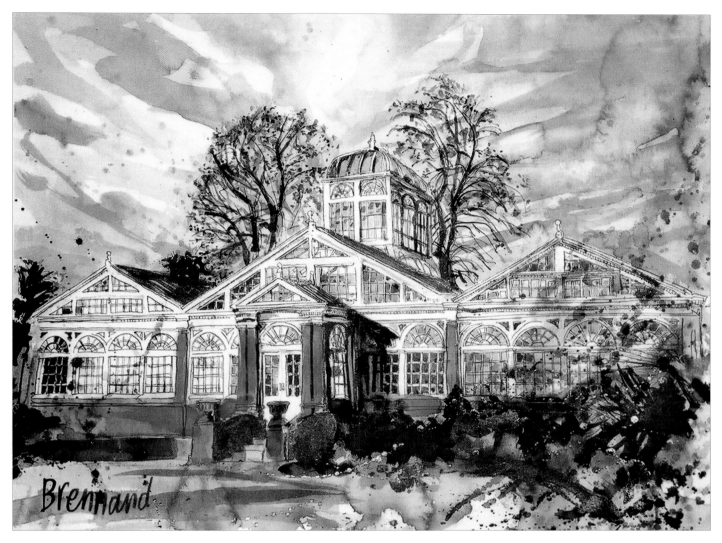

"THE CONSERVATORY, WEST PARK, WOLVERHAMPTON #2"

WHAT THE ARTIST USES

On location

- Any old paper sketchbook, usually A4 cartridge paper, in a ring bound book so I can do a decent sized drawing
- Permanent/waterproof pens and/or a dip-style mapping pen with India ink

In the studio

- Standard HB pencil
- Plastic eraser for drawing
- Mapping pen (triangular holder with separate nib)
- Black India ink
- Artists' quality watercolors
- Brushes in a variety of sizes
- Watercolor paper, stretched to a board with brown paper tape
- Disposable knife for sharpening pencils, scraping excess dried ink off pen nib
- Candle wax (for resist method)
- Lino printing roller
- Collage material (acid-free tissue, newspaper, stamps, locally gathered paper-based material relevant for the subject matter)
- PVA medium

Hatching Ideas

45°

turn the paper round

more 'scribbling' style

more formal look...

more widely spaced dots...

...the bigger the dots the darker it looks

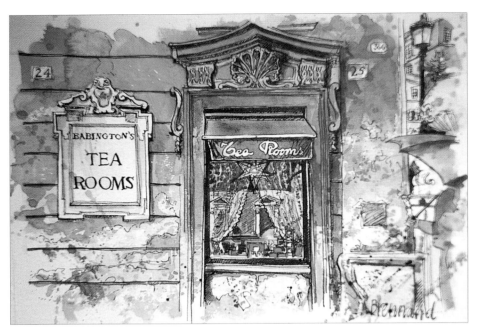

"BABINGTON'S TEA ROOMS, SPANISH STEPS, ROME"

waterproof India ink as it will withstand the coming layers of collage, watercolor and/or ink.

As I ink in the lines, I use a variety of pressures on the pen to vary the width of the lines, plus I sometimes use the nib sideways to create a narrow line. After I've completed the general contours, I often add two and then three directions of hatching to darken different areas. These shadows around the subject give the painting a more three-dimensional effect.

Layering texture and color

The next phase of my process reveals why my pen-and-wash paintings are best done in the studio. From here on out, I will build up the images with consecutive layers of perhaps collage, wax resist, watercolors

ART IN THE MAKING "FONTE GAIA (GAIA FOUNTAIN), PIAZZA DEL CAMPO

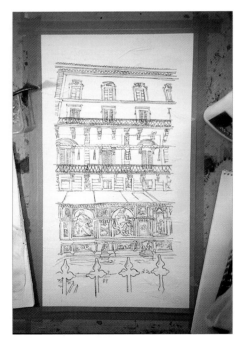

PUTTING TEXTURE OVER LINE
Over a pencil drawing, I went over the lines with a dip pen and India ink. I then added texture with strips of acid-free tissue randomly applied with PVA medium.

MOVING INTO TINTS
Once the collage dried, I mixed up a thin wash of Prussian Blue and a little Burnt Umber, and applied with a lino roller.

DEEPENING THE DARKS
Using darker washes of the same color mix, I blocked in the sky and the water in the fountain and then put in some shadows. Each additional layer deepened the color.

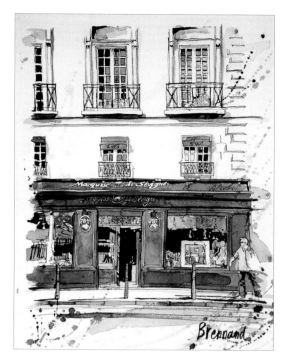

"PLACE DE LA MADELEINE"

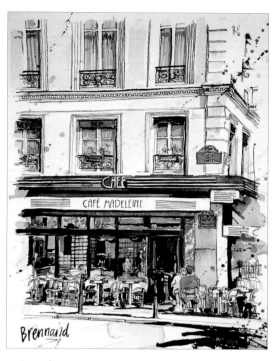

"CAFÉ MADELEINE, PLACE DE LA MADELEINE"

SIENA, TUSCANY"

AS I INK IN THE LINES, I USE A VARIETY OF PRESSURES ON THE PEN TO VARY THE WIDTH OF THE LINES, PLUS I SOMETIMES USE THE NIB SIDEWAYS TO CREATE A NARROW LINE.

COVERING WITH COLOR

Next, I began to build up the colors in the walls, sun blind and carvings around the fountain, using Naples Yellow, Winsor Yellow, Permanent Carmine, Burnt Umber and Prussian Blue. Notice how the collaged tissue grabs the pigment differently than the open paper, contributing to the illusion of old, crumbling walls.

INTENSIFYING THE RESULTS

To finish "Fonte Gaia (Gaia Fountain), Piazza del Campo, Siena, Tuscany" (19 x 10" or 49 x 25cm), I added further layers of these colors until the desired intensity was obtained. A mixture of Prussian Blue and Burnt Umber provided the darkest shadows.

ART IN THE MAKING *"PIAZZA DI SANTA MARIA, TRASTAVERE, ROME"*

STARTING LOOSE
I kept the drawing loose and textured, then used PVA medium to adhere random strips of tissue to the inked-in drawing.

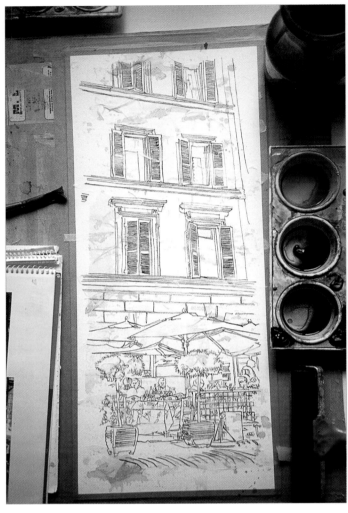

SUGGESTING SHADOW
Wherever I thought I would like to have a bit of darker shadow, I used a lino roller to apply a thin wash of Prussian Blue mixed with Burnt Umber.

and/or inks. Each layer requires time to dry before I can move on to the next layer, and it simply wouldn't be feasible to do this while working on location. It's much better for me to stay in the studio where I can develop more than one painting at a time.

Generally speaking, my next step is to add tactile texture to my painting. One way I do that is by collaging thin papers, such as acid-free tissue or newspaper, over my inked drawing. I use clear-drying PVA medium to adhere the papers to the drawing. Alternatively, I sometimes use candle wax to create areas that will resist later applications of wet color. I find that a layer of actual physical texture, randomly applied, wonderfully echoes the unexpected variations in texture that naturally occur in my subjects.

Moving into color, I typically use a mixture of Burnt Umber and Prussian Blue to put in shadows and darken areas of hatching. Sometimes I apply this light wash with a brush, and sometimes I apply it with a lino roller for a different effect. To complete a painting, I typically build up layers of thin washes until the desired richness and intensity of color are achieved.

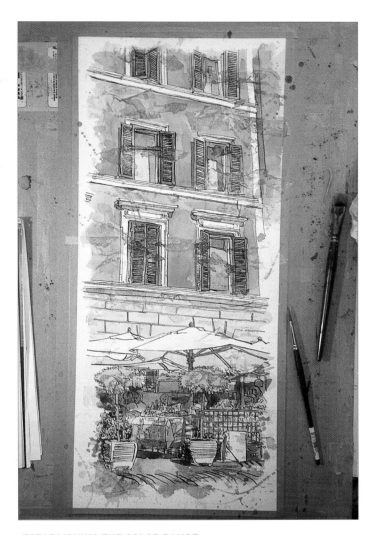

ESTABLISHING THE COLOR RANGE
Working from the top down, I used my full palette of colors to lay in washes over each portion of the image.

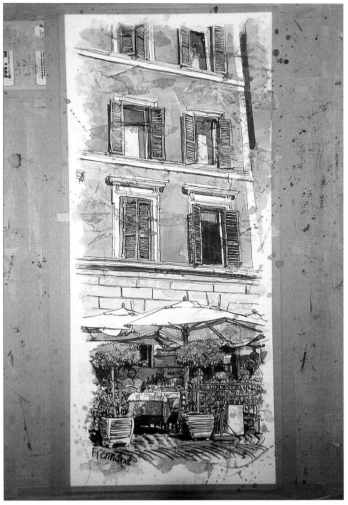

BALANCING DARKS AND LIGHTS
I repeated the washes in some areas to enrich the colors and create a balance of darker shadows in "Piazza di Santa Maria, Trastavere, Rome" (22 x 9" or 56 x 23cm).

Combining techniques

With a little creativity, I have managed to combine the best of two worlds. My paintings are imbued with both the vitality of field work and the care and attention to texture and detail found in the studio. So don't feel as if pen-and-wash sketching is limited to the great outdoors. It just may have a place in your larger repertoire, too. ☐

> I LIKE TO INCORPORATE "OTHER MATERIALS" IN MY PAINTINGS AND TO WORK ON A LARGER SCALE, SO DOING PEN-AND-WATERCOLOR SKETCHES IN THE FIELD IS NOT ALWAYS PRACTICAL FOR ME. FORTUNATELY, I'VE FOUND A WAY TO COMBINE MY ON-SITE DRAWINGS WITH ADDITIONAL STUDIO TECHNIQUES.

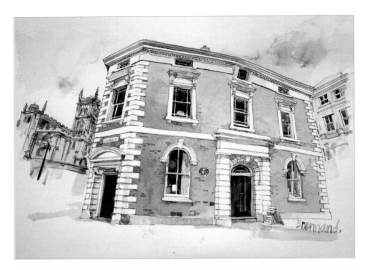

"EXCHANGE STREET AND ST PETERS CHURCH, WOLVERHAMPTON"

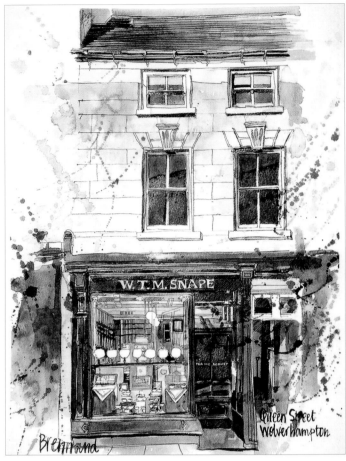

"SNAPE'S TEA MERCHANT, QUEEN STREET, WOLVERHAMPTON"

"BACCARAT, CHAMPS ELYSÉES, PARIS"

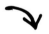

DETAIL

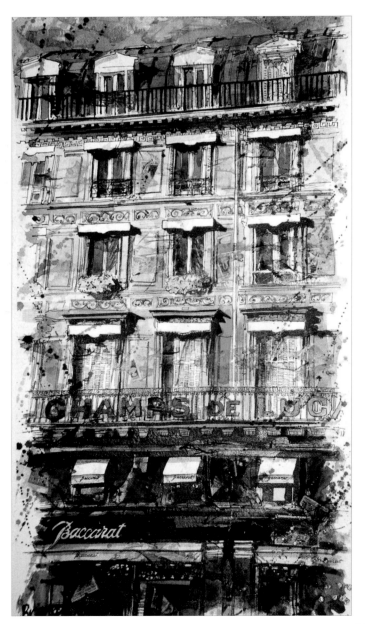

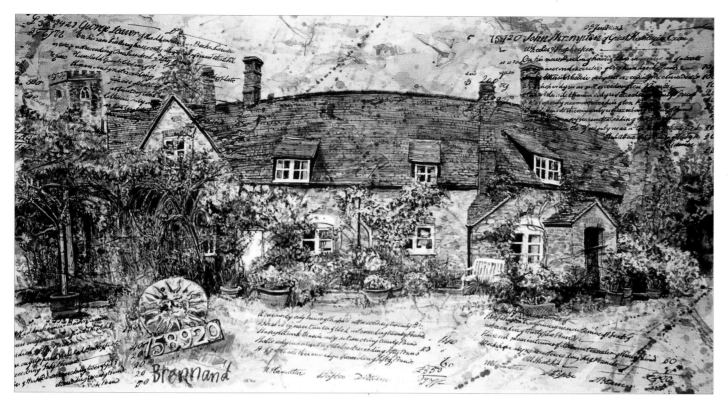

"ENGLISH COTTAGE"

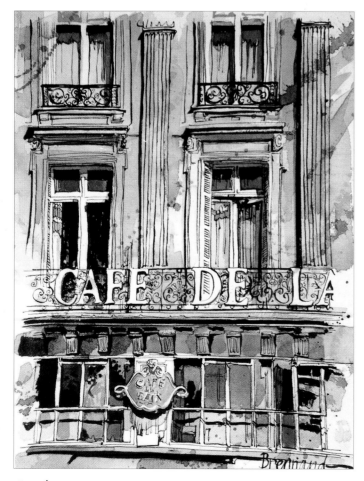

"CAFÉ DE LA PAIX, L'OPERA, PARIS"

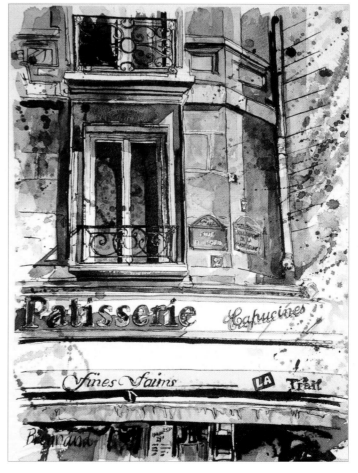

"PLACE DE LA MADELEINE, PATISSERIE CAPUCINES"

KEEPING THE SPONTANEITY ALIVE

Carry the vibrant spontaneity of on-site sketching into finished pen-and-wash drawings. Gerald Brommer shows you how.

Pen-and-wash drawings come in many forms. Some wash drawings are exquisitely detailed, some are powerful with strong contrasts and heavy lines, some are sketchy and loose, while still others are mere wisps of filmy values and delicate lines. Working with ink and washes can also be done for a variety of purposes. It's a technique that can be used for the sake of practice, to study the effects of light on forms or to record visual experiences for later development.

Quite often for me, ink drawings with or without wash embellishment are intended to be finished art from the start. Exploring the many ways I can combine my love of drawing with line and my delight in watercolor in a finished painting is one of the most enjoyable aspects of being an artist. ➡

"PAWLEY'S ISLAND, SOUTH CAROLINA", INK,
8½ x 11" (21 x 28cm)

➡

WHAT THE ARTIST USES

Pens *When sketching on loose sheets of watercolor paper to create finished drawings, I use traditional drawing nibs, mostly C-6 but sometimes larger, inserted into nib holders. For the finest lines, I use crow quill pens. However, when I'm doing quick sketches in my sketchbooks, I prefer Uniball Delux Micro pens and Pilot VBall Grip extra fines.*

Inks *When working with traditional drawing nibs, I use permanent inks in several colors plus India ink. I mix them to get the desired tones for each work.*

Markers *For large drawings I use art markers with pointed nibs in various colors.*

Paints *Over the ink lines, I use artist quality tube watercolors.*

Brushes *I use soft, synthetic brushes in a variety of styles and sizes*

Sketchbooks *I like the black hardcover formats, sometimes spiral bound, 8½ x 11" (21 x 28cm) in size. I stay away from books with thin paper, and instead look for papers dense enough so that marker lines will not show through.*

Papers *For a finished wash drawing, I prefer two-ply Bristol board with a vellum finish.*

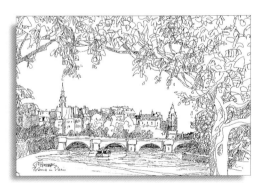

"THE SEINE IN PARIS", INK,
8½ x 11" (21 x 28cm)

➡

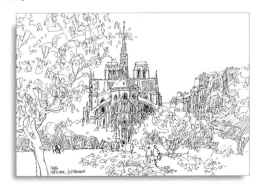

"NOTRE DAME, PARIS", INK,
8½ x 11" (21 x 28cm)

**"MEMORY OF PAWLEY'S ISLAND", WATERCOLOR,
22 x 30" (56 x 76cm)**

I started this sketch of a summer house on Pawley's Island on site, but finished it with shading back in my hotel room. I created value contrasts with a variety of hatching, cross-hatching, scribbles and open spaces. Using the Pawley's Island sketch as a resource, I next painted a watercolor, further editing the subject as the painting process evolved.

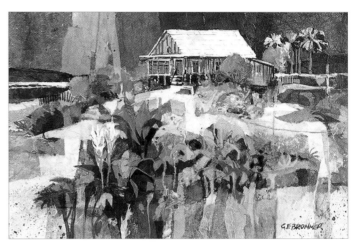

**"ON PAWLEY'S ISLAND", COLLAGE, WATERCOLOR AND GOUACHE,
11 x 15" (28 x 38cm)**

Later, "On Pawley's Island" was also built on the information found in the original sketch. After sketching major elements with a pen, I stained pieces of washi papers with watercolor, then tore and adhered them to 300 lb rough watercolor paper. I used watercolor to darken and gouache to lighten the image in some places.

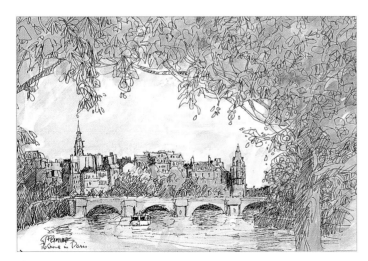

**"THE SEINE IN PARIS", INK AND WATERCOLOR,
8½ x 11" (21 x 28cm)**

Originally, I sketched these two scenes (left) of Paris on location while we were spending a few days in this marvelous city. When I was asked to create two small wash drawings of Paris scenes to be reproduced for use in the rooms of a Las Vegas hotel, I thought of these two sketches in my sketchbook. My goal was to retain the spontaneity of the location sketches without getting a refined and finished look.

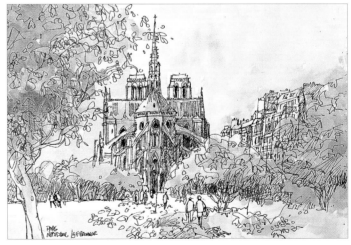

**"NOTRE DAME, PARIS", INK AND WATERCOLOR,
8½ x 11" (21 x 28cm)**

I began by having these pages of my sketchbook copied onto heavy paper stock. I then brushed slightly tinted watercolor washes in tan and pale blue over the duplicated pieces to create the final wash drawings. Several thousand same-size reproductions were made for use in the hotel, but I still retain the original ink drawings in my sketchbook.

Working with pen alone

For me, sketching on site is a preliminary stage. I make many sketches on location and have about 50 sketchbooks crammed with images gathered from around the world. I do not work with wash on location — too many materials to carry besides the sketchbook and pens — but as time permits, I do add value to my contour sketches by shading with my pen in a variety of techniques.

My sketches start with a contour drawing of the major elements of the scene, starting with the focal area. I try to envision the placement on the page and start the drawing immediately in ink, without preliminary studies or pencil sketching. I like the spontaneous feeling that sketches have, and too much care with planning precludes such a feeling.

I edit the scene in front of me as I go along, actually by concentrating on the things I wish to include and placing them where I feel they will work best. Anything else is of no consequence so I do not include it. I might add a few things such as some people or animals, trees, bushes, rocks and flowers. I look around me — a complete 360-degree view — to find objects or things to include, and their placement is made according to my own sense of design and purpose.

I work quickly, rarely trying to complete the sketches on location. For one thing, I always think I might never get back to this location again, so I want to get as many sketches started and gather as much information as I possibly can. Also, I don't like to rely too heavily on the actual subject so each rough, unfinished design then becomes more "mine" as I work with it later in the studio. The sketches are not intended to be complete in themselves, although sometimes they are, but are rather meant to be resources for full-sheet watercolor paintings.

When I have the time, ➡️

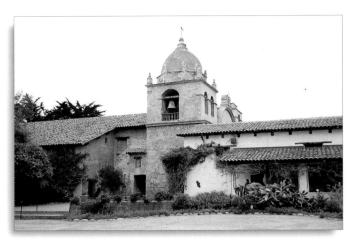

ENVISIONING THE SUBJECT
Although I went to work at this site in winter, I decided in my mind to make the finished line-and-wash drawing a summer scene. ➡️

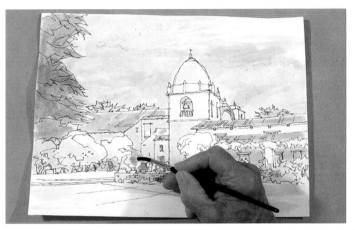

WIDENING THE RANGE OF COLOR
Once some of my values were established, I switched to using a full range of watercolor colors. But I kept the colors muted and light because I wanted the finished work to feel like a drawing, rather than a painting.

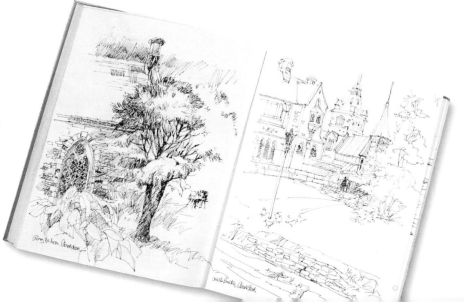

CARMEL, CALIFORNIA

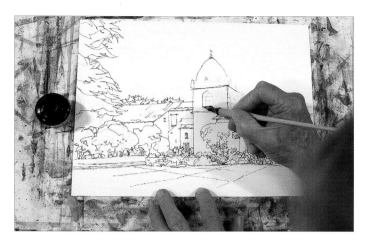

TURNING WINTER TO SUMMER

First, I sketched the building rather loosely with pencil to get the proportions fairly accurate. Then, using a combination of sepia and India ink and a C-6 nib, I inked in the lines. On the foliage, I worked much more loosely and "edited" what I saw to depict summer.

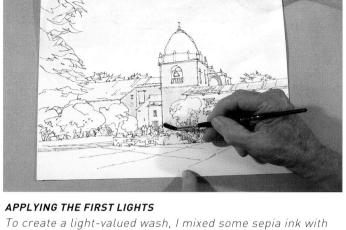

APPLYING THE FIRST LIGHTS

To create a light-valued wash, I mixed some sepia ink with a good amount of water. Although I had not yet established the value pattern, I knew I wanted the sky and part of the building lit by sunlight to remain light, so I applied the light wash to these areas.

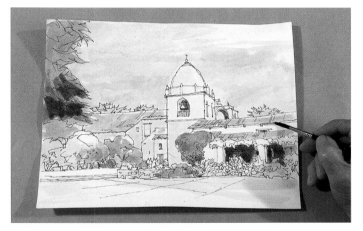

ENHANCING DEPTH

Using both darker watercolor glazes and darker sepia washes, sometimes laying them down over earlier glazes, I began to intensify some of the hues and put more variety in the value pattern to catch the feeling of the location.

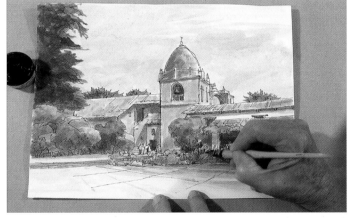

REINFORCING LINES

At this point, I decided to reinforce the lines in some places, while in other parts of the work, the lines ran independently of the shapes and were meant to be extensions of previous lines. Wherever the color washes had obscured the lines, I re-drew the lines to bring them back into play.

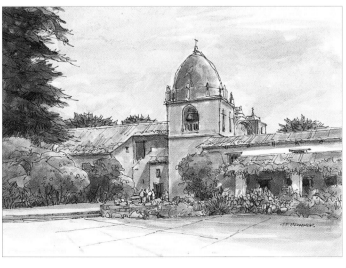

EMPHASIZING THE FOCAL AREA

Finally, I added a few more lines to re-define shapes, create darker values or add textures. Notice that I practically re-drew the focal area around the people for emphasis in **"Carmel Mission"** (ink and watercolor, 10 x 13" or 26 x 33cm).

however, I may use hatching, cross-hatching and other kinds of line work to build up a textural quality in the drawings and to emphasize the element of value, which may be useful in completing a painting from the sketch later on.

Adding washes to the mix

Upon returning to the studio, I edit the location sketch to suit the new purpose of creating a finished product, sometimes including meeting the requirements of a commission. Here, I can change the value structure or the point of emphasis. I may combine elements from two or more location sketches. Working in the studio also allows me to change the size, format or surface of the paper.

To retain the spontaneous feeling and energy of the original sketch in my new studio drawing, I try to work as quickly and loosely as I did on location. Lines are not measured or drawn with care. I never try to replicate the original sketch, but instead use the information it provides. I actually think of the process as starting from scratch. Previously, the physical landscape was my resource; now the sketch is my resource. Work begins anew!

I typically create these drawings on two-ply Bristol board. If the on-site sketch is particularly good, however, I've been known to have it copied onto a sheet of watercolor paper, paving the way for the next step.

Over the initial line drawing, I apply light, middle and middle-dark valued washes over parts of the surface, using either inks or watercolors. I begin by preparing a container with washes in each of the three values, testing them first on scratch paper to make sure there is enough contrast. I apply the light value first, so I immediately see the effect of white paper, light value wash and dark line. I then add middle values and save the darkest value wash for intense contrast areas, the focal ⟶

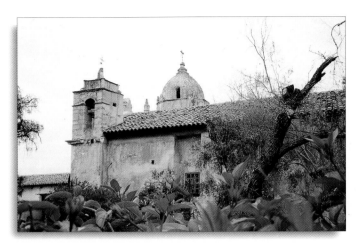

FINDING A NEW ANGLE
I found the back view of the Carmel Mission to be just as interesting a subject as the front.

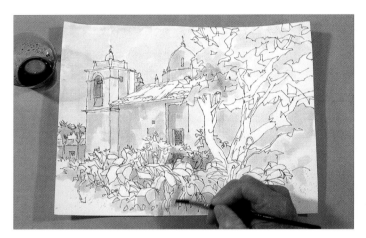

ESTABLISHING THE VALUE PATTERN
I used middle values to begin to define the structure and bring a three-dimensional feel to the foliage. The value pattern began to emerge.

"HE CARMEL MISSION"

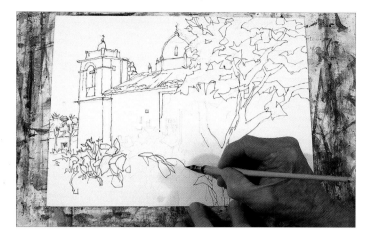

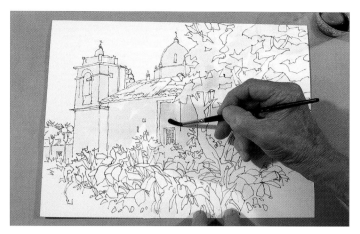

CONTRASTING TIGHT AND LOOSE

Over a very quick pencil drawing, I used a pen with a mixture of sepia and black inks to put down the lines of the building. I took more care to get the building's proportions accurate, but allowed myself to be very loose and inventive with the foliage. I wanted to see good contrast between the two.

LAYING A LIGHT WASH

Next, I applied a light-valued wash over everything except those areas that would be white or very light at the end. Both line and value shapes were already present, but both would be developed further.

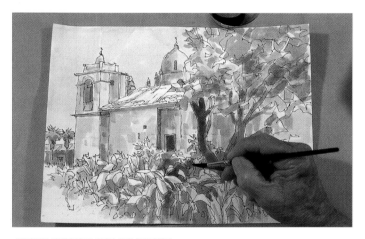

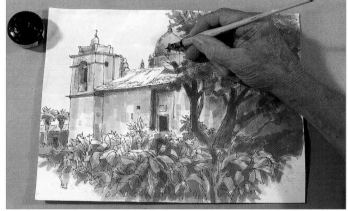

GOING OVERBOARD ON DARKS

After adding darker values, the building began to feel more solid and three-dimensional, and the foliage appeared denser, with shadows. But everything seemed to be fighting for attention, which was not so good.

UNIFYING AREAS

To unite many of the fragmented areas, I applied some large, transparent washes and intensified the value contrasts in the building. The foreground tree began to pull away from the structure. At this point, I started to add more ink lines.

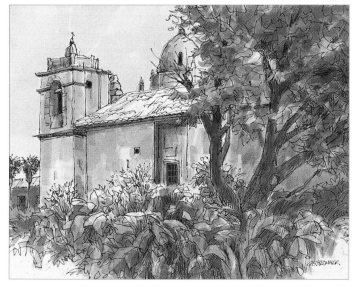

CLARIFYING MY VISION

In the final stage, I used line work to add texture to the foreground plants. They now seemed to be in shade, which allowed the lighter value of the building to feel stronger. More lines strengthened existing edges and hatching created the darkest values and added a final note of texture to *"Back Wall of Carmel Mission"* (ink and watercolor, 10 x 13" or 26 x 33cm).

area and perhaps for detail and even additional line work.

I have always admired the monochromatic work of the Old Masters, so I have simply emulated them when I want to do wash drawings. The colors I use for the washes (typically sepia, gray or some other muted color) are often those that either feel right for the piece or are required by the commission. Every once in a while, I use a more complete set of colors, and the result is more like a watercolor painting than a wash drawing. I use a regular supply of soft, synthetic watercolor brushes to apply the washes.

To complete a finished drawing, I often add more lines to place emphasis on certain aspects of the image and to make sure the lines and values of the finished piece read well. These lines will increase the density around the focal area, giving it a more detailed feeling. Textures and intense darks can also be added through line work and hatching. However, I want the line and value to balance so that one does not seem more important than the other.

Even when I create wash drawings as finished art, I want them to feel sketchy and spontaneous. It's simply an alternate way of creating fine art, as is working in great detail with full color.

Rising to the challenge

On-site sketching is without a doubt one of the best ways to practice your skills of observation and drawing. But line drawings, especially when combined with ink or watercolor washes, can just as easily stand alone as finished works of art, whether they be carefree and casual or detailed and exacting. The techniques, materials or sizes might vary somewhat depending on the subject, but creating paintings from these humble materials is an exciting challenge for any artist. □

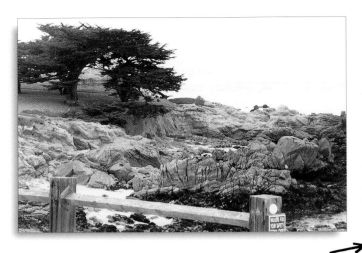

GETTING IN THE MOOD
This day on the coast of Carmel, California, was rather overcast and cloudy, as it often is, but it set a nice mood for the piece.

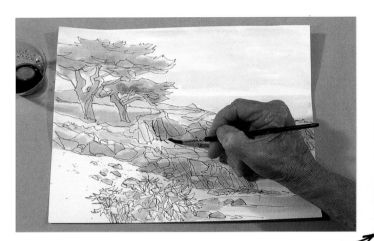

LAYERING WASHES
To create a wash that was a bit darker than the first wash, I mixed sepia and black. When I applied these washes over previous washes, the overlapping areas appeared even darker. However, I wanted to retain the line as an important element in the work.

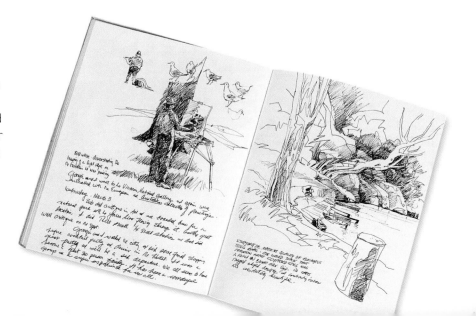

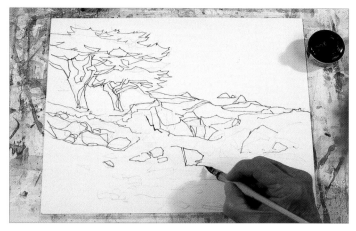

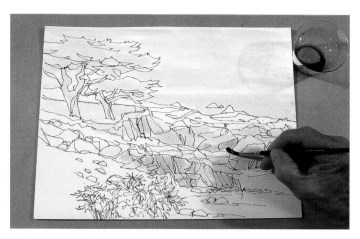

EDITING THE SUBJECT

I began by drawing the contour lines with a C-6 nib and a mixture of sepia and India ink, which makes a stronger line and tone than sepia alone. I deleted the fence and added flowers to soften the foreground and enhance the subject.

DEVELOPING VALUES

Next, I brushed down a light-valued mix of sepia and water, leaving some pure whites to stand as the lightest value. I could sense the value pattern developing already.

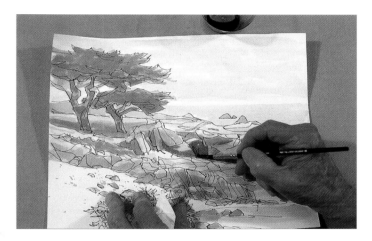

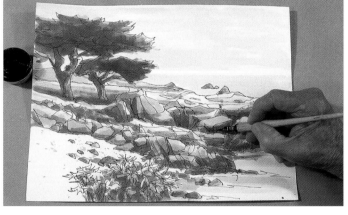

CREATING VISUAL PATHS

At this point, I added dark washes, and the darkest places got a bit of extra-dark value. This strengthened the contrasts and made the link between darks and lights more evident, creating visual paths through the work to the focus area at the base of the dark trees.

BALANCING WASH AND LINE

Returning to the C-6 nib, I drew more line work into and around the various shapes to emphasize the linear aspect of the drawing. I allowed some lines to begin to describe new textures and shapes. As I worked, I wanted the line and wash to feel balanced.

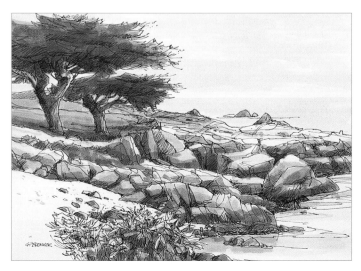

ENHANCING THE LINEAR QUALITIES

A look at the finished product revealed much more line work, so the "drawing" part of the pen-and-wash drawing was more evident in **"The Carmel Coast"** **(ink and wash drawing, 10 x 13" or 26 x 33cm)**. Still, I added new shapes, shading in the darkest areas and texture with several linear techniques.

DESIGNING WITH PEN AND WASH

Pen-and-wash paintings may look casual and loose, but according to Tony Couch, they should also be treated to some structure and design.

Sketching on location is a wonderful way to collect reference material to work with back in the studio. One sketch may be the basis for several paintings; other paintings may be done with parts of several sketches. But regardless of whether I'm working just in ink on location or doing a full-scale pen-and-wash painting in my studio, I place a high priority on good design. Although I want my work to look casual, fresh and spontaneous, it needs to have some structure to hold it together and give it greater impact.

Applying the principles of design

To me, combining a drawing (line) with masses of transparent watercolor (washes) or even just blocks of grays typically produces a particularly attractive work. There is a contrast there that is especially enhanced with an abundance of white paper, which helps make the work look fresh and crisp. But a successful pen-and-wash sketch or painting doesn't happen by accident. It needs to possess some of the basic design principles to make it work.

I still abide by the tried-and-true concepts that I've been using for years. First, I keep in mind the Seven Elements of Design, or components, that can be found and worked with in any painting: shape, size, line, direction, color, value and texture. Good design is achieved when any of these elements are placed or modified according to one or more of the Eight Principles of Design: balance, contrast, harmony, gradation, repetition, alternation, dominance and unity. It's as if the elements are the base materials we have to work with, while the principles are what we can do with the elements to produce a good design. ➡

WHAT THE ARTIST USES

FOR SKETCHING

Sketchpad *I use the largest pad of ordinary bond paper I can find, usually 18 x 24" (46 x 61cm).*

Pens *My favorite tool for sketching is a Tombo brush pen, available at many art supply stores. It has a nylon "nib" at one end and a stiff round brush on the other. I use the nib for drawing and the brush for big, dark areas and thicker lines. This brush comes in 10 grays and several colors, but I use only black for the drawing and one light and*

one dark gray for accents and shaded sides of shapes (if needed). Although the ink is not permanent and waterproof as I would like, I use this tool because I can vary the nib's lines.

Support *With such a large pad, some kind of support is needed. A light easel is ideal, but a folding card table will work, too.*

FOR PEN-AND-WASH DRAWINGS

Drawing pens *I typically use Faber-Castell Pitt artist pens as they are permanent and waterproof. I might just as well use a "Le Plume" drawing tool/brush, which is also permanent and waterproof. Occasionally, I use some other home made drawing instrument, such as a bamboo pen or turkey quill pen, and ink.*

Inks *I take care to use only those inks that are permanent, that is, will not fade over time. The work will be considered a painting and will be purchased with the expectation that it will last for one's lifetime, at least.*

Watercolor *I have no brand preference; any transparent watercolor will do. I use a full range of colors for the washes, but sometimes I like to paint in the lines with a brush. To create a richer black than basic black paint, I mix any brown with Ultramarine or Phthalo, Winsor or Prussian Blue. Another combination is Alizarin Red or Rose Madder and a number of greens, such as Viridian, Phthalo, Winsor or Prussian Green. The painted lines are not waterproof, however, so I must do the washes first in these situations.*

Brushes *I have a big selection of sable and nylon brushes for doing the washes, and use a rigger in Nos. 4, 5 or 6 for painting in thin lines.*

Paper *I use hot pressed, either 140lb or 300lb, since it has a smoother surface. It's harder to suggest texture on this smooth paper, but I'll happily give that up for the ease with which it'll take the pen or brush calligraphy. It's just too difficult to draw on cold-pressed or rough paper.*

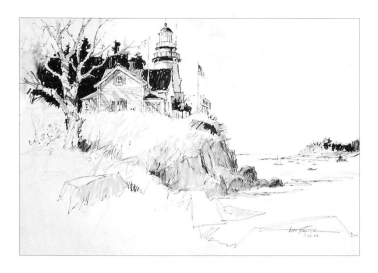

ART IN THE MAKING "LIGHTHOUSE"

I suppose this turned out casual enough, with the line missing the wash in several places, but I could have missed more. This comes pretty close to being half wash and half line, which I see as a flaw. It's hard to see a dominance of one or the other.

1 SKETCHING THE LIGHTHOUSE
To create my original sketch done on location in Maine, I used three brush markers in light gray, dark gray and black and worked on an 18 x 24" bond paper sketchpad. Initially, I included the cliff and harbor below.

2 WASHING FIRST
For the pen-and-wash drawing, I decided to focus in on just the lighthouse. Deciding to employ the looser look of lines painted with watercolor meant having to do the washes first so they wouldn't smear the painted lines. After lightly penciling in the subject to position it on the paper, I put in the washes, carefully leaving plenty of white as I knew I could edit out anything I didn't want to be white later. I worked in a loose manner, trying to only roughly paint each object. Next, I added a few lines.

3 BALANCING THE IMAGE
It looked a little off balance to the left so I added a wash to a portion of the sky on the right to help that. Then I saw the wash was a bit fragmented so I added a dark wash on the roof to join the wash of the green background trees to the wash at the lower part of the painting. Finally, I used the rigger and dark paint to do the calligraphy (lines), being careful to vary the thickness of the lines in *"Lighthouse"* (ink and watercolor, 15 x 22" or 38 x 56cm).

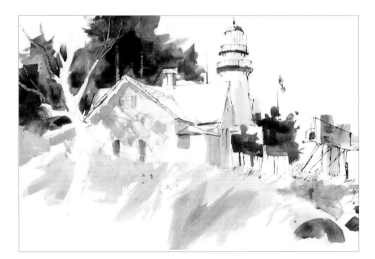

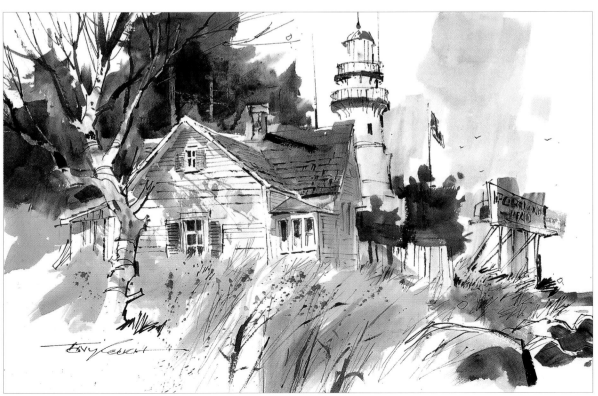

ART IN THE MAKING *"BOAT IN DRY-DOCK"*

I think I got a bit carried away with the line drawing in this one, particularly in the dock on the right, so that it challenges the boat as the center of interest. It also makes the whole work a bit more cluttered than it needs to be.

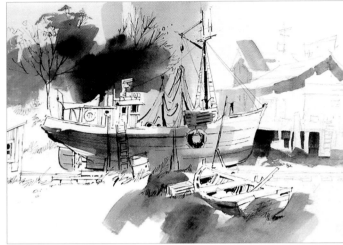

1 **POSITIONING THE IMAGE**
Here, I first sketched in the two boats and the dock with pencil so that I would get things in the proper location and not run off the paper with the ink sketch that would come later. Then I did the wash, trying to be very loose, running the washes together and leaving random white shapes.

2 **VARYING THE LINES**
Next, I started drawing from left to right, using the pencil lines only as a rough guide. There is no particular wisdom in starting left to right; I just had to start somewhere. I used the Faber-Castell pens for this one. Since the pens are not flexible, I could not get a thick and thin line in one stroke as I can with a brush or quill, so I had to settle for uniform thin lines first. Then I went back in with the wider "B" pen and reinforced with thicker lines in spots and filled in the dark areas. I generally put these wider lines in areas that would be "out of the light", such as the stern of the big boat and under the seat in the small boat.

HOW I SKETCH ON LOCATION

I use on-location sketches without the wash to collect reference material from which I work later in the studio. The purpose of the sketch is only to provide detailed information of particular objects, like barns, boats, houses and so on. It's not meant as a finished design or sketch to be hung on a wall, although I can't help designing while sketching and some of these turn out fairly completely.

So that I can later see detail easily without stopping the painting, I do the sketches as large as possible. Then I can mount them on a wall in my studio and just glance at them as I paint, much as I would do on location. The advantage is the sketch is much simpler than either real life or a photograph. All of the unnecessary background and distracting shapes are removed, leaving only the shapes in which I'm interested.

I begin by using the nib end of my black, dual-tipped marker for drawing. I use it like a pencil, varying the pressure I put on the nib and rolling it over to the side to create thick and thin variations in the line. Later, I use the brush end of the grays to mass in shadow areas, making the shapes easier to understand. Thicker lines and accents in black or dark gray, made with the nib or brush, complete my sketches.

However, in any one painting, I don't try to apply all of the principles to all of the elements. I may choose to focus on just one or two principles and typically three elements. For example, one of my favorite principles is dominance, which I often apply to the elements of shape, color and line.

When it comes to pen-and-wash paintings specifically, I believe that in order for the contrast of line and wash to stand out, there should be an uneven balance between the two. Either the painting should be

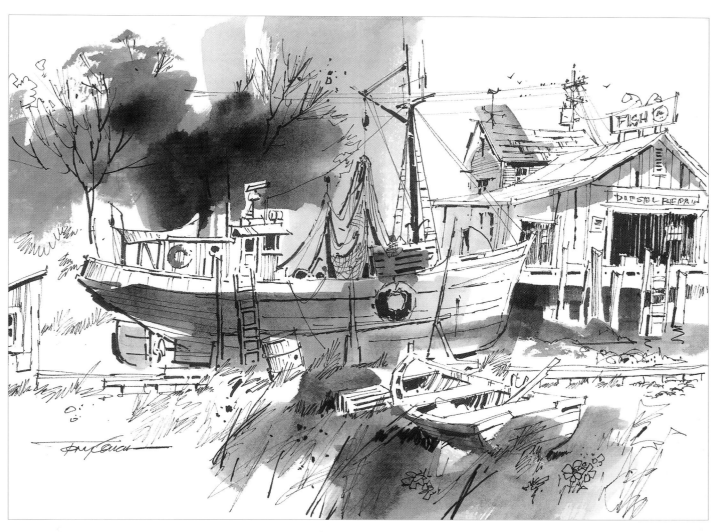

3 **REINFORCING THE SHADOWS**
Finally, I drew in the dock on the right and the foreground grass, then went over the whole painting with the wide pen, dropping in wider lines in darker, out of the light and shadowed areas of **"Boat in Dry-dock"** *(ink and watercolor, 12 x 15" or 31 x 38cm).*

mostly drawing with a little wash or mostly wash with a little drawing. In design terms, either the line or the wash should dominate.

Repetition and variation of shape are also important concepts in my pen-and-wash paintings. I typically use a vignette technique, in which the main image is surrounded with white paper. I then usually run some of the washes off at least two and often three or all four sides of the paper (repetition). But when doing this, I make sure that the

distance from the edge of the runoff to the corners of the paper is uneven all around the painting so that the sizes of the shapes of remaining white paper are varied (variation).

Maintaining spontaneity
Once I have made sure my sketches and paintings are built on a well-designed structure, I then take steps to apply the lines and washes in ways that give the works a spontaneous, casual, even random

feeling. The technique works best if both the drawing and the wash are done in an "off-hand" manner, similar to a fast sketch. Here are some of the steps I take to generate a loose, yet controlled, quality in my line work and my washes:

Line. With any line work, a line of varied width is much more attractive than one of the same width. It provides variety, which is always more entertaining. ➡

ART IN THE MAKING *"CALIFORNIA MISSION CHURCH"*

I think I was much too careful and didn't quite get the casual quality I was looking for in this one. The bamboo quill did it's best to give me a haphazard line, but I was too forceful in making it put the thick and thin where I wanted them. In the wash, too, I was too precise. In my opinion, missing the line with the wash in more places would have looked better.

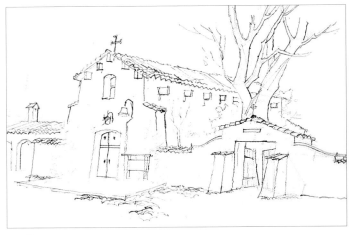

1 SHADING WITH STROKES

For this one, I worked from a black-and-white sketch previously done on location in San Miguel, California. Notice how I used the broad sides of the gray markers, especially the dark gray here, to suggest shadows.

2 DRAWING WITH BAMBOO

First came a rough pencil sketch to insure I got the size of the shapes correct — not so large I'd run off the page before the shape was finished. Then came the drawing. I used a bamboo stick dipped into waterproof India ink. I let the stick give me thick and thin lines wherever it would, but I did guide it a little to make sure lines that fell out of the light got some thicker treatment.

HOW TO MAKE YOUR OWN PENS

Occasionally, I use a bamboo stick or turkey quill shaped into a pen, then dipped into India ink. Both the quill and bamboo pens are home made, using a razor blade for the quill and an ordinary sharp pocket knife for the bamboo. Both are cut to resemble a steel quill pen, right down to a slit in the tip so that it will hold more ink. The advantage to using either the quill or bamboo pen is that they automatically provide informal, casual thick and thin line variations as you draw.

Why not invent your own tool? Some artists have used a paper match dipped into ink to get a mark. With a little creative thinking, you'll generate a myriad of unusual marks, giving your work an unpredictable, yet distinctive, look.

One way to avoid a precise, consistent line is to experiment with different tools and applications.

When I'm using a store-bought pen that holds ink within it, I try to vary the amount of pressure I place on the nib. I also randomly twirl the pen as I draw, further insuring variation in my marks. I change the pressure as well when I'm using pen nibs dipped in ink, such as metal, bamboo or turkey quill pens, although these nibs tend to naturally create thick and thin lines. Using a fine round brush or a rigger brush to apply the lines almost guarantees a range of line widths. An alternate way of providing variation is to occasionally put a uniformly thin line next to a uniformly thicker line.

Although any variety of line is attractive, I usually keep the lines facing the source of light thin, while lines out of the light or at

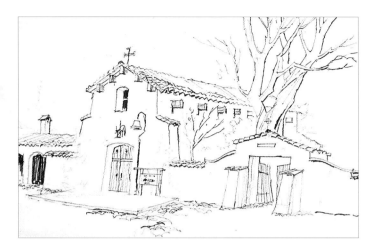

3 DEFINING SOME DARKS

I thought I needed a few large, dark spots in the church windows and doorways on the left, so I went in with the broad Faber-Castell pen for that. At the same time, I added thicker lines under ledges and shapes.

4 PRESERVING WHITE AS LIGHT

Last came the wash stage, for which I let the shaded side of things and cast shadows dictate where the washes would go. Those things in the sunlight and most of the sky were left as white paper in "California Mission Church" (ink and watercolor, 15 x 22" or 38 x 56cm).

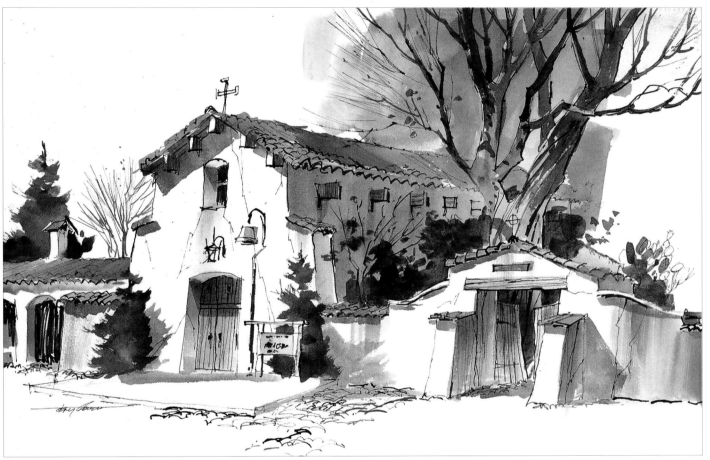

the shaded side of an object are thicker. Keeping this guideline in mind helps me remember to vary the thickness of line and adds a semblance of order to the drawing.

Lines can be any color, although I typically prefer black or a very dark mixture of watercolor paints. If the lines are created with a water-soluble material, such as watercolor paint, the wash must be done first, then the drawing applied over it, after the wash is dry. Otherwise, the wash will smear or destroy the line. But if the ink used is waterproof, such as India ink, it doesn't matter if the drawing or the wash is done first. If allowed to dry thoroughly (about an hour), the ink will remain firm and solid under the watercolor washes, which is what I prefer.

Washes. Just as I don't want my line work to look as precise as an engineering drawing, I don't want my washes to fill in the shapes ➡

ART IN THE MAKING *"BARN"*

With this piece, I think I was a little too careful with the drawing and too timid with the wash,
which was intended to be more bold. It looks too much like an architect's rendering.

1 **STARTING WITH LINE**
This time, I did the drawing first as I knew the ink
would not be disturbed by later washes. I began
with the usual pencil sketch, then started in with
a Faber-Castell thin pen, varying my line widths
as I went.

2 **ENHANCING THE DARKS**
After finishing the drawing, I went back in with
the wide pen and filled in the dark areas inside
the doors and under things. I then randomly put
in thicker lines, mostly over thin lines, on the
shaded sides of objects.

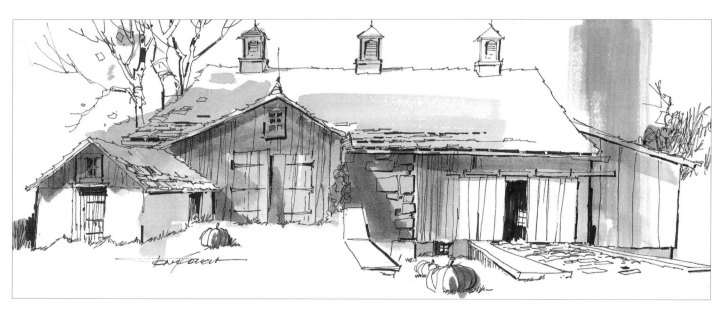

3 **"MISSING" WITH WASH**
Finally, I added the wash. Using a 1" flat brush, I did my best to paint
broadly and boldly, missing the drawing by as much as I dared. To
complete *"Barn"* (ink and watercolor, 7 x 17" or 18 x 44cm), I painted
in the shaded sides of the bright orange pumpkins to add a little color.

WITH ANY LINE WORK, A LINE OF VARIED WIDTH IS MUCH MORE ATTRACTIVE THAN ONE OF THE SAME WIDTH. IT PROVIDES VARIETY, WHICH IS ALWAYS MORE ENTERTAINING.

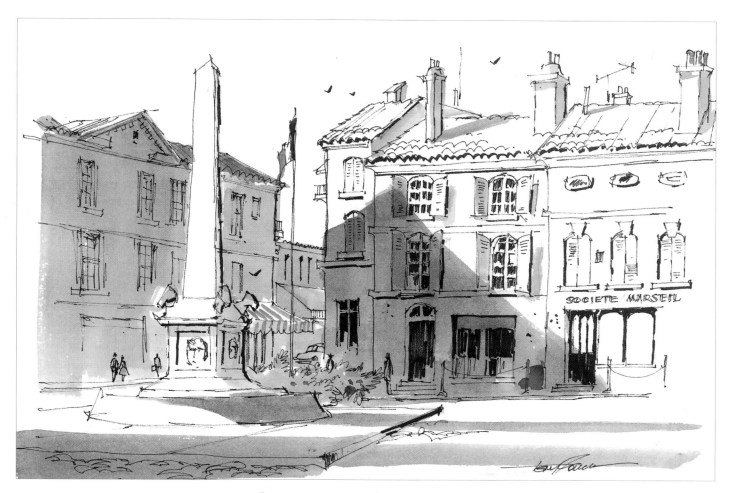

"EUROPEAN SQUARE" (INK AND WATERCOLOR, 12 x 15" or 31 x 38cm)
I created this ink-and-wash painting from a black-and-white sketch, and it's almost identical to the original. I did the drawing first, blocking in large shapes with pencil so I wouldn't run off the page before I got everything in. Then I did the drawing with Faber-Castell pens. I was still careful to get those thick and thin lines in, and I put more detail with dark windows and doorways in the building on the right, as that would be the center of interest. Next, I put the wash over the shapes that were out of the light and in the cast shadows. The shapes in the bright sunlight were left white.

ROAD-SIDE SKETCHING

I've done many a sketch looking through the windshield of my car. I just drive around until I see something I like, park the car facing it, slide the seat all the way back and use the steering wheel as a support for my pad. It's just the right angle. I spread my sketching tools around on the seat or dash, turn on the stereo with my favorite music and go to work. The wind can be blowing and the rain can be pouring down, but I couldn't care less. I'm sketching!

as precisely as a coloring book. I think it's best to keep the washes transparent and only roughly follow the lines of the drawing. The wash should "miss" or overlap the line in several places. It is even possible to combine the drawing with an abstract wash, totally independent of the drawing. This "missing the line" approach sets up a kind of vibration between the line and wash, which adds to the excitement.

Designing for impact

As exciting and dynamic as a pen-and-wash sketch or painting may look, it still needs a foundation of good design. So before you get caught up in the magnetic act of drawing, remember to plan for and apply a few of the seven principles to three or more design elements. Having a solid structure underneath your ink lines and watercolor washes will give your work a more powerful punch. □

POCKETING YOUR STUDIO

Dramatic results don't require a big effort. Janice Thomas Donelson shows you how to trim down your supplies and process, making it easy to practice sketching anytime, anywhere.

The question is often asked, "Were you just born with this talent?" No! Art to me requires technical skills, basic training and commitment, just the same as playing the piano or doing any other art form. Practicing something every day for several hours is how we learn and become proficient. So it's necessary to commit as much time as possible to keeping our eyes and hands at work. Commitment is the cornerstone for success.

Of course, even though we all know that sketching daily will help us become better artists, most of us are overwhelmed by the thought of it. It feels like a big project that calls for big time and big effort. So I've learned to trick myself into daily practice with the idea of working small for just 30 minutes a day, no matter where I am. How do I keep it simple so the practice time always seems like a manageable activity? I use what I call my "pocket studio" for sketching.

Streamlining the process

The pocket studio came into being about 10 or 15 years ago when I realized that having to set up so many materials — either on location or in my studio — was keeping me from getting out there and working. Drawing should be fun, and I wanted the experience to be easier, more portable and more enjoyable. With some thought, I found I could trim down my supply list to a few essentials that would fit in my pockets. This way, I'd always be ready to set up quickly and go to work. The pocket studio gives me a wonderful feeling of simplicity and freedom, and just 30 minutes of drawing a day lifts my creative spirit.

It started with my first accordion sketchbook, which I bought in San Francisco's Chinatown. I experimented with the book and a case of permanent, washable black and sepia ink pens in my pocket. I gradually added three Niji water-filled brush pens and 10 water-based dual-tip pens so that I could add color on the spot. A camera — now a tiny digital one — completes the kit. Once I put these together, I could sketch in buses, trains, planes and cars, even while waiting for the kids at school. When traveling, I often sketch in churches, at the symphony, in villa gardens, at piazzas and markets and while sitting at the seashore. I love the freedom I feel to move around easily without all of the gear.

Now when I'm away from my studio, I use the pocket studio almost exclusively because it's so convenient for outdoor sketching.

I got so tired of lugging practically my entire studio around just to paint on location that I developed the "pocket studio". In cases, I carry a variety of ink pens, dual-tipped water-based brush markers, Niji water-filled brush pens and watercolor crayons. I also carry one small accordion-fold sketchbook and my tiny digital camera. All of these items fit in my pockets so I can walk for miles and go anywhere.

WHAT THE ARTIST USES

PENS *I prefer some finer point pens with black and/or brown permanent, washable ink, such as Scripto permanent fine and extra fine point, Sanford Uniball Gel Impact, Sanford Uniball Micro and Faber Castell markers and brush pens in sepia.*

BRUSH MARKERS *I also enjoy using the dual-tipped water-based markers with a pen on one end and a brush tip on the other. Marvy markers, LePlume markers and Prismacolor dual-tip pens all come in many colors.*

BRUSHES *The Niji water brushes, only sold in the US through Cheap Joe's catalog, are wonderful. Available in four sizes, they have an attached water cartridge, which I unscrew and fill with water before I go out sketching. When squeezed, the water runs through the brush head, distributing water to the surface while cleaning the brush. This means I don't need to carry an extra container of water.*

I also have at least 20 different brushes of all sizes and styles. My selection includes fans, riggers, Nos. 1 through 6 rounds, square-tipped Aquarelles and some brushes used for Japanese and Chinese painting techniques, which I've been practicing for many years.

PAINTS *I prefer to use water-soluble watercolor crayons in a variety of colors. These are easy to carry and allow me to quickly add color to the dry surface of the paper, which I then follow up with water from the Niji brushes to create a wash. However, I also carry a small watercolor field box in my kit.*

WHEN I FEEL INSPIRED TO DRAW A SCENE FOR THE FIRST TIME, I STICK TO THE SUBJECT MATTER. HOWEVER, SUBSEQUENT SKETCHES AND PAINTINGS OF THE SAME SUBJECT WILL VARY BECAUSE I TRANSPOSE ANY AND EVERYTHING

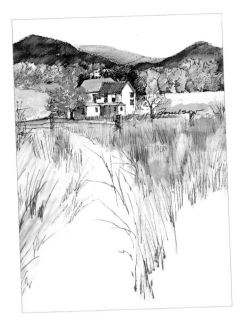

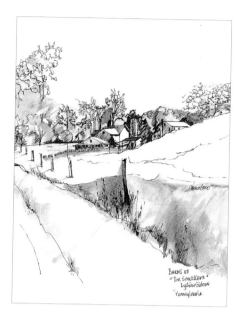

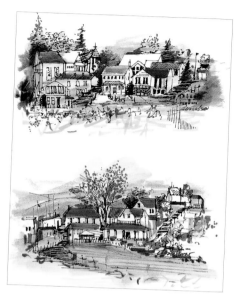

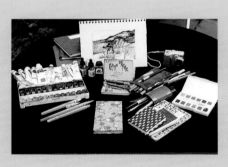

"AMISH HOUSE", INK AND WATERCOLOR, 10 x 7" (26 x 18cm)

I've enjoyed painting around the Amish country of the eastern US for many years. The houses are mostly black and white and the landscape often appears nearly monochromatic, but it is actually very pleasant. It's a challenge to work a little more color into my sketches.

"THE SMUCKERS' BARNS", INK AND WATERCOLOR, 10 x 7" (26 x 18cm)

In this sketch of a typical Pennsylvania barn, you can see the influence of my original X starting off the drawing just above the center of the page.

"WEST VIRGINIA TOWNS", INK AND WATERCOLOR, 11 x 8½" (28 x 21cm)

Armed with my pocket studio, I set out for a drive on a summer's day in West Virginia. I simply stopped the car on the side of the road, and worked spontaneously for an hour on each sketch.

INKS Watercolor inks and permanent inks are also part of my painting gear.

SKETCHBOOKS My favorite type of sketchbook for painting-on-the-go is an imported Japanese accordion-fold book, about 5 x 7" (13 x 18cm) in size so it fits in my pocket. Since the paper inside can range in quality, I look for those with thicker papers that will take a light wash. (The lighter papers will tear apart too easily after several uses of the book.) Most have about 24 folds, so I can sketch nearly 50 scenes in each one. The hard cover makes them easy to carry and protects the sketches.

When I want a heavier paper for a more detailed sketch, I use hardback, spiral-bound sketchbooks filled with 90 lb cold-pressed paper, about 9 x 12" (23 x 31cm) in size. Before I sketch on

this paper, I mask off a 1" margin with artist's tape. This gives the work a matted look after I complete the sketch and remove the tape. The spiral binding allows it to lie flat, making it easy to work with.

CASES I have found some unusual carrying cases that work well for art supplies. A hard plastic flip-top eyeglass case works well for short pens, while a soft eyeglass case with a flexible opening is perfect for longer brush-tip pens. A flip-top cigarette case works well for watercolor crayons. The advantage of these is that they're lightweight and small enough to fit in my pocket.

CAMERA I still love my old, heavy 35mm camera, but I usually choose my tiny digital camera. It has a charger and holds over 500 photos.

Back in my hotel room or apartment, I keep a larger supply of materials so I can refine my small sketches or create bigger, more detailed drawings during the evening. In addition to all of the items from the pocket studio, I carry 9 x 12" watercolor sketchbooks, watercolors (tubes and pans) and assorted inks.

ART IN THE MAKING *PAINTING IN RADDA*

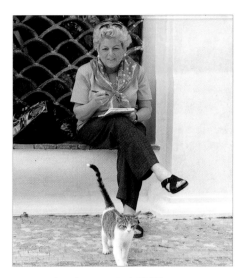

FINDING A QUAINT SUBJECT

On a walking tour of Radda, a quaint Tuscan village, I came upon this scene of an alley. Eventually, it led to an entire series of paintings, each filled with the joy of exploring and inventing from a single theme. I sometimes feel I should donate one of the resulting paintings to the township of Radda for giving me such a thrill!

APPRECIATING DETAILS

Initially, the doorway and the hydrangeas caught my eye, prompting me to snap this photograph. But then the colors of the buildings and the stones and all of the shapes and flowering pots convinced me to stop and work with the subject.

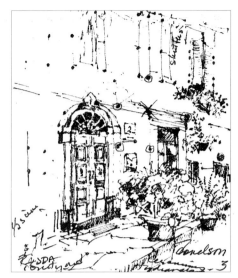

DRAWING IN CIRCLES

As you can see in my quick pen sketch done in my pocket-sized sketchbook, I started with an X just above the center of the page. I then positioned a few concentric rings of dots around the central X. These helped me make comparisons and draw a fairly accurate sketch of the doorway, window and flower pots. This was all I had time for so I was thankful to have the photograph as back-up, although I also sketched from memory when I returned to the hotel.

5 GOOD REASONS TO SKETCH SMALL

1. *It's practical, portable and convenient, especially if you develop a pocket studio.*

2. *Your technical skill will improve because you practice control, which will lead to greater freedom in your performance.*

3. *It makes marketing easier and convenient. You can sell small printed cards or miniatures, and show potential clients the range of your work with your sketchbooks.*

4. *The sketchbooks become great records that are easy to store and review.*

5. *Psychological feelings of mastery come with focus in a small space.*

But I also carry a few other supplies and leave them in my room wherever I'm staying. In the evenings when I return to my lodgings, I sometimes try to enlarge my sketches in bigger sketchbooks, adding content that I have gathered in the smaller sketches. Some of these are finished and others are used as springboards for larger pieces.

Grasping the subject

Wherever I go, I always see plenty of subjects that could make for great paintings. In Europe, especially, classic architectural forms abound — in windows, in columns and on doors. The variety of aging structures form so many colors and textural designs that it is easy to bloom where I am planted. I particularly like to sit in cafés that are located in large, open piazzas because I can do multiple drawings as I turn from side to side.

However, out on location, I can get overwhelmed about where to begin. I would like to paint it all! One of the advantages to using small sketchbooks is that they put a limit on all of this vastness, so to speak. I have to zero in and get focused. After I settle into the scene, I find that sketching is a process that makes me dream and relax. The end result is a sense of accomplishment and joy.

To relieve stress when I go out to sketch, I always take a photo first. Photographs are records that give me ideas, so it's nice to have them as a back-up if I have to leave the scene quickly due to a sudden rain shower or something. But to me, a sketch is the ideal. If I sketch a scene, I put "heart" in it! The sketch provides memories of my travels, which evoke moods and feelings that I draw upon when I am painting the scene later in the studio. I never forget how I felt

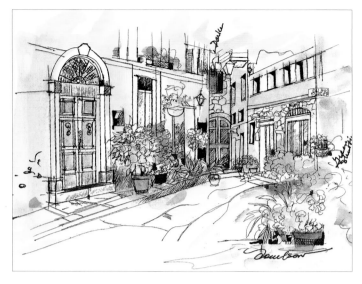

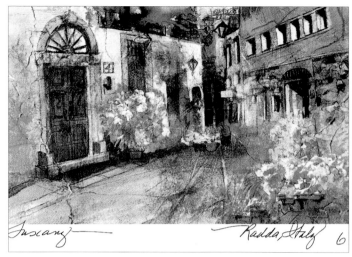

RENDERING AND LOOSENING UP

When I returned home to my studio, I used my photograph and sketches to complete a far more detailed architectural rendering in pen and ink. Light watercolor washes freely applied over the permanent ink loosened up the drawing.

CAPTURING RUSTIC CHARM

Combining my imagination with my references, I was then able to create a number of paintings based on this subject. Here, I modified the composition by adding more windows and a few other details. I used watercolor, gouache, watercolor crayons and ink. I scraped the surface with a stylus and "dirtied" it up a bit to convey the rustic feeling.

when I was sketching, but I easily forget why a photo was taken.

Marking the spot with an X

In addition to being good drawing practice, the process of sketching in pen and ink is often a basic step for me before I begin a painting. It helps me understand the subject and the spatial relationships involved. It is also an exciting, yet relaxing, experience for me. When I feel inspired to draw a scene for the first time, I stick to the subject matter. However, subsequent sketches and paintings of the same subject will vary because I transpose any and everything I wish.

To start a drawing, I mark the page in my sketchbook with an X, which is usually in the area slightly above the middle of the page. I eyeball a circle of dots around the X as the center. Then I create a bigger circle of dots. I keep repeating this process until I run out of space. I put the dots on the paper to mark visually the distance

10 TIPS TO SUCCESS

1 Take professional workshops with many teachers to master your skills.

2 Draw daily to improve your eye, mind and hand coordination.

3 Work in series. Repeat subjects, elaborate on them, change the colors and experiment with the subject until you feel comfortable painting. If you have a computer, get Adobe Photoshop and experiment widely on the computer screen before trying it in the studio.

4 Choose a photograph you like and use a 1 x 1" mat to zoom in on all of the possible subjects found in it. Draw at least six or seven ideas.

5 Get some architecture books and study the tools and techniques listed there. Also study the master painters such as Leonardo da Vinci, Degas and more.

6 When you see something that really gets your attention, photograph it if possible. Write about it and give reasons why you like it, such as the colors and shapes. Think about it and ingest every detail. Your connection with your subject will emerge magically from your subconscious mind and guide you later.

7 Produce artwork in uniform sizes, making it more cost effective to frame and sell.

8 Take a marketing class or workshop, or hire a marketing counselor.

9 Print promotional brochures and keep them close at hand everywhere you go. Always have some in your purse and car.

10 Get your name and work into the public eye by giving away your art to auctions, schools, professional organizations and charities.

ART IN THE MAKING *CAPTURING VENICE*

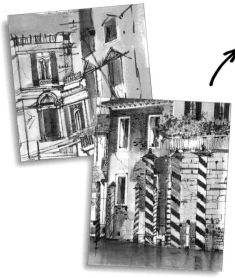

LOOKING AT THE BIG PICTURE
The richness of the architectural forms, windows, awnings, water, boats and reflections along the Grand Canal was just too much for me to take in. It seemed like an impossible subject but I took this photograph anyway.

TACKLING A TOUGH SUBJECT
Venice's luxurious architectural details were both inspiring and overwhelming. The only way I could think of to dig in to such a complex subject was to break it down into smaller pieces first. What a learning experience!

BREAKING DOWN THE ELEMENTS
I thought the best way to approach the subject would be to do small vignettes. I zeroed in on various aspects of the abundant subject, drawing limited portions of the overall view on location. Over each pen-and-ink drawing, I applied washes of watercolor and watercolor crayon to capture the colors and character of the canal.

SPIN-OFF IDEAS
I have a full-time job working in my studio, but there are times when I have the urge to explore ideas that come to me. With my sketchbooks, I have found that I can create spin-off products for my own use and possibly to sell. For example, in the past I have produced six sets of different styles of cards. I also took 30 small drawings from all over Europe and collaged them on a large 36 x 40" (92 x 102cm) sheet of paper. I printed these to make wrapping paper, but it could be used as wallpaper as well. I have also laminated it on clay pots for studio displays and shows. The collaged paper really could be used to decorate any surface.

between one object and another. Basically, I work in concentric circle patterns, especially when the subject matter is very congested and complicated, as in an architectural drawing. The dots make it easier to incorporate basics of one- and two-point perspective, but I don't get all hung up on that aspect. For simpler landscapes, the X is often the only reference I need.

I have a basic glossary of marks that I use to develop the details in a drawing, which I learned from architectural studies and from a class in architectural rendering. They include dark and light lines, broken lines, line gaps, overlapping lines (doors and windows), thick lines together for strength and punch, spattering and smudging, and dots or small square dots in series to move the eye around in the drawing. These dots I call "significant dots" as they are there to force the eye to connect space

and bridge gaps. The dots do not represent anything I actually see. They are a way to jazz up a drawing and get action and movement in it.

After I get the shapes sketched in pen and ink (it's faster when I skip a pencil stage), I add a few dashes of marker or watercolor crayon to get the color scheme going. I may add some water from one of the Niji brushes to enhance the crayons. I typically have four or five earth tones and several yellows, blues and reds with me, but I can get the gist of the scene with even three colors.

Taking a hands-on approach
Before developing a larger 9 x 12" sketch, I first mask off the edges of the page with artist's tape to preserve a handsome white border. With a larger field of paper that is much stronger, I am free to add more water and experiment with colors. When the inks and the watercolor washes run together,

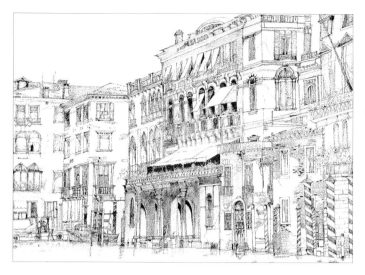

RISING TO THE CHALLENGE

Back in my studio, I was inspired to attempt to draw this entire subject. I bought a double-elephant sheet of watercolor paper and began to draw. It took many hours over many days to finish the project, but I learned immensely. Doing the smaller vignettes gave me a better understanding of the structure and its details. It is the largest detailed drawing I have ever done, and I loved it.

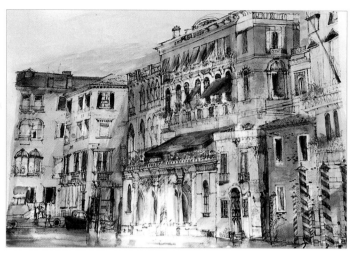

MULTIPLYING SUCCESS

Later, I took it to a professional printer and ordered 50 prints on watercolor paper. I then hand-painted each one, creating a different mood every time. It was a costly and time-consuming venture, but the results were truly exciting and have sold well.

"VILLA, SIDE DOOR", INK AND WATERCOLOR, 11 x 8½" (28 x 21cm)

My commission to paint this villa in Alexandria, Virginia, turned out to be a fantastic experience in drawing. The charming structure was laced with very complicated ironwork. I ended up doing detailed drawings of all four sides of the villa, which I then rendered in color with watercolor washes.

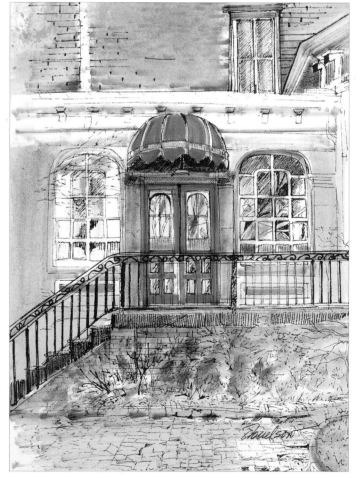

JOURNALING

I am a real believer in journaling when you paint.

If I sketch a scene and write about it in my book, it has a "double whammy" impact on my psyche! I have engraved it in my subconscious mind. My brain registers double-time with the images and the words combined. I call these times my creative intermissions.

OUT ON LOCATION, I CAN GET OVERWHELMED ABOUT WHERE TO BEGIN. ONE OF THE ADVANTAGES TO USING SMALL SKETCHBOOKS IS THAT THEY PUT A LIMIT ON ALL OF THIS VASTNESS

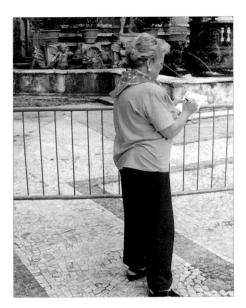

SURRENDERING TO THE URGE
Wandering around in Tuscany, I found this archway into a small town to be so inviting. It has a way of enticing you to enter into the painting with your imagination.

WORKING WITH ONE-POINT PERSPECTIVE
The pocket studio is so convenient to use, I can even sketch standing up, as I had to do with this subject. As always, I began my small on-site sketch with an X above center and a series of dots emanating out from the X. This helped me capture the one-point perspective of this view of the archway. After putting in some of the architectural forms in the distance, I applied light sienna shades and the suggestion of figures.

ENHANCING THE IMAGE
I completed the sketch by adding richer color, textures and details with watercolor crayons. Water from the Niji brushes softened some areas.

DOCUMENTING YOUR LIFE'S WORK

Before every new piece goes out the studio door, I digitally photograph, download and label it and record where it goes. Keeping documented files and notebooks of my work has been very valuable in my experience. Often a client who has bought a painting calls and would like to get another. I have the notebooks in my studio so I can look up instantly what they have bought to determine what they may want. I paint in different countries and it is hard to remember all the details. Quite simply, when someone says it's Italian and has warm colors, I have no idea of what or where. But with good records, I can be more cordial and helpful immediately without feeling clueless. Buyers always assume that the artist will remember every detail of their paintings. Unless you have a photographic memory, it is not likely.

there is a magical transformation that is totally unpredictable. I like the surprises and the accidents. The splashes and runs are exciting. I love the contrast between detailed drawing and the splashing and spattering all around the solid forms. The washes bring out the lights and the darks, and this gives life to the work.

I usually get into it with my hands. I smudge, spatter and print off the end of my fingers. It is the direct touching of the paper and the contact with the water and ink that I like. It is a bit messy at times but it works for me. When I use brushes, I try to get that same feeling but they do distance me somewhat. Nevertheless, I try to stay in the flow and let the painting be free.

Embracing your talents
Using the small accordion books has given me indelible memories

and images of my travels at home and abroad, records that will always be with me in my head and heart of the places, moods, events, times with friends and artists in the field, or time alone sketching. I keep years of drawing experiences on a small shelf in my studio, and I like to go through them and reminisce.

However, sketching is as practical as it is enjoyable. It allows us to develop our talent, to act on it, produce, express and shine creatively! With greater skill comes the joy that is our destiny as artists. Others will benefit from our creative expressions and they will also feel our joy. Feeling like an artist comes gradually after much practice, but it becomes so much a part of you at a certain point that you know you will never be separated from it. □

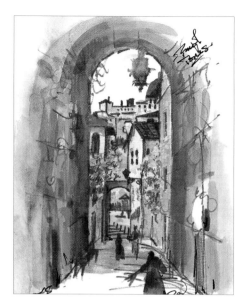

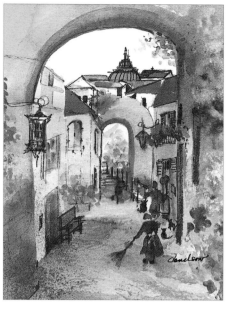

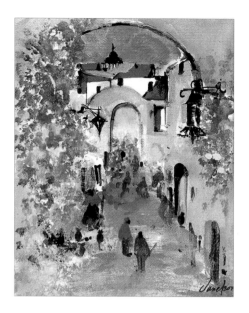

PLAYING WITH VARIATIONS

Back in my hotel room, I decided to do a variation of the scene by accentuating the blues and yellows. I changed the architecture in the distance and included a woman sweeping to get a little movement in there. I was quite pleased with this sketch and knew I would probably want to develop it further back in the studio. I made little notes to myself regarding the cool tones and cropping ideas to serve as reminders when I got home.

EXPLORING POSSIBILITIES

Here are just two of the many versions of the archway series that resulted from my sketches. With each variation, I gave myself the freedom to experiment with changes in composition, color, media, techniques, details and more. Experimenting was fun and kept the image fresh and new.

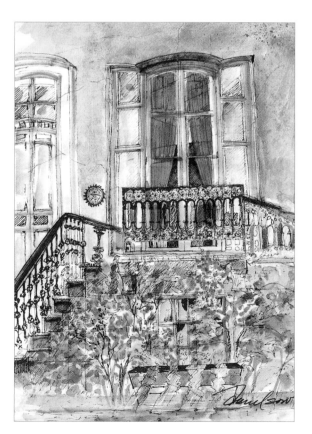

PERPETUAL SALES

Always be prepared to seize an opportunity to sell your work when it arises. I try to carry a few brochures as well as my business cards at all times. My brochure is just a simple black-and-white with some examples of my work, my photo, a bio and my contact info. I have received many commissions and sales from handing these out to interested onlookers when I'm working on location. I also take along a stash of line drawings that I have printed on card stock. They're a nice way to leave behind a remembrance and let people know how much I've appreciated the experience of painting in their homeland.

"VILLA, TERRACE", INK AND WATERCOLOR, 11 x 8½" (28 x 21cm)

I spent an extraordinary amount of time rendering this complicated subject, a villa in Virginia. Because I'd put so much work into the project, I decided to extend the benefits by printing my drawings as cards. They sold well, and provided good memories for me.

HOW ONE ARTIST BRINGS THE TOURISTS BACK ALIVE!

When you have to earn a living from your art, you sometimes have to think differently. Here's how Terry Eyre set out to tailor an "art product" specifically for the tourist market.

SUBJECT MATTER? AUSTRALIAN ICONS, OF COURSE.

Because I knew I would be producing a lot of paintings, I decided to paint favorite subject matter. Sketching the rural buildings of Australia gives me a great deal of pleasure, and the knowledge I acquired of buildings during my career as an architect is, of course, very useful. I also spent much of my life drawing buildings in a more formal way, and this contrast makes for a great change. But most of all, I believe that Australian farm buildings are quite unique. Corrugated iron is our vernacular. It is popular because timber burns, building clay is not abundant and stone and slate are in limited supply. We certainly use these materials, and they lend great beauty and variation to our rural buildings, but the easily transported, rapidly erected, sturdy corrugated iron is the Australian building emblem.

And with it comes the rust! Red rusty iron blends happily into our red dusty landscape, and when you add to this the brittle dead gums, the spiteful barbed wire, and the scattered debris which expresses our happy reluctance to tidy up, set off by the deep, deep shadows of our sun-soaked country — who could resist having a go?

Since I am a professional artist, I decided to launch an art "product" that I called "Australian Glimpses". These paintings would be aimed at tourists who want a moderately priced, easy to carry, fair quality and, if possible, unique memento of Australia, to take back home with them as a souvenir or as a gift.

With this target established, I set the following parameters:
1. The work should be small.
2. It should be easy to pack and post.
3. Materials and techniques must permit short "production" time.
4. Cost of materials must be kept low.
5. I should produce original drawings as opposed to prints.
6. I had better enjoy doing them because I was probably going to paint a lot of them!

Working small

Because my "Australian Glimpses" are small — the window size of the mount is 3 x 4" or 7 x 10cm — I am

A QUICK AND EASY PRODUCTION LINE THAT WILL GIVE YOU A STEAD

I cut the mounts and backboards from offcuts of mountboard. I draw the mount perimeter and window on the back of the board using a template then bevel cut this with a hand held mount cutter. I cut the backboard to match and hang the mount and back at the top using gummed tape. I trim and place the drawings in position and tape them, at the top, to the backboard.

1. LAY OUT ALL YOUR TOOLS

2. GET YOUR REFERENCES READY

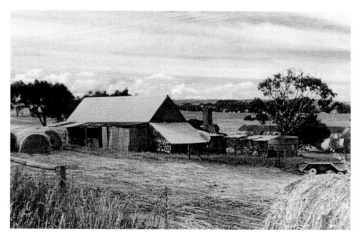

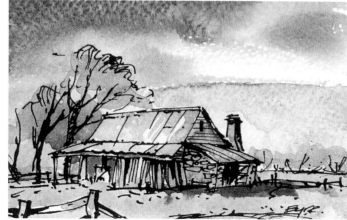

INSPIRATION AND FINISHED PAINTING

therefore able to use offcuts of good quality watercolor paper. With drawings of this size the weight of the paper is not important. Good quality waterproof ink is essential, and a mixture of black and brown gives me something pretty dark, but with a little more life than black. The ink is applied using a traditional writing nib in a dip pen and, when bolder lines are needed, I use a natural reed cut as a quill; the cut reed makes for a free expressive line. Generally the darks are put in with ink. A stub of candle wax is handy to provide a moderate amount of resist if required.

Artist quality watercolors and watersoluble colored pencils are used for rendering the drawings.

The number of colors is limited to three or four warm reds and yellows and usually only one blue.

I avoid small brushes because I want to apply the color washes freely over the more detailed ink sketches.

Even though I sell the work unframed, I do supply mounts and backboards. When I start each drawing I place a mount on the paper, mark its edges, then make my sketch ½" (1cm) larger in each direction than the window of the mount.

When I start work, I will make perhaps ten drawings in ink, never pencil. This directness is essential if I am to achieve the sketch quality that I want. I hope to capture the character of the buildings, the

ancillary objects and the landscape and the hot, dry atmosphere that characterizes the Australian rural scene.

I then render the drawings in watercolor, taking every advantage of the spontaneous effects of watercolor, and again I try for the sketch quality. A final line or two with the pen may be needed but the well-established rule applies — know when to stop. I sign the work and it is ready for packaging.

Packaging the "product"
Again the small size allows me to use what might almost be considered waste materials. I cut the mounts and backboards from offcuts of mountboard. I draw the mount perimeter ⟶

ANDARDIZE YOUR MAT SIZES

4. CUT, FOLD, MOUNT AND STAPLE

5. THE FINISHED PRODUCT READY FOR SALE

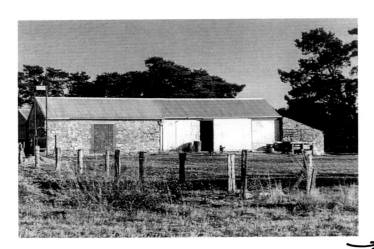

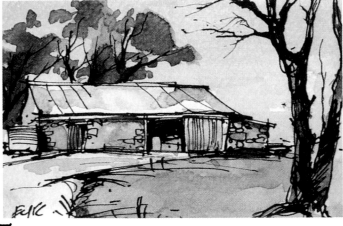

INSPIRATION AND FINISHED PAINTING

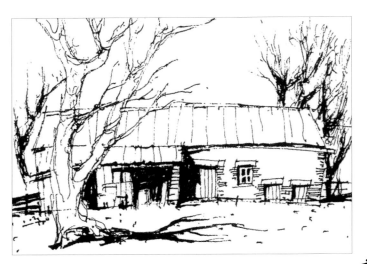

THE ORIGINAL PEN AND INK SKETCH . . .

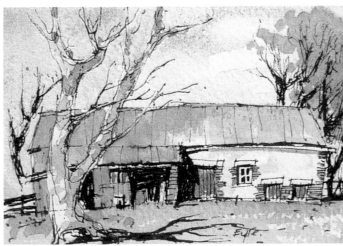

. . . WITH THE WATERCOLOR WASH ADDED

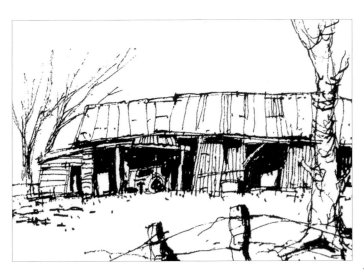

THE ORIGINAL PEN AND INK SKETCH . . .

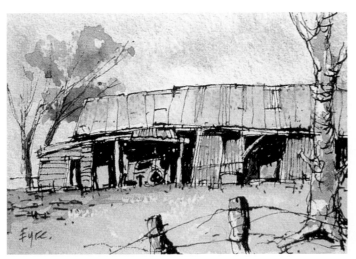

. . . WITH THE WATERCOLOR WASH ADDED

and window on the back of the board using a template, then bevel cut this with a handheld mount cutter. I cut the backboard to match and hang the mount and back at the top using gummed tape. I trim and place the drawings in position and tape them, at the top, to the backboard.

I collect the bits of scrap board which are too good to throw out, and I give them to the local primary school where tomorrow's artists convert them into forms using imagination that I envy.

I cut envelopes from recycled paper, using a standard pattern, then I make two folds and staple twice. When I'm cutting with my knife or mount cutter I use an old T-square to which I have attached a drawer knob and this provides a safe firm grip. Since the introduction of Computer Aided Drafting, second-hand T-squares are readily available, ask around.

Finishing touches

Two more small tasks remain and both of them help me sell the product. When I put the work into the envelope, I include a short printed biography. On the front of the envelope I attach a gummed label which reads, "An original by Terry Eyre of South Australia". My products, "Australian Glimpses", are then ready for the gallery.

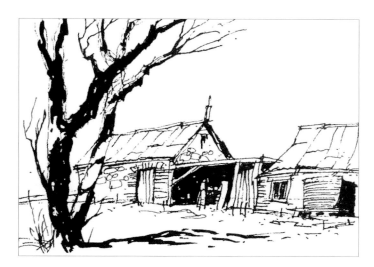

THE ORIGINAL PEN AND INK SKETCH . . .

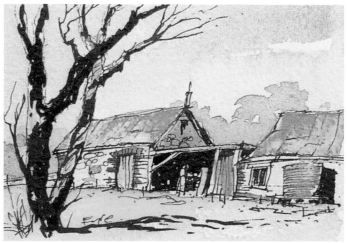

. . . WITH THE WATERCOLOR WASH ADDED

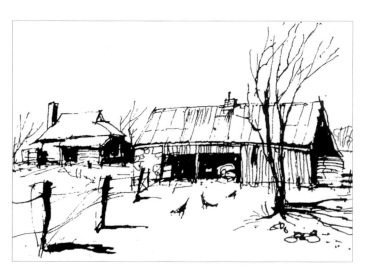

THE ORIGINAL PEN AND INK SKETCH . . .

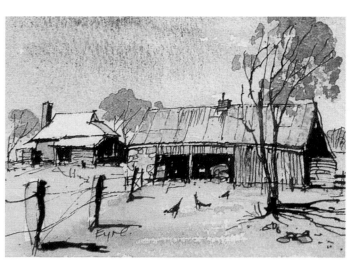

. . . WITH THE WATERCOLOR WASH ADDED

JOURNALIZING WITH GUSTO

Why not document your painting journeys or favorite subjects in a personalized painted journal of your own? Don Getz demonstrates how to capture the moments.

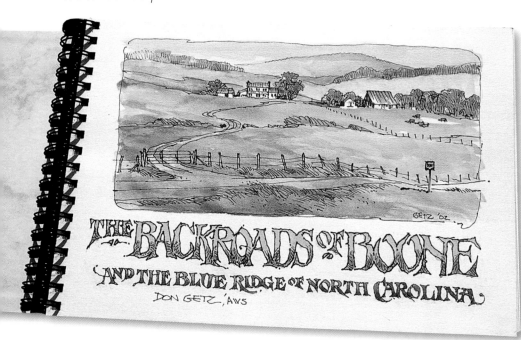

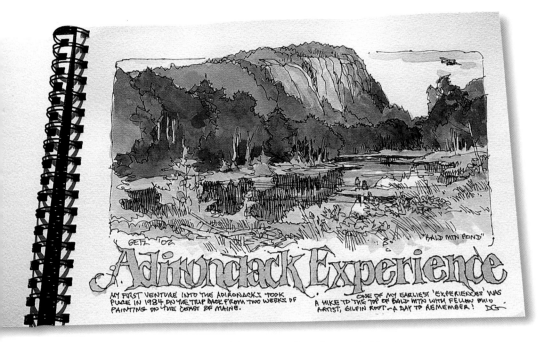

I like to leave the covers and title pages of my journals blank for a few days until I get the feeling of the place I'm visiting. Then I decorate them with a sketch and lettering style that's appropriate to the region. This practice emphasizes that my journals are real books to be treasured and shared.

Like other artists I know, I often enjoy the simpler process of sketching with ink and watercolor on location, as opposed to lugging all of my gear around so I can paint "en plein air". However, I no longer create random sketches in my sketchbooks. I've adopted a unique method of turning my sketchbooks into journals — treasure troves full of sketches, notes and other memorabilia.

The value and fun of watercolor journalizing was introduced to me a few years back when I viewed the beautiful, fresh journals of Texas artist Betty Lynch. Since that time, I have collected other artist's journals and have come to realize the true pleasure of creating a colorful journal of pen-and-watercolor sketches that tell a story. Every time I review one of my journals, which is often, I relive the complete experience.

Designing the overall look

Each of my journals cover a specific trip. It might be several weeks in the Adirondack Mountains of upstate New York, weeks at a time on the coast of Maine or a trip to Provence, France, with a group of fellow artists. I managed to fill most of a 25-page journal in just 10 days in Ruidoso, New Mexico! While my journals cover specific trips, it would be just as easy to create one about a particular subject. Imagine a journal dedicated to people, animals, birds, flowers or architecture, all observed while traveling or at home.

In doing my journals, I sketch on the right-hand pages first as these are visually more noticeable when someone leafs through the book. But sometimes I decide that the subject would be more ideally carried over to the left page. In my opinion, this spread is really attractive and provides a nice mix of sketch sizes as the journal is viewed. →

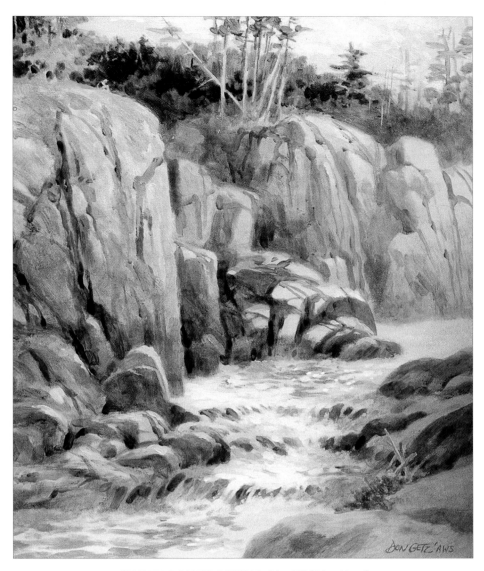

WHAT THE ARTIST USES

Journals There are many available but my favorite is Cheap Joe's American Journey journal with 140 lb cold-pressed rag paper. The hot-pressed journal is also nice, but I prefer the texture of the cold-pressed paper. Spiral bound journals are easier to work with as the pages lie flat. The book can also be folded under while painting.

Palettes My favorite is the Yarka plastic palette, although there are many to choose from.

Colors Since I paint mainly landscapes, I typically keep about four blues, three greens, a few reds and yellows and a Permanent Magenta on hand so I can mix a wider variety of sky and foliage colors. I leave out most of the browns and siennas, preferring to mix my duller colors from my primaries.

Carrying bag I use a canvas bag with four pockets inside to hold the palette and other items. Two inner pockets have a flap to keep pens and pencils from falling out. Four outer pockets are useful for holding the water bottle, collapsible water can, camera and film (which have recently been replaced with a small digital camera), paper towels and so on. The journal itself fits inside the large inner pocket. Sometimes I prefer to streamline my materials and pare down to just a fanny pack, with the journal carried separately by hand.

Miscellaneous Among my other gear are a lightweight folding aluminum chair or stool, which I normally carry in my van. I have added fittings onto the left side of the chair to hold a tray for the palette and water can. A white umbrella really comes in handy when I'm working in a sunny locale with nary a tree in sight. By attaching the umbrella to the chair with a bungee cord, the umbrella can flex and sway with the air currents without falling off. I also carry a bottle of drinking water and a small bottle of insect repellant.

"AUSABLE GOLD", ACRYLIC, 24 x 18" (61 x 46cm)
I created this studio painting based on sketches and color notes from my Adirondack journal.

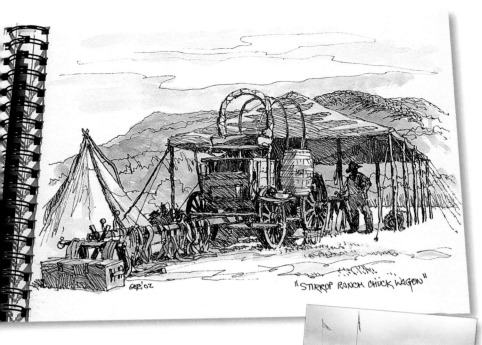

"STIRRUP RANCH CHUCK WAGON"

Upon arriving in Ruidoso, New Mexico, I discovered there was a big event happening. Ranches had sent their chuck wagons and cowboys there to compete in a big cook-off. High scores go to the most authentic equipment, dress and methods of preparation. What a great opportunity to sketch some really interesting subjects!

When I'm not using that left-hand page for half of a two-page sketch, my habit is to do a small sketch there, leaving room for hand printed copy about the sketches on that spread. This adds much more to the content and interest of the journal. In this way, my journals tell a story, reveal more about the location and allow me to explain my interest in the site. I even note directions on how to get there again!

Ticket stubs, postage stamps, restaurant menus, hotel matchbook covers and other tidbits are used to add to the interest of my sketches. The journals are then completed with digital photo references, some of which I print during my trips on a small digital printer that works directly from the camera's memory card — no computer required!

To add a finishing touch that makes the journal feel very special and professional, I like to write the location on the cover and create a title page on the first sheet. I usually design a lettering style that reflects the feeling and culture of the place I've visited, and work it into a full-page sketch from the area.

ART IN THE MAKING *"RAM'S HEAD"*

MAKING MY MARKS

To begin this small sketch, I made a few marks in ink (such as the small mark at the chin) to indicate the general position of the outer contours of the head and horns. I then began to develop the rest of the contours.

COMPLETING THE IMAGE

After putting in the main portions of the head, I then added the supporting barrel shape and other details, such as the shapes of the cast shadows.

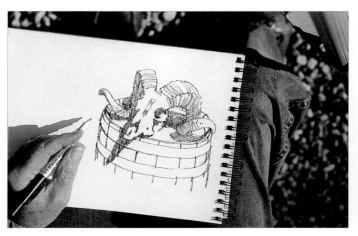

Starting the sketch

Many of my sketches begin with drawing a casual, broken border line on the paper. The openings in the line allow the viewer's eyes to freely enter the sketch. I also frequently leave a space for an important part of the subject to break through that border line. This gives the sketch a unique quality not evident if the entire drawing is captured inside a continuous border line.

Next, I lay in the outline of the subject in ink. No preliminary pencil lines for me! I create a fresher, and obviously quicker, sketch by starting right off with the ink. I used to be somewhat hesitant to do this, knowing that "ink is forever". But then I realized that the whole idea behind creating a journal is to get many sketches done in a rather short period of time, often in a cramped location. My goal is to get my feelings down on paper and move on. Thus, proper perspective or accurate drawing are secondary concerns. Besides, my skills have improved with practice and I've developed a unique style of sketching along the way.

After establishing the ⟶

This is a typical two-page spread from one of my journals, in this case, from Maine. I prefer to place the pen-and-wash sketch on the right-hand page because it will be more prominent when a viewer looks through the journal. The left-hand page is reserved for supplemental material, such as photo references and notes about the location.

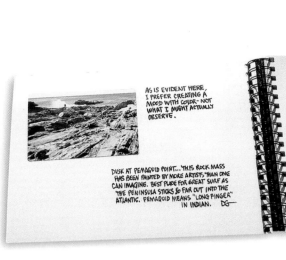

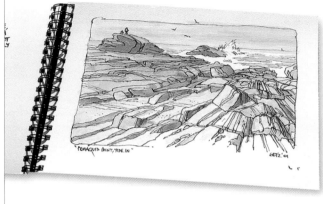

ADDING IMPACT

Darker washes of Permanent Magenta mixed with orange and blues placed around the subject made the shape of the ram's head stand out.

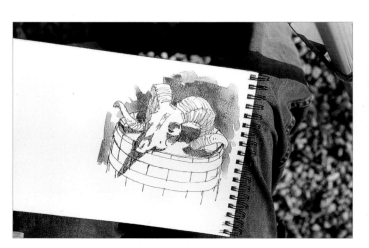

SKETCHING WITH PUNCH

Overall, "Ram's Head" (5 x 6" or 13 x 15cm) is simplified but has a great deal of visual impact.

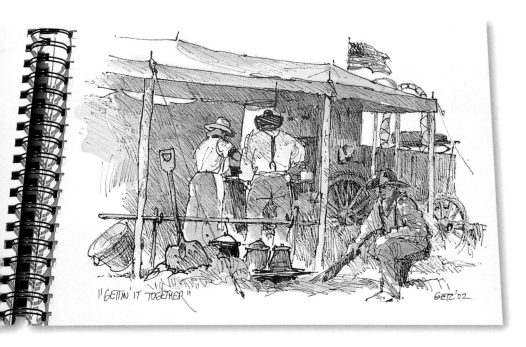

"GETTIN' IT TOGETHER" GETZ '02

subject's outline, I add details to the subject, including background foliage and foreground figures or details. I also add calligraphic lines to indicate textural patterns or darker-valued areas, such as shadows. Titling the sketch is also done at this point as a way to help me focus on the "story line" of the sketch.

Generally, I try to keep my initial sketching sessions to 10 to 15 minutes, but this depends on the amount of detail included in the sketch. Frequently, I will add the fine detail, if any, after I've laid in the initial watercolor wash, as this helps to clue me in on whether I really need those final details.

Moving into color

Surveying the sketch and the subject, I initially establish a very limited palette. I typically select one warm and one cool of my basic colors to start with, which is the same method I use when painting a half-sheet on location or in the studio. I start with the most obvious dark washes around or in the focal area, and then add more washes to complement the focal area. Finally, I add whatever colors

Line work is an important component of my sketches. I used a variety of line weights and patterns to suggest the different types of trees and grasses around this Boone, North Carolina, farm.

ON THE BOOKSHELF

A number of artists have either published their own journals or had them reproduced by book publishers. Although there are many published journals available from bookstores and book web sites, I particularly recommend these four for their diverse styles and presentations:

Artist En Route, *by Betty Lynch. International Graphics, Scottsdale, Arizona.*

Joe's Journal, *by Joe Miller. Cheap Joe's Artstuff, Boone, North Carolina.*

Back Roads of New England *(also of California, Arizona, Oregon and Washington), all by Earl Thollender. Clarkson N. Potter, Inc. Publishers, New York, New York.*

Very California, *by Diana Hollingsworth Gessler. Algonquin Books of Chapel Hill, North Carolina.*

ART IN THE MAKING *"AGE LINES"*

POSITIONING FOR INTEREST
Right from the start, I knew the old New Mexican log structure would be my center of interest so I positioned it in an attractive location toward the upper left-hand corner of the page. I then developed the darker background foliage immediately behind the structure.

I feel are needed to bring the sketch to completion.

Some of my sketches are very complex and some are simplified, depending on how I wish to present the subject. I use local colors on occasion, but more often I prefer to develop my own color scheme to make a more personal statement. The wash stage usually takes five to 10 minutes, again depending on the level of detail.

Finishing my efforts

After the washes dry, I usually survey the sketch and frequently add more calligraphy as I am a lover of line, textures and patterns. Again, this is usually controlled by the amount of detail in the sketch.

When finished, I sign or initial each sketch. As there is a historical significance to me in these journals, I also date each sketch with the year.

Generating excitement

Creating watercolor journals has given me a new outlook on sketching, especially while traveling. I now have a greater interest in visiting new as well as familiar locations, as the concept lends itself to so many ➔

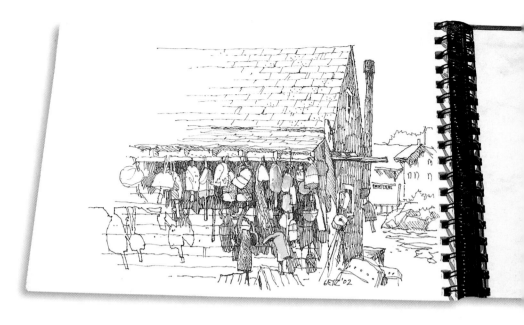

For me, sketching is a good time to try various compositions. Here, I positioned the old schoolhouse of this mountain mining town front and center. The challenge then was to balance it with the patterns of foliage and nearby tin roofs.

LEADING YOUR EYE

Next, I designed the fence, foliage patterns and grasses surrounding the building in a way that would balance the image and lead your eye toward the main object.

WORKING TOP TO BOTTOM

I then applied washes over the sky, trees, building and foreground of "Age Lines" (9 x 12" or 23 x 31cm). Notice that I reflected some of the analogous colors (yellow, green and blue) — for example, the sky blue appears on the tin roof — to unify the painting.

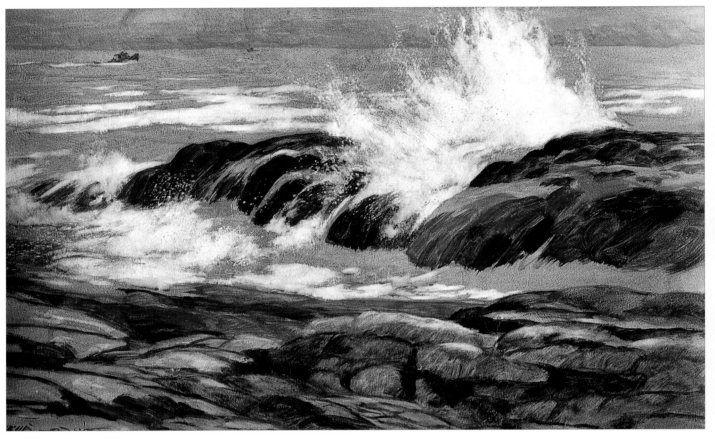

"AMERICAN SUNRISE", WATERCOLOR ON GESSO, 15 x 22" (38 x 56cm)
Although the subject was based on photographs taken in Maine, I relied on my sketches as the inspiration for my color scheme.

different directions and subjects. It's much more enjoyable than simply taking photos and doing random sketches, and my journals give me much more to work from when I get home.

Try it — you'll have a grand time with this new challenge. And I guarantee your family and friends will enjoy looking at your journals as much as you'll enjoy making them. ☐

Sometimes I cover both pages of a spread with one sketch, carefully designing the pages to complement and balance each other. Here, I used the tiny canoe to suggest the scale of this majestic scene in the Adirondacks.

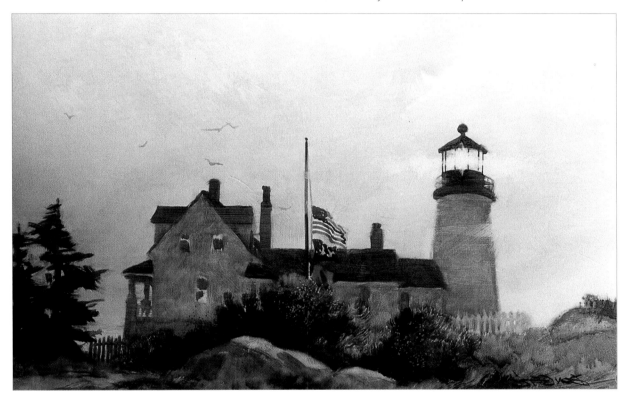

"WE HONOR THOSE WHO DIED",
WATERCOLOR, 18 x 24" (46 x 61cm)
Visiting Maine just after 9/11/01, I found the flag at Pemaquid lighthouse flying at half-mast. I was moved by the scene and decided to record it in my journal. Back in my studio, I decided to do a watercolor, using my sketches and photos as reference.

When in Maine, the trip is not complete without visiting Pemaquid Point. I used this page to record not only a quick sketch of the lighthouse tower, but to jot down the site's history as well. Tickets to the lighthouse make a nice memento of the day and complete the documentation of my visit.

PEN AND WATERCOLOR
THE CONFIDENCE-BUILDING ALTERNATIVE

Get out of the habit of thinking every painting you make must be a masterpiece. Try Guy Gruwier's method of combining three classic drawing methods to quickly build your self-confidence.

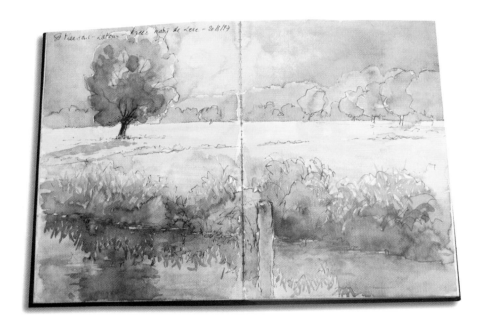

Have you ever been nervous when standing in front of a sheet of beautiful pure white cotton paper, believing that any moment you could ruin it with your first black, inevitable, definite sharp lines? You can almost hear that quality white art paper laughing at you: "Well, how do you want to smudge me today?" Questions paralyze you — "Is this the right line to begin with?" "Where do I come out when I start at this very point?" "Will my subject be represented well enough if I draw it that small?"

If you have this white paper anxiety, don't be afraid. You're not alone! I have this every time before I start!

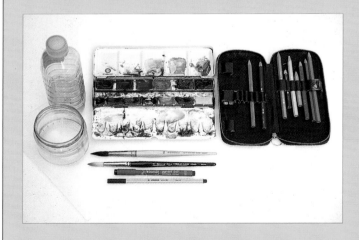

WHAT THE ARTIST USES

For preliminary sketches: Waterproof ink Stead tier 0.8 and Stabilo 0.4 felt pens

WATERCOLORS

I use my small field sketching set which is perfect for small sketches.

BRUSHES

I prefer two brushes — a round squirrel hair Da Vinci Petit Gris # 14 which holds large amounts of water and is especially suited for foliage and larger areas.

For tree-trunks and branches and for adding more defined shapes I use a Taklon round # 12. It is made of nylon and therefore both stiff and flexible.

Finally I take a small plastic bottle and can for the water, a few rags or soft kitchen paper, and my kit is complete! Not a heavy load for going outside, I can assure you.

The fact is you only need to kick off and get rid of that white paper to show it you're the master!

The key is SELF CONFIDENCE. It means knowing that you're doing the right thing when you make that first line. Confidence is something I have learned to appreciate over the years and it is so important because it sets the mood for the rest of the painting.

Working outdoors forces you to condense the scene

One of the best things you can do is go outside. Why? Because in your studio, everything is quiet, light is constant, you're not disturbed by wind, the sun disappearing and reappearing again, or raindrops, or the all too curious passersby. In essence, you are focused and ready to create that promising watercolor. Once outside, that all appears to be impossible: all those natural elements come up and FORCE you to condense everything. You make an elementary sketch that contains just the essential information. And the laughing paper? Well, instead of precious art paper I use a cheap, thin 190 gsm paper with a smooth surface. You'll find this in artist material stores.

Using sketchbooks

The advantage of a sketchbook is that the representation of your sketches is compact and easy to refer to. The cheaper paper invites you to consider the whole drawing action as a practicing exercise instead of the "must-be-a-masterpiece" attitude of the studio! It doesn't matter if that first line is totally wrong. On the contrary, I know those try out lines are vivid, they show courage and contain a lot of movement.

MAKING A SIMPLE SKETCH

To make a simple sketch I use black pencils of different hardness, mostly I prefer a 4B, 2B and a HB because using three different hardnesses gives depth to your drawing: The softer 4B pencil gives an attractive clear line and emphasizes foreground subjects. The 2B can be used for middle plane lines and the hardest pencil HB makes a hazy "distant" impression. Don't be misled by the terms "hard" and "soft"! A soft pencil leaves more graphite on your paper and therefore gives a deeper tone. A hard pencil is more difficult to draw with and leaves softer strokes.

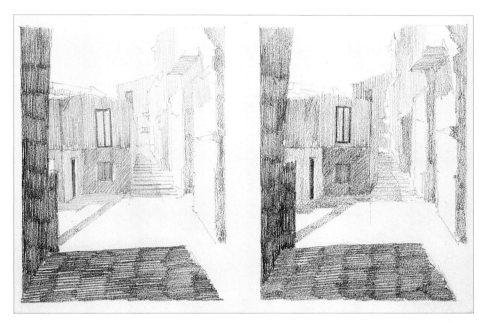

THREE DIFFERENT GRADES OF PENCIL

You can see how the hardness of different leads creates an interesting pattern on the drawing which could not be accomplished with one pencil hardness alone:

On the left side three different hardnesses were used : HB, 2B and 4B. There's depth in the drawing because distant structures are softer (HB), closer buildings are deeper (2B) and the front shadow is really strong because of the use of a 4B pencil.

On the right hand side the whole drawing was made with a 4B resulting in an undefined sketch without much character.

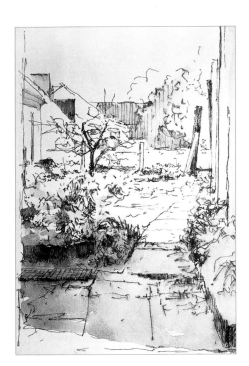

WATERSOLUBLE FELT PENS

A very graphic looking drawing can be achieved with a felt pen. However, because many pens are watersoluble you can very easily make a watercolor-like drawing by washing the drawing with a damp brush.

This is a good option when you don't want to carry all your watercolor stuff along! A bit of water and a good brush give depth to a sketch. But be careful when "washing" your drawing. DON'T USE TOO MUCH WATER because the drawing will keep dissolving and turn the sketch into unrecognizable mud.

WATERPROOF FELT PENS

A waterproof pen will preserve the original character of the sketch when washed with watercolor later on.

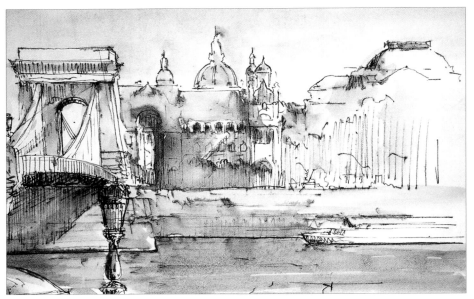

PEN AND WATERCOLOR WASH

In this pen and wash image you will find my beloved River Leie, which meanders through the landscape of Deinze, Belgium.

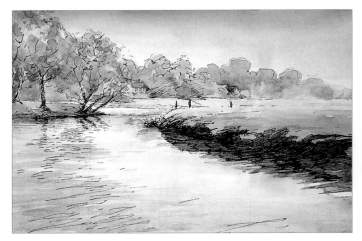

INITIAL PEN SKETCH

First I made a raw but intrinsically correct sketch with a waterproof felt pen. Felt pens are available in different thicknesses ranging from 0.1 to 1.2. I prefer the 0.4 and the 0.8 size for the same reason I explained with the black pencils — their different thicknesses can provide depth in your landscape when combined with each other.

WASH OVER PEN SKETCH

Then I applied a simple wash of basic watercolor over it, resulting in a vivid, vital full sketch.

"SOFT GRASS", BELGIUM 2002, WATERCOLOR, 13¾ x 20¾" (35 x 53cm)

COWS MAKE GOOD MODELS

In this sketch the head of the cow was emphasized by a darker spot achieved by the combination of dense pen strokes with violet colored pencil. Notice the use of fuzzy oriented colored pencil strokes for suggesting the grass. Another cow was left uncolored.

PEN AND COLORED PENCIL

The loose structure of the drawing stays attractive even if more lines indicate a search for the right proportions.

WHAT IS A SKETCH?

First of all, a sketch should be a first contact between you and the subject. It gives you an idea whether your subject can be represented just as you saw and felt it when looking at it for the first time.

Basically I use three different approaches to drawing:

1. *Contour drawing.*
2. *Full stroke method.*
3. *Shape indicating lines.*

However, not one of these methods is used in its pure form.

WHEN I LOOK AT MY SKETCHES I NOTICE HOW I CONSTANTLY RETURN TO MIXING THESE THREE WAYS OF DRAWING TOGETHER. SOMETIMES I MAKE A FULL CONTOUR ANALYSIS OF THE SUBJECT AND IT REMAINS PURE, BUT IN THE END, A BALANCED SKETCH IS ALWAYS A SENSITIVE MIXTURE OF THOSE THREE ELEMENTS.

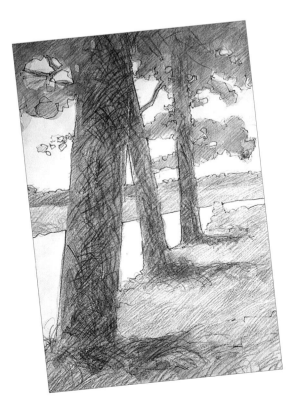

PEN AND SOFT PENCIL

Combinations of these three techniques are possible and even necessary for obtaining the desired result. I use them constantly in the dry method with colored pencils, creating a darker surface by using a complementary color which is placed on top of the first one but at a different angle.

1 CONTOUR DRAWING

Contour drawing is a quick, one line way of representing your subject. Pablo Picasso and Egon Schiele used it for their nude studies. Morandi used it for his still lifes and landscapes. Contour drawing is not easy and requires lots of exercise but is a sure way of representing the subject since every part is involved. It forces you to divide your subject in enlightened parts and shadowed parts which is a preliminary way of looking at basic color values. In an advanced sketch, those shadowed parts could be put down with a glow of French Ultra. This makes a nice contrast with the enlightened parts that could be represented by another color. This method gives immediate volume to your sketch. A fairly good example of it can be found in the drawing below.

CONTOUR DRAWING

In this example I marked the shadowed parts of the church by contouring them with one line. That line is closed since each shadowed part of the church has its obvious borders. Different shadowed parts may be separated from each other but the result should resemble the architecture of the church as a whole.

2 THE FULL STROKE METHOD

The second way of sketching is very classical and Morandi exploited it in order to achieve a different tonal value plan for his etching prints. Giorgio Morandi, an early 20th century Italian artist, used the full stroke method and developed it in a very strict, almost geometrical way. Basically it consists of putting parallel strokes beside each other, creating a darker surface than the white paper. When the strokes are repeated over the same surface but with a different angle, then an even darker pattern appears and this can be repeated until an almost black surface is obtained as in the example below. In this way, different grayscales can be obtained and that's exactly what creates depth in your drawing!

3 SHAPE DRAWING

The third way of abstracting reality is shape drawing using a discontinuous line which surrounds those shapes. It's a bit like the first method, contour drawing, but not so explicitly applied and therefore easier to handle. Less pure, of course, since you do not force yourself to discover the black and white patterns of the subject.

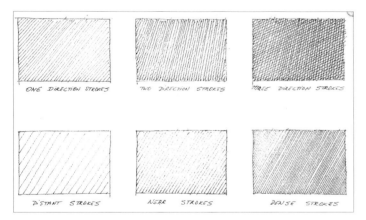

THE FULL STROKE METHOD

SHAPE DRAWING

A part of the Antwerp Cathedral is represented here and I drew a continuous line for as far as I could. Although I did not follow exactly the contour of the roof tops, a clear impression exists of a gothic church roof since all the elements are there. You don't want to emphasize all the details, it is more like a scan of the church's silhouette. Here a combination of black pencils was used.

This explanation may seem complicated, but I can assure you that once you've tried these three different drawing methods, you will be convinced they are a very quick and complementary way of capturing impressions. Quick, because circumstances urge you to move on, and complementary because if one method doesn't suit the subject matter there's always another that will.

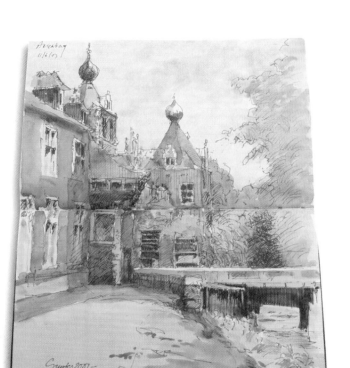

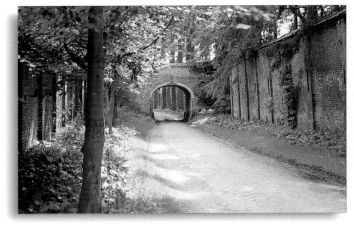

THE SCENE

The essence of pen and watercolor drawing is to build a solid sketch into a vibrant color painting that you can use as the basis for a larger studio painting.

In this case I was commissioned by a farmer to paint the old gate in the grounds of the castle which leads to an open field

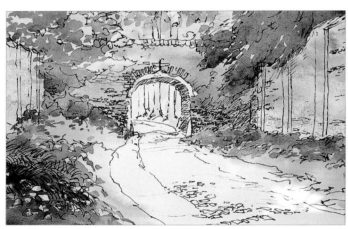

INTENSIFYING THE COLOR

When the painting was dry, I applied more concentrated greens for the foliage (a mixture of French Ultramarine and Hookers Green).

WHEN BUYING PENS MAKE SURE YOU KNOW WHETHER THEY USE WATERPROOF OR WATERSOLUBLE INK!

OLOR OF THE OLD CASTLE GATE

MY WATERPROOF PEN SKETCH

At first, I made a fairly simple sketch with a waterproof felt pen.

MY FIRST WASH

Then, a wet-in-wet wash was applied using Raw Sienna, Burnt Sienna, Hookers Green and Cadmium Yellow.

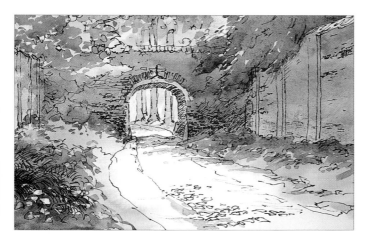

INSERTING THE SHADOWS

The shadows on the brick walls and the foreground came next. I used a wash of Alizarin Crimson and French Ultramarine. Notice how the mood appeared as soon as I added the shadows!

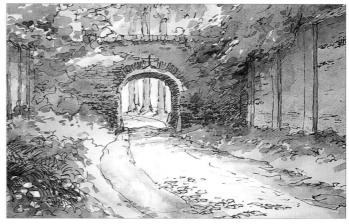

ENHANCING THE FOREGROUND

To finish, I applied a warm touch of Burnt Sienna to give depth to the bricks and the foreground.

CONCLUSION

Have I given you enough ideas and techniques to start with? The important thing to remember is that no matter how much talent you have, building self-confidence is a question of regular, systematic analysis of the images of the world surrounding you. If you continue like that and believe in what you're doing, your technique will evolve so it becomes a part of you, a

powerful tool for representing what you feel. Always remember that what the eye sees is not what your brain tells your hand to draw. In between there's a whole process of interpreting, influenced by your education, background and daily life experiences. Therefore, the end result is the signature of your soul!

OVERCOMING THE FEAR OF MAKING MISTAKES

Give yourself permission to be less than perfect! Your sketchbook, proclaims Daniel Izzard, is the ideal place to fumble along and make mistakes in the process of mastering the art of drawing.

Drawing is the most important element of fine art. A "practiced eye" can only be acquired through constant drawing, by which our eyes and brains learn to work together to instinctively observe relationships of form, make visual measurements and put them on paper without conscious thought. Drawing is a discipline that reveals itself in the brushwork of our gallery paintings, giving them a spontaneity and directness vital for any work.

We only have to look at the Old Masters with their variety of styles, all different in execution, all wonderfully direct, positive and highly spontaneous, to see the value of masterful drawing. Michelangelo, da Vinci, Dürer, Raphael, Titian, Pieter Bruegel, Rubens, Murillo and — my favorites — Van Dyke and Rembrandt are all highly revered today because their works convey emotion, movement, nature and beauty through superb draftsmanship.

Yet, it is surprising to learn that in their day, drawing was taken for granted. Pen-and-ink drawings were considered to be little more than concept sketches or working drawings, most of which never survived because they were not valued and saved. This is an important note, as it was probably the disregard for ink drawings as works of art in their own right that freed the authors from the constraints imposed by the high academic standards of the day. The act of drawing in ink gave their prodigious talents free reign to soar and express themselves joyously.

Like the Old Masters, we can benefit from adopting this same attitude — seeing sketching as merely one stepping stone on our path to mastery in art. Too ⟶

ART IN THE MAKING *"WORK ON ANA LUIS"*

Sesimbra, Portugal, is a fishing port with a large concrete ramp where boats of all sizes are hauled out for service. The harbor is jam-packed with craft of every color and size with the most imaginative combinations and designs. This was a great find.

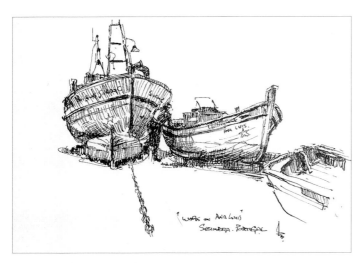

LAYING THE FOUNDATION
Making direct lines with my fountain pen and sepia ink, I established the main boats. I then added some detail, and used hatching and scribbling to shade the boats.

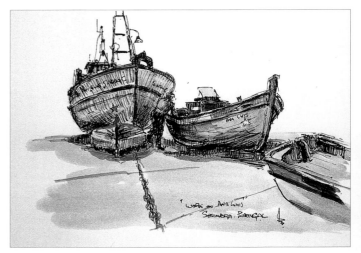

CAPTURING COLOR
Due to the bright, lively decoration of the boats, I decided to record their colors with a watercolor wash treatment.

WHAT THE ARTIST USES

Pen and ink drawing is a very convenient form of expression, and the required paraphernalia is small, highly portable and inexpensive. If I have to walk any distance, I limit myself to just three items:

Sketchbooks I carry two pads of drawing paper, an 8½ x 11" and an 11 x 14", both acid free and of 110lb weight; I prefer a smooth, velvety finish that allows the pen to glide easily and readily accepts watercolor, even oil paint for the occasional color notes; I prefer coil binding with micro perforations for clean tear-outs; these pads must have a very stiff back to facilitate hand-held drawing.

Ink and Pens I use a sepia-colored, lightfast, non-waterproof calligraphy ink for both dip and fountain pens; I use both, but I do prefer my fountain pen that is designed specifically for drawing and includes a converter refillable cartridge, which allows me to draw for hours unencumbered; this simplifies the process and obviates all manner of problems that can and do occur with an open bottle of ink.

A three-legged folding stool, made of oak with a heavy leather seat.

When I drive, I add the following items to my portable studio:

- A folding easel, which contains a full oil-painting kit and panels
- A small container of clean water
- Watercolors — my kit contains a small metal box with cradles for 18 tubes of paint, a section for three brushes and a lid which slides out to open to a palette, complete with a thumb hole and depressions for preparation of washes
- A small sable brush
- A collapsible chair

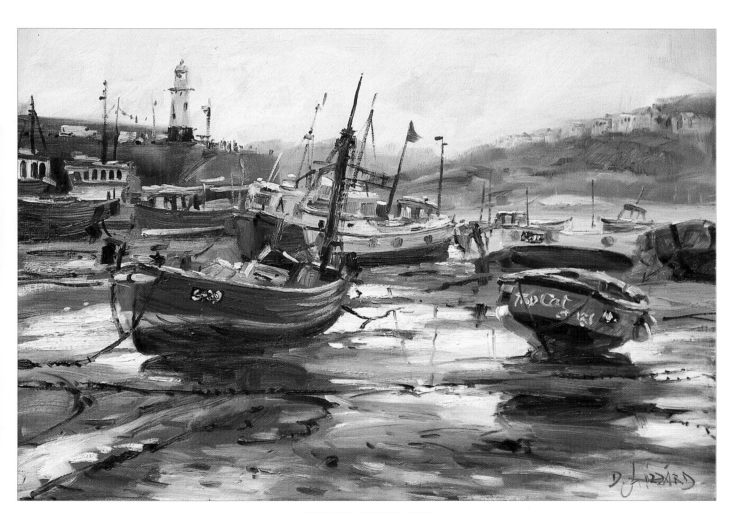

USING THE INFORMATION
Later, this sketch from Portugal contributed to a painting of St Ives, England!
It's called **"Low Water, St Ives, Cornwall"** *(oil, 24 x 36" or 61 x 92cm).*

ART IN THE MAKING *"SESIMBRA, PORTUGAL"*

This sunset scene is of backlit boats bobbing at anchor in line astern on a golden river with the brilliance of the setting sun right down the middle.

POSITIONING MY SUBJECT
I began by locating the general shape of the boat closest to the foreground with a few direct lines to establish the scale for what was to follow.

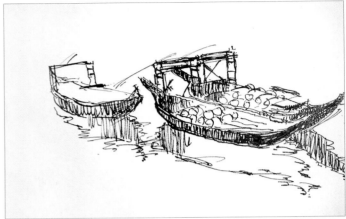

ADDING TO THE IMAGE
After putting in a little more detail on the first boat, I added the next boat in line. I indicated the reflections of the boats by drawing their shapes while suggesting movement in the water, and then included some vertical shading.

often we think our sketches must be perfect, and knowing we don't have that level of skill, we forego drawing altogether. We're intimidated by putting pen to white paper because we're fearful of the medium's permanent, non-erasable nature. Instead, we must remember that the purpose of sketching is not to create a masterpiece (although if that happens, we have reached a new plateau) but is rather a means to improving our skills. When we stop worrying about making mistakes, we will set ourselves free to soar as well.

Drawing with ease
When I sit down to do a pen-and-ink or pen-and-wash drawing, I typically go directly to working in pen loaded with sepia ink. There's nothing wrong with doing a light pencil drawing to lay out the image first, but I prefer to start right in with a permanent ink line. I know that any errors I may make along the way can always be modified. ➡

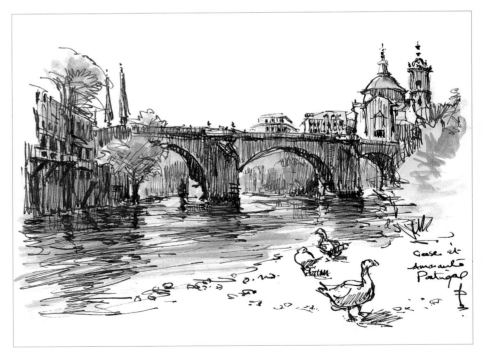

"AMARANTE, PORTUGAL #3", 8½ x 11" (21 x 28cm)

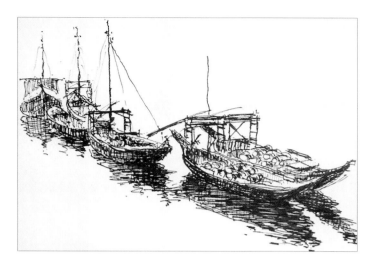

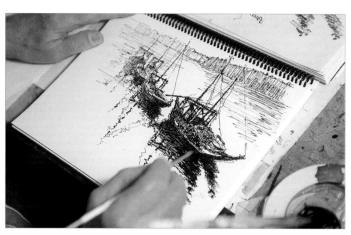

GETTING INTO DETAIL

Here, I progressed to drawing the complete line of boats and their reflections, including some details of masts and rigging.

ENHANCING THE DRAWING

To complete the drawing, I added the distant shore, some horizontal scribbling to suggest the river, the balance of the rigging and its reflections. As you can see, I then used my sable brush with clean water to dilute areas of pen work, creating a sepia wash to enhance the modeling.

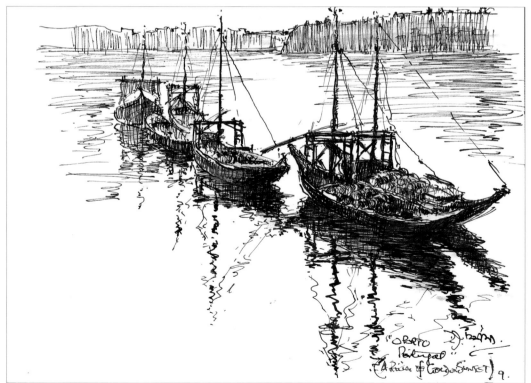

CONSIDERING FURTHER WORK

*I contemplated whether I should add a watercolor wash to indicate the overall golden hue of **"Sesimbra, Portugal"** (pen-and-wash, 8½ x 11" or 21 x 28cm). But since it was already burnt into my mind's eye, I decided I didn't need a reference to paint it. I may change my mind later.*

TURNING POINTS

In my early years as an artist, I met two established artists who greatly influenced me. The first was a very talented elderly Italian painter in Messina, Italy, whom I met while serving in World War II. I spent a lot of time in his studio in Sicily. His particular specialty was drawing in the classic Old Master sense, in the style of da Vinci. I met the second artist, Frank Berrisford of England, after the war when we both happened to be painting the battleship HMS Vanguard on which I was serving. While it was at dockside in Portsmouth, he gave me an autographed reproduction of his painting of the Royal Family on horseback. I still have it in my studio. I learned a lot from both men by just watching them work.

Besides, I'm simply not too concerned with being perfect in my sketches, although I love it when they are.

I prefer to start by drawing the center of most interest. For a portrait, this would be the eyes, but any object in a still life, landscape or other subject can be used as a starting point. From there, I put in the rest of the obvious, dominant shapes, using my initial object or area as the standard by which I visually judge and place the other elements. Almost always, I find I need to make revisions by drawing over or near these general outlines, but these corrections tend to impart a feeling of airiness and movement, which I think is a plus.

Next, I begin to include shading strokes to indicate the shape, type of construction and volume of each given object. For example, I like to use a series of diagonal, parallel lines to model or shade some of the forms, or series of curved strokes to show volume in rounded objects. I find vertical lines useful for showing the direction of light and to suggest the illusion of distance and atmosphere, while horizontal strokes are excellent for cast shadows. Finally, I like to do

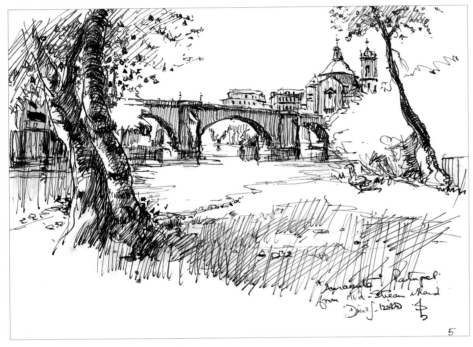

"AMARANTE, PORTUGAL #4", 8 1/2 x 11" (21 x 28cm)

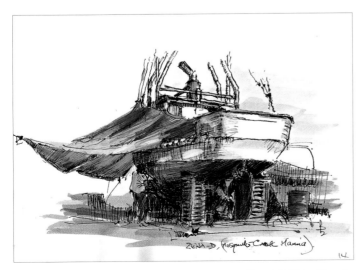

"THE ZENA-D, MOSQUITO CREEK MARINA", 8 1/2 x 11" (21 x 28cm)

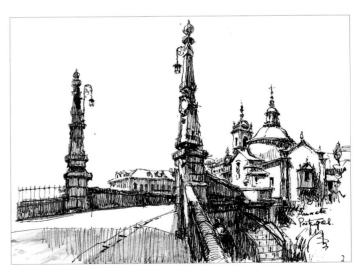

"AMARANTE, PORTUGAL #2", 8 1/2 x 11" (21 x 28cm)

what I call "scribbling", and that is exactly what it is. It is a very quick way to add some weight or dark contrast to a drawing. Incidentally, this is easy to do with a fountain pen but less so with a dip-type pen.

My pen work gets very bold and spontaneous as I develop and complete a picture. In the course of giving my creative impulses free reign, I sometimes get a little heavy-handed. But I simply remind myself to have fun and move on. I draw and re-draw the emerging image until I get it to my satisfaction.

Building on the drawing

In lieu of applying a full-color watercolor wash, I often prefer to enhance the drawing with lighter tones of the same sepia ink. To do this, I use a sable brush to apply clean water directly to the drawing. The water dissolves some of the non-waterproof drawing ink so I can spread it around as I see fit. This has the added benefit of sometimes softening overly dark tones or eliminating stray lines. A clear water wash can be done at the time of the drawing or months later.

However, for very colorful subjects, I do enjoy adding watercolors to my drawings. I tend to use this medium in the same way I learnt to use it years ago as a beginning artist — stick with transparent colors, do not use heavier body colors and paint around the whites without using frisket or other masking techniques. I think of these rules as "old English principles", and I am too set in my ways to change now!

Mastering our craft

I believe that artists must draw from life in order for their art to bear some meaningful relationships to beauty, truth and

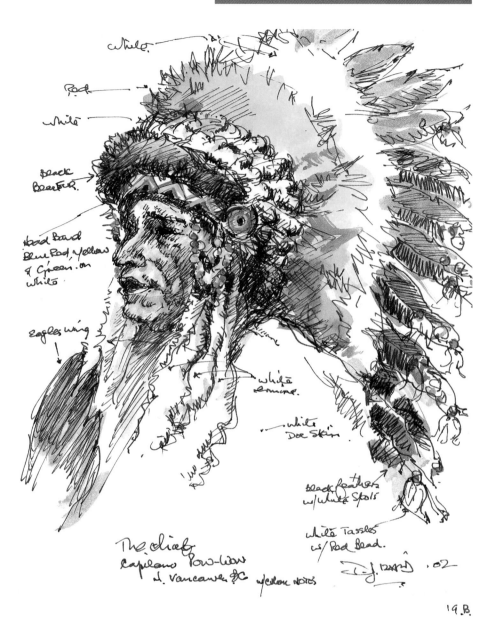

"THE CHIEF, CAPILANO POW-WOW, VANCOUVER", 11 x 8 1/2" (28 x 21cm)

nature. I also believe artists should strive to include something of themselves in their work. Each of us sees with different eyes, and we all perceive things differently. I am convinced that our unique interpretations of the world become clearer to our viewers through consummate draftsmanship. That, coupled with imagination, is the measure of an artist's competence. But there's only one way to learn to draw and that's to just do it — practice makes perfect. □

A FUN ALTERNATIVE

From time to time, I have also used oil paint to add color notes over my ink drawings. This approach works perfectly for me as it can provide a very pleasing drybrush effect as the paper soaks up the oil.

GIVING YOURSELF A BOOST OF CONFIDENCE

A fresh, spontaneous look is largely a result of the artist's confidence. If you want this quality in your paintings, says J Richard Plincke, work out your compositions in preliminary sketches so you can paint with certainty.

There is a lightness and vivacity in the act of sketching, a spring in the step perhaps. Why is there not more of this particular activity among artists? At the very least, it is an enjoyable activity.

The process does not need overmuch equipment: a soft pencil or two, a mixing tray with water and a brush or two are sufficient for putting a wide range of ideas onto paper. One needs only to add a lightweight seat, a warm jacket for comfort, a sunhat and a lunch pack to avoid going home earlier than intended.

Artists can sketch just about anywhere, varying from remote countryside to crowded beaches or cafés. And it can be private or sociable as preferred. More often than not, it is both.

Sketching gives you a chance to develop ideas, a view, atmosphere or even feelings on paper — a form of communication. Yet, in recent times the process has been much neglected. Schools, for example, tend to concentrate on conceptual art rather than two-dimensional painting. Preliminary workings and black-and-white images have declined. Artists now often launch straight into their final paintings. That surely breaks a tradition that has been running for centuries,

(Continued on page 107)

ART IN THE MAKING "CARTERET"

Carteret is a charming small-scale port on the west coast of the Cherbourg Peninsula. It also proved a good example of the use of sketches in paving the way for a final larger painting.

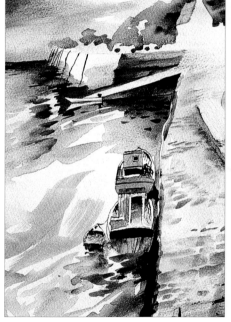

2 ADVANCING THE SCHEME
I continued to fill in the larger shapes while advancing the main thrust of the overall scheme. I kept a close watch on the values and textures within my subject as I went.

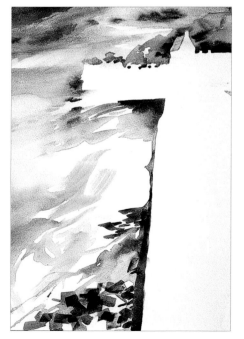

1 DIVING IN
Taking no more than a few moments to do a sketch, I was able to establish the main features in pencil. I then moved on to a more considered working in ink and wash. Using several wide brushes and India ink, I gave some careful attention to the watery elements of the composition.

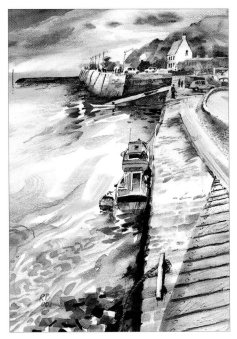

3 DETAILING THE IMAGE

Finally, I added a few
details with both a small
brush and a pen, though
not so many as to make
the composition too tight.

4 LAUNCHING INTO THE FINAL

The process of working out the
essentials of the composition
in the sketch proved especially
helpful in creating the final
painting, for it clarified the
lines of emphasis in relation to
cottage and headland, as well
as numerous other points. The
preliminary sketch revealed
plenty of possibilities when
addressing the final painting
called *"Cliffscape"*, and I was
thus able to launch straight
into full and lively color. By
this time, the subject was so
well known as to be virtually
automatic, so I had no
difficulties to encounter
nor any problems to resolve.

"CLIFFSCAPE"

ART IN THE MAKING *"JERSEY CLIFFS"*

We were in Jersey — one of the Channel Islands — on a hot, torrid day. As I drove out past Bonne Nuit Bay and round the coast road, I stopped at a favorable vantage point.

NOTING DRAMA

Coastal rocks and tidal surge far below the cliffs receded dramatically to the horizon — an excellent subject.

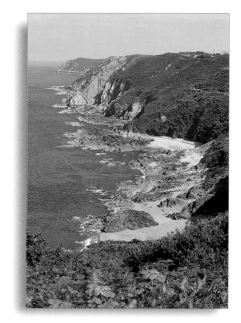

EXPLORING WITH INK

I set up my gear and made an initial exploratory sweep in rough pen-and-wash technique on inferior paper to test the possibilities. This was merely a trial run, useful for examining the evidence, as it were, and establishing what went where.

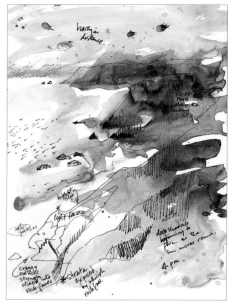

WORKING QUICKLY

As a matter of luck rather than forethought, I had stretched a sheet of paper of excellent quality over a proprietary board. The 12 x 10" (31 x 26cm) size was very handy for sketching within the short time I had. Rapidly and with a wide brush, I applied a light wash over the general area of the sea, linking in with an even more rapid treatment of the sky, ensuring that both washes molded into each other at the horizon to achieve a hazy effect. A good opportunity here to lay in a few patches to suggest the various shades below the surface of the water coming from large areas of seaweed interspersed with submerged rocks. This wet-in-wet application created suffused edges rather than hard edges better reserved for objects above water level. This pass needed to dry before I could apply darker washes for the land masses, but the afternoon heat quickly saw to that.

MAKING A MESS

On went the cliffs and higher areas clothed in bracken in two or three washes applied consecutively. I allowed only partial drying between each wash so that a few craggy edges began to appear. (At this point, technique is all and application onto paper is at best instinctive.) I knew then that the work as a whole was beginning to take shape. But was it falling into place? No. I realized it was showing signs of looking messy — less promising, frankly.

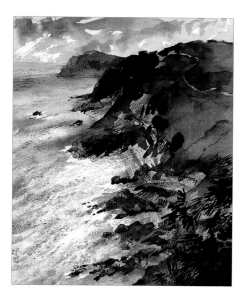

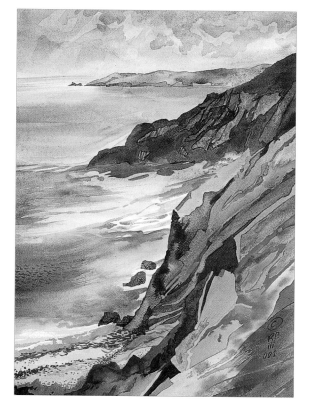

IMAGINING THE FUTURE

No final painting has as yet resulted from this sketch, but an earlier, similar effort along the same coast — *"Jersey Cliffscape"* (16 x 12" or 41 x 31cm) — gave rise to the kind of painting that I would have in mind were I to take the newer sketch to its next logical stage.

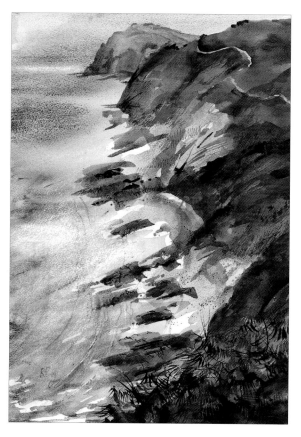

CLARIFYING MY INTENT

Despite all the work, the sketch was not as dramatic in its tonal values as I would have liked. After returning to the studio, I set about transposing the general intent of the scene onto a new surface, choosing a more elongated format (20 x 14" or 51 x 36cm) but using the same techniques. This time round the composition more readily fell into place, both with massing and with tonal variations. This drawing demonstrates greater clarity of thought and vision, as well as more intuition and confidence, than that first attempt. It has been set aside for now, perhaps to be interpreted in color at a later date. Will that final painting become a masterpiece? Who knows?

SAVING THE DAY

Still unhappy with my efforts, I decided it was worth one more attempt to save the day. Due to the high quality of the paper, I was able to scratch off part of the inked surface to show highlights such as the surf around the outer rocks and white reflections for wave tops.

ART IN THE MAKING
THE BELFRY

I remember being on holiday with my parents in early teenage days, at some hotel in Lynton, North Devon. The church nearby was full of interest. The ladder up the interior tower wall showed promise, up two storeys and with intervening trapdoors. Once inside the belfry, what a visual feast met my eyes — bells, pulleys, wheels, all set up within a complex bell frame, ropes everywhere.

Having a sketchbook with me, I fell to sketching the bell frame and its contents, spiders' webs, ropes, rafters, and all else before me. But I had not bargained for the church clock so suddenly striking noon, so desperately loud! Pigeons fluttered away and dust drifted down off the beams. I became slightly nervous of the whole business, scampered off back down the ladder and eventually finished the sketch later on in the holiday. And yet, the fascination for such subjects has never left me.

This explains why I was delighted to comply with a local parish's request to do a series of paintings of their structure. The following demonstration is just one in a long string of different aspects of this subject. The belfry is an undeniably complex subject with quite demanding perspective, especially in regards to the bells and bell-wheels. It is exactly the type of subject that is much better worked out in a preliminary pen-and-wash sketch before attempting a full-color painting.

WHAT THE ARTIST USES

The following is a list of the readily available materials I have used on all of the pieces you see here.

Pens
1. Disposable "Pilot" SW/DR disposable ink pens, light and water-resistant
2. Rotring Rapidoliner, .50 size preferred
3. Pentel fine ball-point, which I use only for general sketching when time is short.

Inks Rotring India Ink is useful for its versatility, although it can partly wash out and tends to stain so it needs to be used with restraint. A tube of artist's quality Ivory Black watercolor is an excellent alternative as it washes out more readily. To achieve a textured or granulated result with the watercolor, it can be useful to mix in a little Winsor and Newton Granulation medium.

Brushes I use ¹/₂", 1" and 2" flat, synthetic sable brushes.

Paper For use with an ink or watercolor wash, I use primarily Saunders Waterford paper, "not" grade, produced by a handmade process at St Cuthbert's Mill in the UK, as well as Daler-Rowney's Bockingford 140lb not paper, available in 14 x 10" sketch pads. As these papers are somewhat less absorbent, they are more easily "washed" than others. There are all manner of other sketchbooks suitable for pencil sketching.

Pencils I tend to prefer soft-leaded graphite pencils, 6B to 8B. Almost any quality brand of pencil is acceptable, although I normally use a Rexel Cumberland "Derwent" Graphic.

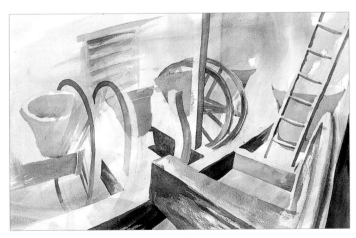

STAYING LOOSE
I began by sketching in approximate outlines to position the main elements — a matter of moments. I purposely slightly curved the pictorial plane to suggest the confined space of the belfry. Immediately, I followed up with a light wash, intuitively applied to keep the composition loose and flexible. Note that I needed a bold treatment to express the outline of the main framework.

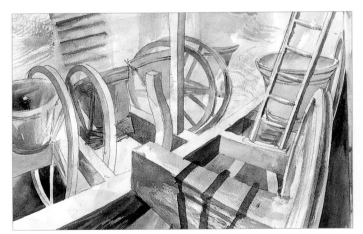

CREATING PATTERN AND ATMOSPHERE
Time for decisions: Was the painting to be devoted to pattern or atmosphere? Probably both. I applied another rapid wash — vigorously wiping here and there with a paper tissue while still wet — to place the main composition and map in the forms more positively.

(Continued from page 102) including the great days of the Renaissance. An artist can paint far more spontaneously if he or she has sketched out alternatives beforehand. With the greater certainty of application and deft touches of a confident approach, finished work can positively sparkle in its freshness.

Pen-and-ink drawings, with or without a wash — the process of sketching, whether a means of planning and setting out one's eventual paintings or merely a form of relaxation, offers up so many possibilities for exploration, of thought evolving before your very eyes. How inspired that can be; lively and inventive.

A good sketching technique searches for new images, varies the work as it takes shape, altering and adjusting outlines to suit those changes as they occur.

Sketching explores possibilities, and maybe full circle is reached when the results express most fully what attracted one's attention in the first place.

As can be seen from the examples I have described, the

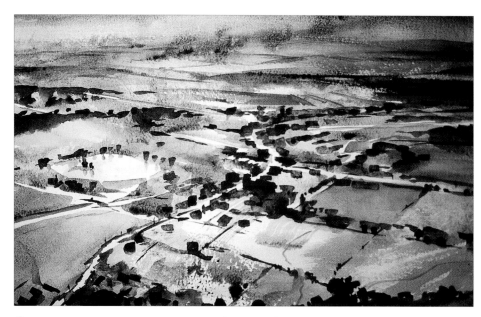

"THE VILLAGE OF ST MARYBOURNE", 8¹/₄ x 11³/₄" (20 x 30cm)

whole process for sketching can be an end in itself or it can be more than a transient phase, but the results are capable of inspiring a great diversity of effects.

For me, it serves more often than not as a means to an end, a stage in the evolution of visual thought and a setting down of ideas on paper which can, and often does, lead to finished work. The contents of my sketchbooks have proved a consistent source of inspiration for those eventual paintings and, indeed, many of them are returned to again and again, extending to several years. Such work is seldom wasted. Whatever else may be said of the nature of sketching, it is undoubtedly a self-educative process. One marshals one's thoughts.

STUDYING MY PROGRESS

With the massing complete, I added further pen-and-ink details and texture to identify and emphasize important features, such as framework and metal straps. After setting the work aside overnight so that I could get a fresh look at it, I decided stronger contrasts were needed. I applied a further wash to darken some areas.

ADDING TEXTURE

Finally, it was time for final touches. To add texture to the wall surfaces, I used a roller, scratched some areas with a razor blade and scrubbed the slightly damp surface with paper tissues. This provided some counterpoint to the sense of drama inherent in the depicted structures. One needs a sure touch in these late stages because, unlike other media such as oil or acrylic, these later features are not easily removed or altered.

ART IN THE MAKING *"ILE DE CALLOT"*

*I always carry a sketchbook with me on holiday, and often so at other times.
It is amazing how useful this has proved to be when selecting subjects for
paintings. The Ile de Callot was a case in point, and a whole series of work
has emanated from the original brief sketches. This shows one example.*

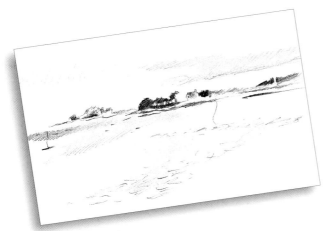

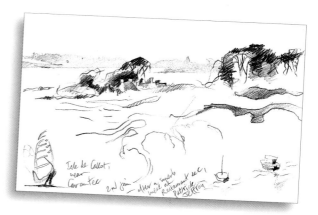

SEARCHING FOR THE ESSENCE
*The initial pencil sketch was very ordinary, no more than merely factual,
but the subject matter sparked off an idea. I followed it straight away with
a second pencil sketch, exploring patterns in a swiftly falling tide evident
in the far distance. It thus has the benefit of a more searching look.*

TRYING ONE POSSIBILITY
*About six months later perhaps, I put together
a competent, yet overly factual, watercolor
called **"Ile de Callot" (12 x 17" or 31 x 44cm)**.
But I could still see further potential.*

BENDING TO FIT
*Deciding to mine this new rich seam,
I explored the real interest of the
subject: the foreground. Once I had
decided to try curving the horizon as a
framework within which other ideas —
pattern, curvature and living form —
could be developed, the ink-and-wash
sketch very nearly evolved itself.
I seized opportunities to add greater
interest through the intuitive additions
of the occasional windsurfer, dinghy,
landing stage and other features.
Finally, scratching and chipping with a
razor blade, I sufficiently raised the
paper surface to suggest rippling
water with the sparkle of reflected sun.*

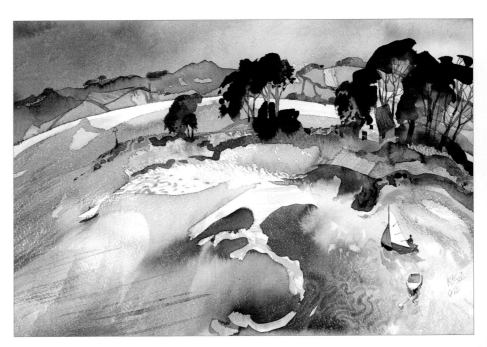

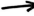

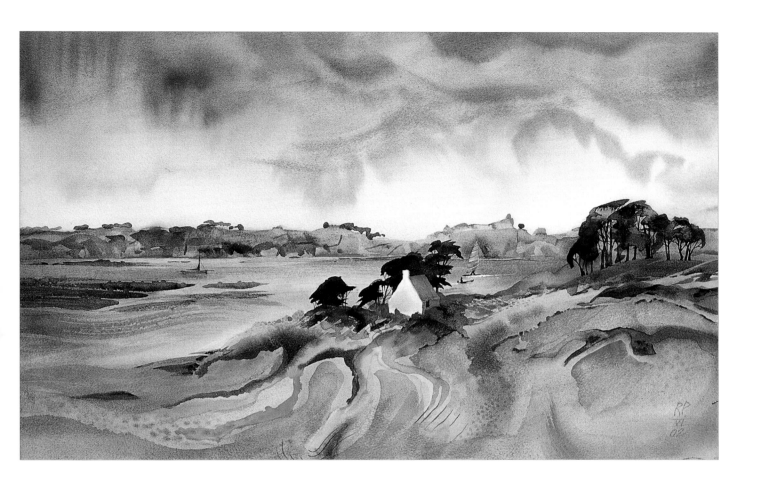

BRINGING IT TO A RICHER CONCLUSION

Having resolved the issues of pattern, curvature and living form in the sketch, I was able to easily complete a full-color version.

This is not quite the end of the run. More than a year later, I am still painting new versions based on this original theme, as there is still potential in that early pair of sketches.

THINKING OUTSIDE THE BOOK

Rather than work in a sketchbook, Judy Schroeder shows you how to use ink and watercolor wash on loose sheets of richly textured handmade paper.

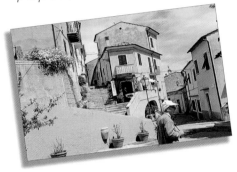

"POGGIO, ELBA ISLAND", INK AND WATERCOLOR, 12 x 9" (31 x 23cm)
Perched high on Elba Island, Poggio is a superb place for artists. I was interested in the narrow space between the two building shapes. The scene was so wonderful that there was little to adjust or change. We painted in comfort beneath a row of plane trees and had a spectacular view over olive orchards and vineyards to the marina in the distance.

Other than times with family and friends, I'm never happier than on location at the easel with a fresh sheet of watercolor paper on the board. There is such a feeling of possibility and excitement in the process. That easel, however, can present a problem on occasion. Sometimes there is not enough time to set up for a painting. And in some cultures, my easel and

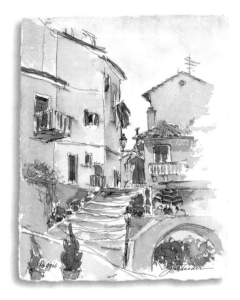

painting gear are like a beacon, attracting overwhelming crowds. Several years ago, I set up to paint in the city of Apia, in Western Samoa, and an eager audience suddenly surrounded me. I might as well have hoisted flags!

On the other hand, the camera is quick and efficient, enabling me to gather many images in a few minutes. But I find that photos never live up to the images I had in mind and include too much detail.

"Artistic snapshots" in ink and watercolor are a wonderful alternative. Working with these limited tools on location, even briefly, gives me a link to the place that photographs can augment but in no way replace. Tucked close against a wall in a busy walkway, at a table in an outdoor café or comfortable in the countryside, I find ink-and-watercolor sketching a splendid way to capture a moment.

Working on loose sheets
Perhaps what is unique to my approach is that when traveling,

WHAT THE ARTIST USES

In addition to a lightweight folding camp stool or chair with a sling for carrying and an umbrella with a c-clamp for sunny weather, I carry the following in a lightweight satchel with a shoulder strap:

Roller ball pens A wide enough tip and good ink flow are required to allow automatic drawing. If the pen tip is too small, the line is broken and not fluid. I prefer somewhat water-soluble inks that "melt" with water, at least a bit. The blended effect will occur more readily if the watercolor is applied immediately and the paper is not overly absorbent. My favorite (found at an office supply store) remains the Zeb-Roller 2000 medium

point. Others I like: Pilot G-2; Sakura Gelly Roll; Sanford Uni-ball Gel Impact; Zebra Sarasa; Zebra Jimnie Gel Rollerball; Uni-ball Vision.
Tip: Keep the pens in an airtight plastic bag as a precaution; high altitude causes them to leak.

Brushes I have a short-handled sable brush — a No. 10 — that has served me well because I take special care of the bristles. A toothbrush cover makes a handy protector as long as the brush isn't crammed in too far. The short handle makes it easier to fit in the carrying pouch.

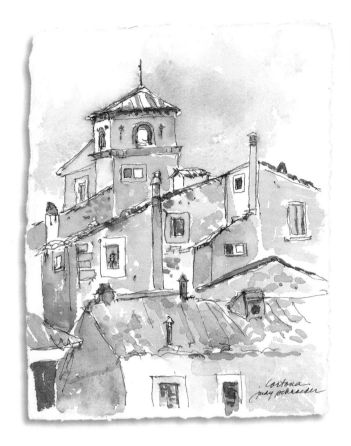

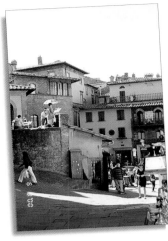

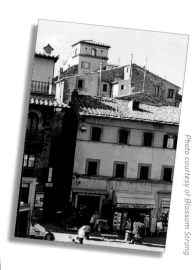

"CORTONA, ITALY", INK AND WATERCOLOR, 12 x 9" (31 x 23cm)
This is the first painting done in the method described in this chapter. I am so grateful that the painting was not going well. The only mistake in making mistakes is to ignore the opportunity to learn from them. In this initial sketch, I added watercolor in the sky before the rest of the ink was added. Now I think it's best to finish the ink drawing before putting on the watercolor paint.

I wanted to emphasize the tower, so that was the first part drawn. I shifted the color to show the planes and tried to suggest the many varied textures by surface treatment. Notice how a small fragment of the whole wall is sufficient for subject matter.

I carry small sheets of handmade watercolor paper in my sketchbook. These refreshingly textured papers soak up the ink and watercolor, lending a unique quality to the work. The way they suggest textures within the subject is an important part of the process. The size of the paper — I prefer 9 x 12" or 23 x 31cm — is ideal for intimate portraits of places as well as longer distance views. Plus, the beautiful deckled edge bordering all four sides of these small sheets adds a delightful finishing touch to my sketches.

When I'm ready to begin, I find a comfortable and appealing place to set up my folding chair, unless I find a ready-made seat at a café or someplace similar. At times →

Small watercolor kit *I prefer field painting kits that have a thumbhole or ring for holding, are made of a durable material and can be refilled as needed with fresh pans or tube colors. An attached water container is also handy. Many have brushes that are too small, which is why I carry extras.*

Small sheets of handmade watercolor paper *I prefer handmade papers that are very absorbent and will soak up the ink. I also look for papers that fit my size requirements. It is possible to cut down larger sheets but I like to frame them with the deckle edges showing. If you can't find any in your local art-supply store, finding sources on the Internet is easy. Just type "handmade paper" into a search engine and you will have plenty of options. A few suggestions:*

- *Khadi (India): 8.5 x 12", 150gsm, cream in color rough surface.*
- *Nujabi (India): 9 x 12", 400gsm, white, 4 deckles.*
- *Lama Li (India): 9 x 12" rough, 100lb., 4 deckle edges, comes in a book form but pages may be removed for framing.*
- *Moulin de Larroque (France): 9 x 13", 400gsm, white, beautiful edges.*
- *Punjab (India): 9 x 12", white, three weights, deckle edges.*
- *Twinrocker (USA): 10 x 14", 400gsm, white with decorative deckle edge.*

Sketchbook similar in size to the paper being used *I like to have a sketchbook with a fairly sturdy paper that has some tooth to it, making it suitable for working with ink, watercolor and pencil. A spiral binding has enough give to allow for the insertion of several handmade paper sheets of similar size. The deckled edges on the paper are beautiful, so having the sketchbook larger than the sheets helps to protect the loose paintings completely.*

- *Clips to hold paper to sketchbook*
- *Tissues*
- *Travel size sun block*
- *Portable eye-wetting solution for those times when I look so steadily that I don't blink often enough*
- *Flask of water*
- *Visor*

USING YOUR PENCIL OR PEN AS A MEASURING TOOL

Your drawing pencil/pen is a valuable tool when you are on location and need to determine accurate angles and measurements.

To measure relative lengths (such as the length of a roof compared to the wall height):
- *Hold your pencil/pen with four fingers and the thumb opposing. Close one eye and measure horizontally across the roof. Placing the eraser/tip at one end of the roof put your thumbnail on the other end of the roof. Holding that measurement, line up the pencil/pen vertically along the wall height.*
- *Compare the measurements. Which is longer? By how much?*
- *This comparison can be used with any number of measurements, including still life and figures.*

To determine the angles in a landscape:
- *Hold your pencil/pen as above. Close one eye. Line up the pencil with the angle of a road, roof receding, etc.*
- *Keeping your elbow stationary, bring your hand down to the paper. Hold the pencil/pen in the angle, put your other thumb at one point of the angle and draw the line.*
- *Continue with the other lines. Remember that the walls of buildings are vertical unless, of course, you are in Bodie, California, or some other such old town.*

Drawing the landscape using approximated relationships rather than formal perspective results in a less rigid drawing.

SPOTTING A GOOD LINE
Street scenes offer lots of material for ink-and-watercolor work. I chose this site due to the interesting rooflines and abundance of signage. Since those shapes were the focus, I eliminated the cars.

I take another look at the watercolors at the end of the day or later at the studio and judge the results based on painting requirements.

Developing my technique
This particular approach is somewhat new for me, although I have been doing a combination of ink and watercolor since high school. My current method came to me while on a workshop in Cortona, Italy. I had begun a half-sheet painting and was unhappy with its progress. With limited time left and being unwilling to leave without getting something from this wonderful hill town, I took out the small Indian Punjab paper I had brought along in the sketchbook. Beginning the drawing with a rollerball pen, I added watercolor as the sketch progressed.

The results of that first attempt pleased me so I continued the practice for the remainder of the trip. Small images were gathered along with larger paintings, and I came home with an abundance of reference material tucked into my

I do thumbnails in a sketchbook in preparation. Then I place the sheet of handmade paper on my sketchbook, which acts as a board or support for the drawing. I secure the paper to the book with a clip since breezes have a way of playing havoc with my paper, especially when both hands are busy. I have forgotten the clip on occasion and have had to improvise by using the clip on the pen cap.

I begin the drawing by placing it on the page with composition in mind. By this, I mean I identify which element or quality in the subject caught my attention, and then put the first line of the drawing in a spot that will emphasize that element. The drawing grows from there, and I draw as quickly as possible with

ink pens of the roller ball variety, preferably somewhat water-soluble. I find I unconsciously edit the scene and freely rearrange other parts if necessary. I eliminate any extraneous things and distracting detail, meanwhile I "move" edges of objects to create more interesting shapes.

When the drawing is sufficient, I open my small watercolor set and fill my water container. I hold the set in one hand and the brush in the other and get to work, balancing the sketchbook/paper on my lap or the tabletop. Usually, I have time to complete the painting before leaving the location, but if I cannot get to the paint because of time constraints, I make notes on the reverse side of the paper to remind me of colors and more.

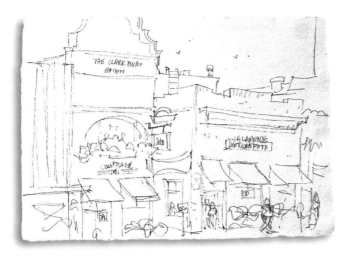

EMHASIZING SHAPES

In order to emphasize the negative sky shape created by the buildings, I drew the tallest building going off the page at both top and bottom.

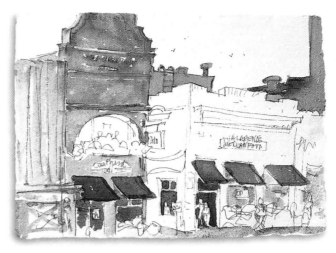

SHIFTING THE FOCAL POINT

I limited my first wash to blues and grays. Notice that I exchanged the values of the two buildings on the right in order to make the center building appear light. Without this shift, my area of emphasis would have fell on the far right.

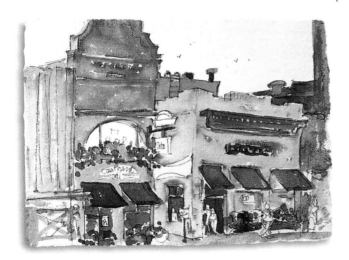

CONTRASTING WITH WARMS

Next, I put in a variety of warm colors throughout the entire image, exaggerating both the hues and the values somewhat to make the painting more lively.

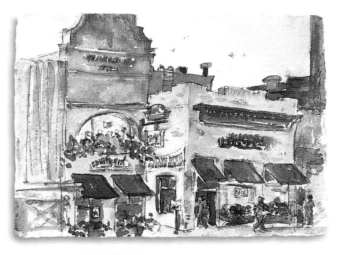

DOWNPLAYING THE EDGES

To complete the sketch, I strengthened the darks on the edges and in part of the sky. The "cloud" suggested by the remaining white shape makes the upper portion of ***"The Courtyard"*** *(9 x 12" or 23 x 31cm) more interesting.*

sketchbook and several paintings almost completed. I felt that a number of the small sketches were worthy of framing and selling, so I copied them on a color copier and added the copies to my sketchbook. That way, I could sell the originals while retaining the imagery as fodder for future work.

Many of my sketches have inspired future paintings, but I often use a different technique for the subsequent works. For example, I might wet the paper thoroughly and add moist paint to the paper without a preliminary drawing, or I might change the values, colors or edges to put the emphasis on a different part of the subject. The options are endless, and I learn so much by painting the same scene a variety of different ways. Then again, sometimes the sketches are simply a remembrance of the day, the colors and the feelings of the place . . . a distillation, if you will. My own little "espressos" in ink and watercolor.

Communicating with feeling

Catching a glimpse with ink and watercolor wash is a wonderful way to work. I find it a more →

BENEFITS TO NEW PAINTERS

I enjoy being part of an activity where age, background and experience take a back seat to the communal goal of good painting, which is why I share my love of art through teaching. I always include a lesson in ink-and-watercolor sketching in my classes. After teaching this technique to many students throughout the years, I've noticed several exciting benefits to beginners:

- It gets you going. The process is not complicated, and the minimal materials required are easy to carry. Ease makes the whole thing more inviting to do on a regular basis.
- It keeps you focused. By working quickly, you'll be more inclined to concentrate on big shapes and really, truly observe the environment.
- It makes you practice drawing. Starting with pen, not pencil, is a huge boost. Unable to second-guess yourself once the pen touches the paper, you'll keep drawing even though corrections need to be made along the way.
- It helps you get over perfectionism. When the watercolor is added, some of the drawing lines are blurred so "making it perfect" is no longer a concern.
- It encourages you to work outdoors. There is relative anonymity in this approach. With a chair or stool placed against a wall, you become somewhat invisible to passersby, removing the likelihood of over-the-shoulder viewers.
- It keeps you on task. Demanding that the work be completed in a defined time frame is a sure defense against procrastination.
- It builds confidence quickly. Many adult beginners come to painting later in life, after they are used to performing at a very high level as attorneys, architects, scientists, teachers and so on. With ink-and-watercolor sketching, you'll soon see wonderful results in this arena, too, inspiring you to keep at it.
- It reduces your stress level. It's the kind of fun that takes complete concentration. You can't worry about anything when you're so happily engaged in painting.
- It keeps you young by engaging the mind and body and teaching you to see the world differently. Perhaps we artists have found our own magic elixir. Ponce de Leon, that seeker of the fountain of youth, had it half right. All he had to do was add paint to his search for water!

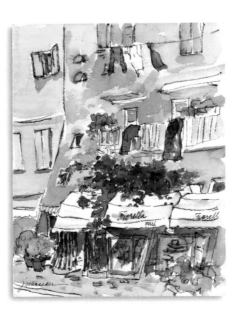

"SHOPS, ELBA", INK AND WATERCOLOR, 12 x 9" (31 x 23cm)

The port city of Portoferraio was chock full of painting opportunities, and the shop entrances were so different from those at home. By doing a small version first, I was able to "soak up" the color before going on to the larger, final version. The sketch helped me determine that I should leave the awnings white to set off the brilliant colored walls and bougainvillea vine. Although I prefer the deckled edge and texture of handmade papers, I sometimes use watercolor paper from a block or pad, as I did here.

emotional response than a detailed drawing or a painting that takes more time. Sketching is portable and quickly done, enabling me to finish several pieces during times of waiting, traveling with non-artists and situations demanding a quick solution. An unexpected benefit is that I have discovered a method that works well when I travel with my husband. I can't turn off the excitement and desire to work when we are together and he, understandably, does not want to tarry for a couple of hours while I paint. Taking short breaks during outings makes us both happy.

I find joy in doing these small paintings and that enjoyment is conveyed to the viewer. The reaction is often about the drawing, but more so about the feeling that is communicated. In the end, that day of disappointing painting in Cortona has turned out to be serendipity for me as an artist. □

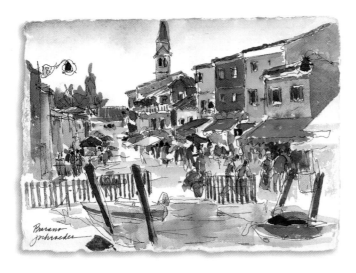

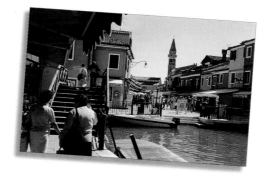

**"BURANO ISLAND, ITALY", INK AND WATERCOLOR,
9 x 12" (23 x 31CM)**

I had only a few hours on this enchanting island and had to choose how I would use my time. I took many photographs, and then while waiting for lunch, I got a quick drawing and about half of the watercolor completed. It was finished at home several weeks later when I attempted to replicate the pace I set during the first part. Wanting to do everything in a limited amount of time is a constant dilemma, so I've had to learn to be more realistic about what I can and want to accomplish in a short period.

"SCOTT STREET, SAN FRANCISCO, CALIFORNIA", INK AND WATERCOLOR, 9 x 12" (23 x 31cm)

I didn't take a photograph from the exact site of my drawing, preferring to gather other images. I often get so involved in the process that I forget to get a photo, even if I had planned to do so. After I got home, I looked at the work done at the site. I wanted the yellow building to be the focus so I brightened the color there and darkened the building on the left. Different versions of red were placed around the golden building for bright spots.

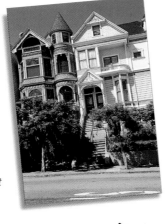

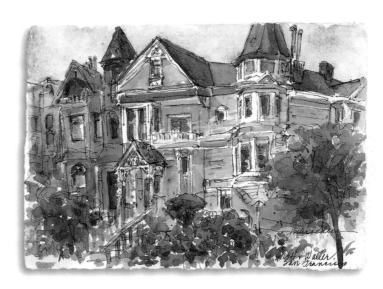

"COFFEE CORNER, ORANGE, CALIFORNIA", INK AND WATERCOLOR, 9 x 12" (23 x 31cm)

A popular gathering place for local residents is a coffeehouse located in the historic plaza district. The birds wait for handouts with hopeful anticipation. There is continual activity so whenever I want a figure shape to help guide the viewer's eye, I just wait a minute. Someone will accommodate me. On the other hand, I decided to eliminate all the cars coming and going, which meant I had to make up part of the foreground. Fortunately, no one ever questions my lack of accuracy.

**"OLD OAK, PASO ROBLES, CALIFORNIA",
INK AND WATERCOLOR, 9 x 12" (23 x 31cm)**

The Carnegie Library sits in the middle of a large, grassy square surrounded by majestic oak trees. I liked the dark tree in contrast to the lighter building, a contrast I heightened by using complementary colors of red and green. The tree's attitude of protection is quite symbolic — many cities have lost their Carnegie Library buildings to expansion plans.

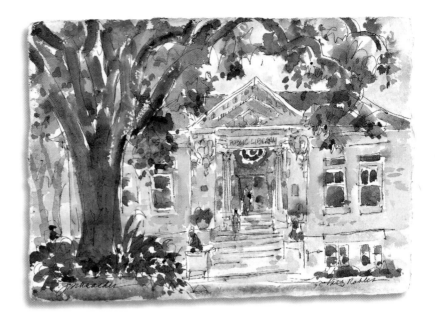

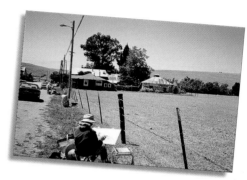

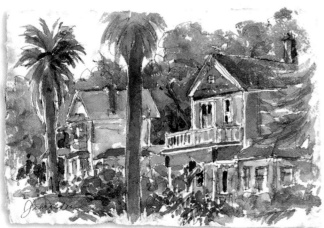

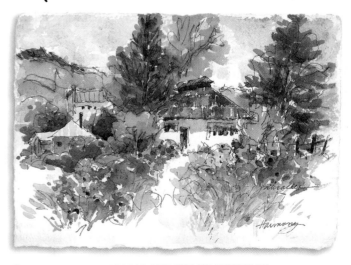

**"VINE STREET VICTORIANS, PASO ROBLES, CALIFORNIA",
INK AND WATERCOLOR, 9 x 12" (23 x 31cm)**

Because of the strong August sunshine, I attached a small umbrella to my chair. The resulting shade made working easier and more comfortable. Having the umbrella enables me to choose my spot without being concerned about dappled light or too much sun.

The two old homes were nicely set off by the dark foliage behind them, and the strong verticals of the palms made for an interesting subject. There is so much detail on this architecture but I chose to minimize it. I wanted to emphasize the close proximity of these venerable old homes rather than the trims and accents.

**"HARMONY, CALIFORNIA", INK AND WATERCOLOR,
9 x 12" (23 x 31cm)**

Located on California's Central Coast, tiny Harmony proudly announces its 18 residents and is a favorite spot for painters. While doing this small version, I noticed the quilt-like appearance of the tin roof on the large building. I was staying with my sister, a quilter, and thought about the sunflowers in her garden. The subsequent painting had the roof as quilt and happy sunflowers included. Sometimes I get ideas for the larger painting while working on the small ones.

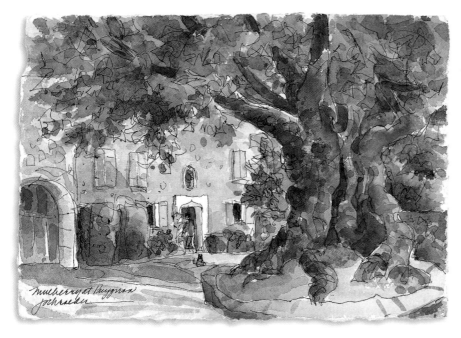

"MULBERRY TREE, PROVENCE", INK AND WATERCOLOR, 9 x 12" (23 x 31cm)

An ancient, gnarled mulberry tree shaded the tiny square in Puygiron. As often happens, someone came along at just the opportune time to serve as a model.

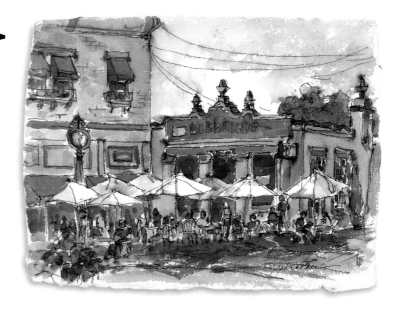

"COFFEE & CONVERSATION, ORANGE, CALIFORNIA", INK AND WATERCOLOR, 9 x 12" (23 x 31cm)

The rooftop shapes in the southwest quadrant of Orange's plaza square are a draw for artists. It is probably the most painted site in the city. A flock of green umbrellas provide shade for diners and make a nice horizontal, but I left them white as a contrast to the buildings.

IF I CANNOT GET TO THE PAINT BECAUSE OF TIME CONSTRAINTS, I MAKE NOTES ON THE REVERSE SIDE OF THE PAPER TO REMIND ME OF COLORS AND MORE.

THE SECRET TO REDUCING A BIG, COMPLICATED SUBJECT T[

Take a look at the watercolor below. How do you think it was painted? The answer is, it was dashed off in a cheap sketchbook, on ordinary cartridge paper, and was the product of a few minutes work. Pen and watercolor paintings like this are a great

confidence builder. Let me show you how to combine pen (or pencil) and watercolor in the simplest way ever. Let's call this method, "simplified" pen and watercolor, because the key is to work very simply and quickly.

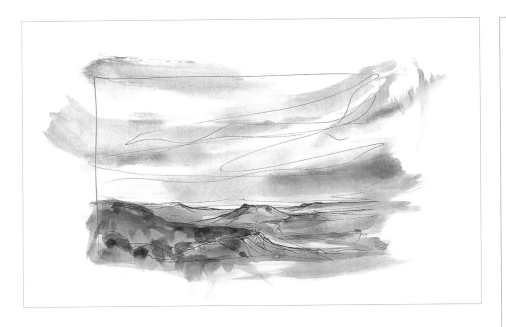

THREE BRUSHSTOKES

1. SIMPLE PEN SKETCH
Using a non-soluble ink pen (even a ballpoint pen will do) sketch an imaginary landscape with foreground and distant mountains. Don't fuss with it. Keep this one uncomplicated.

YOUR SECRET WEAPON! *A 3-LINE SKETCH AND A FEW COLORS*

This is my "secret weapon", the planning tool that helps me to simplify and analyze landscape and also to figure out how to incorporate quite complicated subjects into finished watercolors. How do you reduce a big, complicated subject to a simple sketch, and then, into a watercolor?

1. THE SCENE
It was a beautiful day, and we were en route to our family vacation at the beach. The family car stopped just long enough for me to snap a photo of the coastline — which was quite spectacular! This is a big view and seems quite complicated at first glance. But it can be simplified.

Here's how to reduce it to a three-line pen sketch and three or four strokes of watercolor. What's more, this can all be done in about as much time as it would take you to get out your camera!

2. THREE-LINE SKETCH
It's easy! First establish the foreground with one line, the far shore of the inlet with another, and the outline of the dunes with a third.

A SIMPLE SKETCH

SPEEDY PEN AND WATERCOLOR

For the exercise below simply lay down broad washes over the drawing — a simple pen sketch, then a few horizontal passes of color — applied wet-in-wet. Use Cobalt Blue for the sky, a warm Yellow Ochre/Light Red mix for the nearby land and a sweep of Indigo for the distant mountains.

These washes unify the sketch and "colorize" it (as they might say in the movies). It's actually a simplified historical method reflecting the 17th century when watercolors were known as "stained" or "tinted" drawings.

'S ALL IT TAKES TO GET YOU STARTED!

2. SKY WITH ONE BRUSHSTROKE!
Brush clean water over it to prepare for "wet-in wet". Load a large brush with suitable sky color (I used Cobalt Blue) and establish the sky with a very direct, broad, horizontal sweep that runs right across the picture.

3. LAND WITH ONE BRUSHSTROKE!
Now rinse your brush and reload with a suitable color (I used Yellow Ochre), and lay down the foreground with a broad horizontal sweep. You could use any color you like because, of course, a green or dark "earth" brown will create very different results.

4. MOUNTAINS WITH ONE BRUSHSTROKE!
Rinse again and reload with a suitable color (Indigo was my choice) to lay a broad band across the mountains. The aim is to create a colored "atmosphere". I find this a great confidence builder, suggesting lots of other ways to sketch in watercolor, with or without pen-work.

 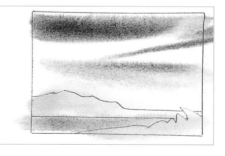 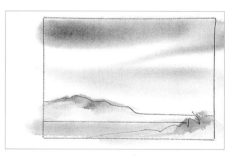

3. SKY AND WATER WITH A FEW BRUSHSTROKES
Now, wet the entire picture and load your brush with a suitable sky color. I used Cobalt Blue. Create the windswept sky with a few sweeps of the brush. Don't try to create the exact sky — create the idea of the sky (there's a big difference!).

Use the same blue to wash in the water. "But it's a different color from the sky", I can hear you saying, and you're right. However, remember that we're NOT TRYING TO COPY NATURE. We're simplifying a big subject.

4. TWO SWEEPS FOR THE LAND
Once again, don't worry about the exact color. I loaded with a pale Yellow Ochre then colored the dunes and foreground with a couple of brush sweeps.

5. FINISHING OFF
Pick up a little green (I used Yellow Ochre, "greened" with a touch of Hooker's Green Dark) and charge the upper area of the dunes and near-foreground. Then pick up a little of a darker color (I used the warmish gray made by mixing Cobalt Blue and Light Red), and charge the green areas to strengthen the form. That's all there is to it! Later, if you decide to work up a larger painting from this you might shift the landforms around quite a bit to establish your composition. (In the sketch for example, I completely ignored the wonderful, thin line of dark blue that the distant ocean creates.)

TACKLING COMPLEX SUBJECTS IN PEN AND WASH

Accuracy is everything when it comes to painting complex architecture. Murray Zanoni shows why a preliminary pen and wash drawing is so helpful.

Traditionally, a pen and watercolor study was the artist's rough for the finished painting. That's how I use it. Pen and watercolor helps me to work out the form and light in a painting and helps me to develop the composition.

Drawing complex architectural structures is a test of your understanding of perspective, vanishing points and eyeline. But when you are making such detailed work, with all those lines, adding a multitude of colored washes over the top can turn the whole thing into a busy, overcrowded mess. That's why I enjoy working with pen and a few simple, tonally correct watercolor washes. Pen and watercolor allows you to capture the architectural truth of the scene, create unity and inject some painterly atmosphere as well.

Once I have decided on a subject, I try to view it at several times of the day, seeing what effect the changes in light will have on the subject, as well as trying to pick up on all the elements that describe and create the mood and atmosphere of that particular place.

I begin by making a light pencil drawing of the scene. Once the drawing is correct, I then use a dip nib and ink to go over my lines. →

THE TOOLS

When traveling I use a fountain pen or a roller ball pen, which are accessible. I always use waterproof ink so subsequent watercolor washes won't bleed the line work.

In my studio I use a dip pen with a nib that produces a hard, fine line, but that will also give a thicker line when I press harder.

I use diluted waterproof Indian ink.

I use acrylic paint, which I dilute so that I can brush on thin washes with the consistency of watercolor. When they are dry, acrylics are completely waterproof, enabling me to build up endless glazes without fear of the paint lifting off.

I prefer to work on acid free cartridge paper and a range of quality acid free watercolor papers. A hot press paper will accept a dip nib easier than a rough surface, but a rough paper can give a nice ragged line. It depends on the effect I want.

"QUEEN VICTORIA BUILDING, SYDNEY"
My focus with this pen and watercolor drawing was the light falling across the domes of the building.

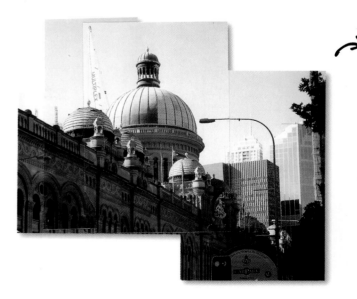

I made a drawing at the scene from scratch. Then I took several photographs and put them together to work from, just as basic visual information.

On-site drawing

"TUSCANY"

Finished painting

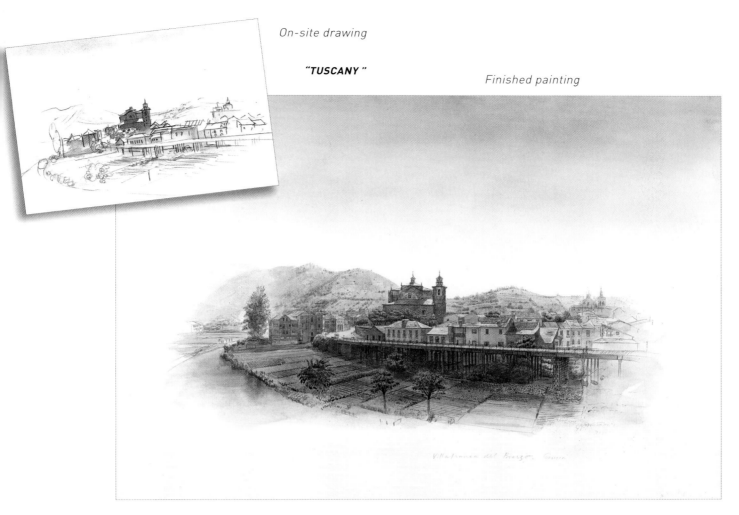

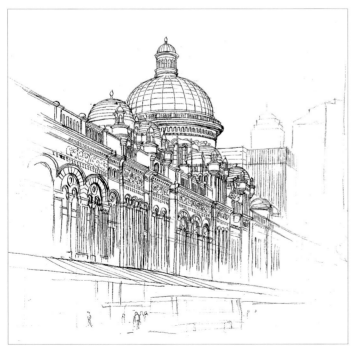

On a blank sheet of watercolor paper I plotted my vanishing point, made a few pencil guidelines and then drew around them with pen and ink.

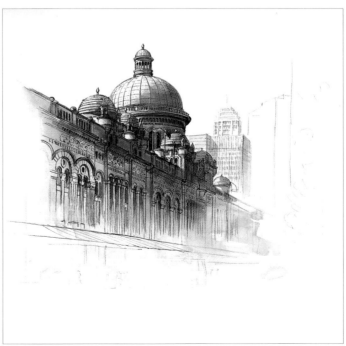

I applied several ink washes diluted with water to build up the light and shadow effects.

Usually, I use a blue-violet watercolor for the shadow areas and while this is still wet I drop in some local color. This pulls everything together. When that stage is dry, I apply more local color as needed. When the pen and watercolor work is complete, and all the groundwork has been done, I can then start on the major painting with confidence.

I love the sensation that pen or pencil drawn directly onto paper gives. Even though there is so much whiz-bang technology available these days, including computer aided art, I still find that the sensitivity of a line drawn by the human hand is pretty convincing in comparison. As my art teacher used to say, drawing is knowing, not just seeing. □

"G'DAY CAFÉ, THE ROCKS, SYDNEY"

Working over roughly blocked in pencil lines, I drew with a dip nib pen using a slightly diluted black ink.

I then washed in the main shadow areas with a watercolor wash of blue-violet, adding a drop of Burnt Sienna inside the café doorway, all wet-in-wet.

I then masked the shop signs with masking fluid and masked other spots of light inside the shop.

I drew up more detail in the window with pen and ink.

ART IN THE MAKING VANISHING POINTS ARE THE KEYS TO SUCCESS

ESTABLISHING THE VANISHING POINTS

I did the drawing on site during my travels in Jeddah. First, I roughly blocked in the main areas with pencil and worked out where my vanishing points should be. Even though I was working at ground level for the drawing I elevated my viewpoint to give the viewer the impression they are looking down onto the street — perhaps from their hotel room.

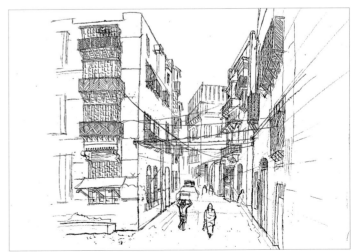

MY PEN DRAWING

I worked directly with pen and ink roughly within the pencil guidelines I had blocked in. I made adjustments and corrections as I drew.

Finally, I built up the local colors with two or three more washes. Once the painting was dry I rubbed off the masking fluid, revealing areas of white paper. Then I adjusted the shadow over the signs.

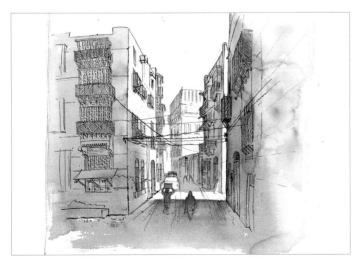

APPLYING COLOR

Light is a very important part of my work. I pay attention to the light source because it can add a dramatic edge to a scene. Before I attempted any coloring I washed in the shadow areas with a blue-biased wash. This gave me the basic line and form of the scene. I usually begin with the lightest areas of color and slowly build up the tonal areas using three or four wet-over-dry washes. I increase tonal values in the shadow areas where needed using further transparent washes.

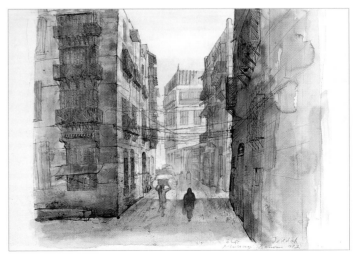

PAINTING FROM PEN AND WASH

The detailed pen and watercolor study gave me all the information I needed to complete a finished painting.

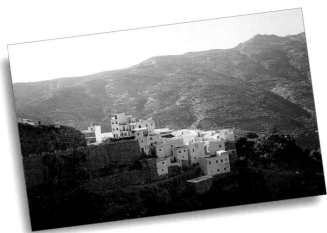

The scene

"OTIVAR, ANDALUCIA"
*Resulting painting in line and
watercolor wash, done on location.*

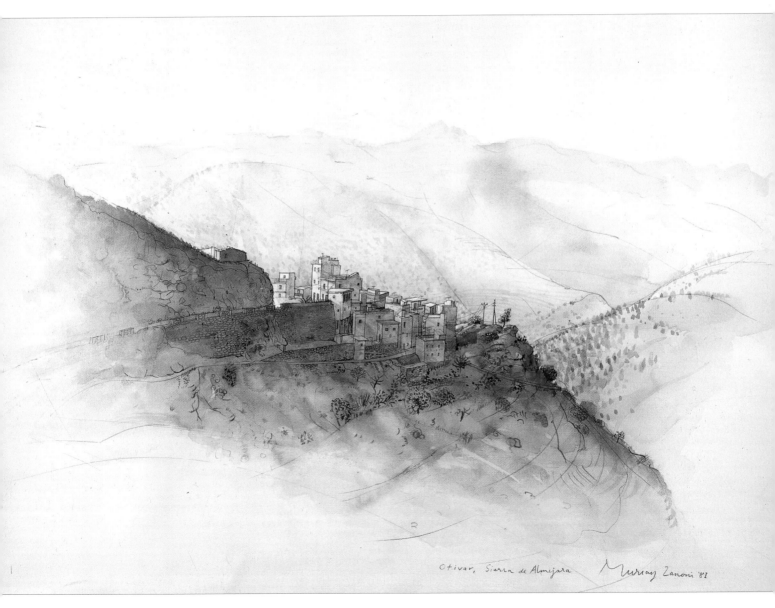

Otivar, Sierra de Almijara Murray Zanoni '81

BIOGRAPHIES

ANTHONY J BATTEN PAGE 6

Born in Eynsham Hall, Oxfordshire, England, Anthony J Batten now resides in Canada. He has earned several degrees in art and art history from L'Ecole des Beaux Arts, Montreal; Concordia University and the University of Toronto.

A long-time art educator, he left teaching in 1998 to pursue a full-time career as an exhibiting artist. A popular demonstrator in watercolor workshops, he strives to share his profound knowledge of architectural history and form as well as the techniques associated with this medium.

Anthony's work is widely recognized throughout Canada and beyond, thanks in part to his busy exhibition schedule. He has had numerous solo shows in Toronto, Montreal and other locations. His paintings are now represented in many prestigious collections, such as The Royal Collection, Windsor Castle; The Prince of Wales; the City of Toronto Archives; St. John's College at Cambridge University in the UK and many corporations around the world.

He is also quite active in several professional organizations. Anthony was elected a member of The Canadian Society of Painters in Water Color in 1980, and has since served for 20 years as one of the group's leaders, including a two-year term as President. In 2002, he was given the Julius Griffith Award for lifetime contributions to the CSPWC. He also became a member of The Society of Canadian Artists in 1998 and of The Federation of Canadian Artists in 2002. Additionally, Anthony has served on the Board of the John B. Aird Gallery (Toronto); on The Art Committee of the National Ballet of Canada (Volunteer Committee); and for three consecutive years, he was the guest-artist with the Cambridge University, North American Summer School based in Newnham College.

Among the many honors accorded him, Anthony was the 1996 recipient of the A J Casson Medal for outstanding achievement in watercolor painting. In 2002, he was awarded the Queen's Golden Jubilee Medal.

MALCOLM BEATTIE PAGE 12

Malcolm Beattie was born in Australia in 1945. He is married with two children, and he works and teaches from his studio in Melbourne. As a professional artist, he places great emphasis on the composition and content of a subject. He combines sound draftsmanship and an understanding of tonal contrasts and color to produce paintings that are both visually interesting and straightforward statements of the everyday places and things around us.

His paintings depict the life and activity of his environment. Malcolm's watercolors are characterized by purity of color and a straightforward arrangement of tonal values. This emphasizes the light in his paintings and, together with a broad approach to detail and careful composition, makes them stand out from the crowd.

Malcolm's work is represented in corporate and private collections around the world and is available through a number of Melbourne and regional galleries. He undertakes regular workshops and demonstrations throughout Australia, and runs a school conducting classes in both watercolor and oil painting technique. He has led painting tours overseas, and is a regular contributor to "Australian Artist" and "International Artist" magazines.

His first book, "Simplifying Complex Scenes in Watercolor", recently published by International Artist Publishing is an international bestseller.

Malcolm has won many prizes and commendations, including the prestigious First Prize and Gold Medal for Watercolor at the 1996 Camberwell Rotary Art Show, and Best Urban Landscape at the 1999 Camberwell Rotary Art Show.

DAVE BECKETT PAGE 20

Born in Winnipeg, Manitoba, in 1939, Dave Beckett's life-long ambition was to become a professional artist. This goal was achieved at the age of 40 when he traded his marketing briefcase for his pastels and easel. He resides and creates his award-winning pastel works at his restored 160-year-old log home and gallery. When not in his studio, he travels extensively, searching out subjects across Canada, Mexico and the UK. It is not unusual to find him canoeing in Algonquin Park or Georgian Bay.

Last year he began to kayak on the rugged west coast gathering material for his seascapes.

His original works have been reproduced in 20 limited editions, which are available across Canada and the United States.

With as many as three exhibitions a year, private collectors find his art welcome additions to their collections. Dave's paintings are also included in numerous corporate and government art collections, such as CIBC, Laurentian Bank, Government of Ontario, Government of Canada's "National Capital Collection", K.F. Prueter Collection, the Etobicoke Board of Education, Stephen Leacock Home and Yankovich Partners of Connecticut.

Dave has been recognized and is a signature member of the Pastel Society of America and the Pastel Society of Canada. His work has been featured in several international art publications, including "International Artist" magazine.

FRANCIS BOAG PAGE 28

Francis Boag was born in Dundee in 1948 and studied at Duncan of Jordanstone College of Art in the late sixties. His tutors in Dundee included Alberto Morrocco and David McLure, whose influence can be readily seen in his love of vibrant color and the sensuous application of paint.

For many years, Francis maintained dual careers as both painter and art educator, which saw him teach in Dundee and Perth before being appointed Head of Art at Aberdeen Grammar School in 1989. It was this move to the North East which signaled a major change of direction in his work. In 1995 when his expressionist interpretations of the local landscape first began appearing in galleries in the North East, the demand for his vibrant colorful paintings started to grow. Sell-out exhibitions in Dublin and London indicated Francis was becoming a prominent figure among the new generation of Scottish colorists.

In 1999 a major commission from John Lewis plc for three large paintings for permanent display in their new flagship store in the Buchanan Galleries in Glasgow

prompted Francis to take a year-long sabbatical from teaching. During this period, he studied for an MA at Grays School of Art.

Francis became a full-time professional artist in June, 2001.

Francis now exhibits widely throughout the UK and is beginning to attract attention from an international market. His feature in "International Artist" magazine has helped to raise his profile. In 2003 the international children's charity Unicef will publish several of his works, making Francis the first Scottish artist to be included in their permanent collection.

KEITH BOWEN PAGE 36

Keith Bowen was born in North Wales where his pre-diploma studies were taken at the Denbighshire Technical College. From there, he attended the Faculty of Art and Design at Manchester Polytechnic, graduating with honors in 1972.

He has exhibited extensively over the subsequent years at various venues including the Summer Exhibition at The Royal Academy of Arts, London; the Portrait Awards at The National Portrait Gallery, London; the Singer and Friedlander Touring Exhibition; and at The Royal Cambrian Academy, Conwy, where he was elected a member in 1992. In the past few years, Keith has staged four solo shows at the Richard Hagen Gallery, Broadway, Worcestershire, and two solo shows with the Open Eye Gallery, Edinburgh. His work is now included in numerous public and private collections.

Not surprisingly, Keith has received various awards, including First Prize, The North Wales Open Exhibition, Mostyn Gallery, 1984; First Prize, Gold Medal for Fine Art, The Royal National Eisteddfod of Wales, 1986; The Frank Herring Award, Pastel Society, Mall Gallery, London, 1991; Honorary Fellowship to The N.E. Wales Institute of Higher Education, University of Wales, 1997; Winner of the Contemporary Award, Pastel Artist International Magazine, 2000.

A lot of Keith's work has found its way into publication. He has designed two issues of stamps for The Royal Mail, the first in 1988 (Welsh Bible) and the second in 1992 (Wintertime). In 1991 Keith's words and pictures about the life and work of the shepherds around Snowdonia was published as Snowdon Shepherd (Gomer Press). This was accompanied by a launch and exhibition at the National Museum of Wales, Museum of the North, Llanberis, and followed by an HTV series, which was later released as a video package. More recently, Keith was commissioned to record the Old Order Amish community of Lancaster County, Pennsylvania, USA, which was then published in Among the Amish (Running Press). The accompanying touring exhibition was sponsored by the Arts Council of Wales.

Keith currently lives with his wife in a farmhouse in southern Scotland.

CATHERINE BRENNAND PAGE 44

Catherine Brennand was born near London in 1961, but grew up in a small village in East Kent. After graduating from University College, Chichester, with a degree in Art and Design, she was still undecided as to either medium or subject in which to specialize. However, her first job as Technical and Graphic Artist in the construction industry awakened her interest in architecture, and she rapidly developed her individual interpretation of buildings.

In 1991, at the Royal Institute of Painters in Water Colour (RI) exhibition, she was presented with the Young Painters in Water Colour Award sponsored by Winsor & Newton. At the 1992 RI exhibition, she won the Frank Herring & Son Award for Best Painting of an Architectural Subject. Following the exhibition, she was invited to become a full member of the RI. Since 2001, she has been on the council of the RI. Among other prizes Catherine has won are the 1995 Linda Blackstone Gallery Award for the Most Innovative Use of Water Colour at the RI Exhibition and the 2000 Llewellyn Alexander Gallery Award at the RI Exhibition, the top prize awarded to her for a group of four paintings depicting Paris shops.

Catherine regularly exhibits at major galleries in Britain and has accepted numerous commissions. Since 1998, Catherine has been part of Artists in Residence, a commissions service for people wishing to have paintings of their houses. She has completed 11 works to date through this service.

GERALD BROMMER PAGE 52

As an innovative watercolor and acrylic painter, collagist, teacher, author and juror, Gerald Brommer is completely immersed in the world of art. His award-winning works have been exhibited in numerous one-man and group exhibitions around the world, and can be found in literally thousands of private, museum and corporate collections. He is a member of several national and western US art organizations, and has authored and/or contributed to dozens of art instruction books and magazines. In 2003, his new book, "Emotional Content: How to create paintings that communicate", will be published by International Artist Publishing.

TONY COUCH PAGE 60

Tony Couch received a BA in Art from the University of Tampa and did further work at Pratt Institute in New York while working as an artist for the Associated Press. He also studied privately with renowned watercolorist Edgar A Whitney.

Tony regularly enters national exhibitions where he's won countless awards. His work has been exhibited at the National Academy of Design several times, and he is a member of many prestigious art organizations, including Allied Artists of America, the Salmagundi Club, the Society of Marine Painters and Watercolor West among others.

Tony Couch's "Keys to Successful Painting" and "Watercolor: You Can Do It!" (both published by North Light) are just two of the art instruction books and magazine articles he's written through the years. Tony also has an extensive line of videos, and his US and foreign workshops sell out quickly. For more information, visit his web site at www.tonycouch.com

JANICE DONELSON PAGE 68

Janice Thomas Donelson paints primarily with water-based media including watercolor, acrylics, gouache, collage and pen and ink. Inspired by travel, her subject matter since 1997 has been mostly European city scenes of open air markets, architectural studies, bridges and landscapes. She sketches continuously on frequent trips across Italy, France